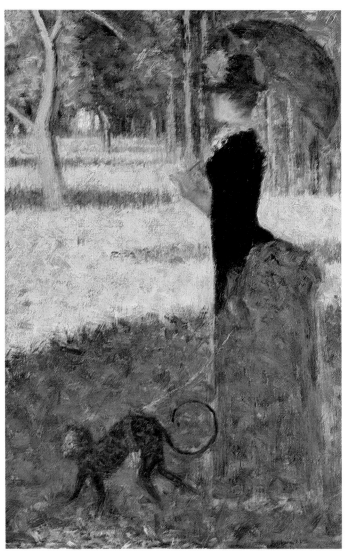

SEURAT

SEU

A Biography

John Rewald

RAT

Thames and Hudson

EDITOR: Robert Morton
DESIGNER: Judith Michael
PHOTO RESEARCH: Neil Ryder Hoos

First published in Great Britain in 1990
by Thames and Hudson Ltd, London

Printed and bound in Italy

Contents

To
the memory of
Félix Fénéon
with
undiminished
gratitude and
admiration

SEURAT

Portrait of Georges Seurat

Introduction

"An unbiased mind perceives with stupefaction that even in his first productions, even in his youth, he was great. At times he may have been more delicate, at times more singular, at times he may have been more of a painter, but he was always great."

These words, written by Charles Baudelaire about Eugène Delacroix, are surely relevant to Georges Seurat, who was at once the disciple of the painter of the *Massacre at Chios* and of his rival Jean-Auguste-Dominique Ingres. Seurat was indeed great. He was able to record unhesitatingly whatever his eye and his intelligence dictated to his brush, and the very least of his sketches bears the stamp of an incomparable artistic personality. He was able to perceive and transfer to his canvas a fundamental sense of the animate and inanimate that is today part of our aesthetic patrimony.

It was Seurat's conception of art rather than his purely technical innovations that was the decisive element of his contribution, the invigoration of Impressionism. He was not the only painter who wanted to give new impetus to the movement initiated by Manet and his friends, Seurat's elders by a generation. His contemporaries Vincent van Gogh and Henri de Toulouse-Lautrec were also seeking new paths. Van Gogh with his explosive color and charged expressiveness, Lautrec with his keen, observant wit and nervous draftsmanship, and Seurat with his deliberate method and precise harmonies—all three went beyond Impressionism. Contemporary art begins with them, with Cézanne working in self-imposed isolation at Aix, and with Gauguin's search for utopia in the distant tropics.

Seurat, van Gogh, Lautrec. Three glorious entries in the history of painting in the twilight years of the nineteenth century; three industrious lives brought down at the height of their creativity. Van Gogh was thirty-seven years old when he committed suicide in 1890. Seurat died suddenly at thirty-one in 1891. Lautrec burned himself out at the age of thirty-seven in 1901. Despite their youth, all three achieved what Cézanne called *réalisation*, giving their full measure at an age when others are still seeking. As if sensing that they had only a few years in which to express themselves, they bypassed the usual stages, reached maturity quickly, and left a body of work that proclaims their genius.

If Lautrec regarded his contemporaries with a pitiless and ironical eye, if van Gogh consumed himself in impassioned solitude, Seurat, basing himself on scientific research and singularly conscious of his role, hurled himself into the fray. Without seeking the limelight, he feared neither the opinions nor the ridicule of the public. He was less isolated than either Lautrec or van Gogh; early in his career he attracted companions who adopted his methods and with him formed the Neo-Impressionist group. Surrounded by young comrades and encouraged by the support of the venerable Camille Pissarro, he was able to direct the struggle for a new vision expressed by a new method. But after his unexpected death, there was no one to take his place, for though his disciples shared his vision and technique, his genius was his alone.

After Seurat's death there were those who were quick to say that he had not lived long enough to realize his aesthetic discovery, his new formula for beauty, that he had "bequeathed a stammering revelation that dazzled without enlightening." He was even blamed for the "pernicious confusion of art and science, the most dangerous error in the history of art." It would be idle to discuss these questions today when Seurat's work is celebrated and respected as a source of inspiration. During the artist's lifetime his friends Félix Fénéon and Emile Verhaeren assiduously pointed out that his scientific approach did not contradict the essence of art, for the most perfect knowledge of the laws of optics had never produced an artist. Those who believed they had found an infallible recipe for art in Seurat's discoveries simply forgot that no technique or theory is valid unless applied by a person of genius, and that no method, however ingenious, can provide an escape from mediocrity.

In this study, no attempt is made to analyze the views of Seurat. To understand his work and the movement he created, it is less important to search out the validity or fallibility of his ideas than to know the ideas themselves. Thus, this

account is limited to a review of Seurat's life, of the development of his ideas—and, paralleling them, his work—and of the reception accorded them. To the extent that it has been possible, whatever was said or written about Seurat in his lifetime is reported here, with the sources cited where known. By this means an attempt has been made to reconstitute the intellectual atmosphere in which Seurat worked. Others may study his place in the history of art or analyze his paintings; the aim here has been to present the facts without embellishment, to assemble the significant evidence, and to retrieve essential documents while such research was still possible.

I would not have been able to realize these aims without the untiring efforts of Félix Fénéon, the only man who could speak with authority about Georges Seurat. Harbored within his reclusive silence was a thorough knowledge of the life and work of his great friend. He agreed to vet this study, and his prodigious memory supplied much new information. He gave me access to his collection of reviews of the early exhibitions of Seurat's work, which I have supplemented with additional items discovered in contemporaneous publications. Without the friendly collaboration of Félix Fénéon, this study could not have been written.

Paul Signac and Maximilien Luce, who, with Fénéon, were named by Seurat's family to distribute his works among his friends, eagerly related their recollections. Another friend of Seurat, Lucien Pissarro, entrusted me with his father's letters to him, which permitted the clarification of certain important points. These letters have since been published as *Camille Pissarro: Letters to His Son Lucien*. To this day I am indebted to César M. de Haucke, who, in collaboration with Félix Fénéon, prepared the catalogue raisonné of Seurat's work and who permitted me to consult the files of his then-unpublished collection of photographs.

The writing of this study began in Paris in 1938 and was finally completed in 1942 in New York City. It first appeared in an English translation in 1943, published by Wittenborn and Company, and in a second edition in 1946. In spite of material difficulties of every kind, notably the impossibility of obtaining the photographs already collected in France, thanks to the energies of George Wittenborn and Heinz Schultz, the publication was able to reproduce what amounted to an important and representative selection of Seurat's work.

Meyer Schapiro made a number of suggestions for the bibliography and sent me David Sutter's articles, the importance of which he planned to demonstrate in a study then in preparation. I was also greatly aided by the Museum

of Modern Art, New York; the College Art Association of America; the Art Foundation, Inc., which put its plates at our disposal; the Kröller-Müller Foundation, Otterlo; and the Courtauld Institute of Art, London, as well as by many persons who lent me photographs. I am still grateful to the collectors who permitted me to reproduce the works in their possession.

The original French text appeared in Paris in 1948, supplemented with little-known documents, notably, important articles by Fénéon which his modesty had prevented him from indicating to me but which I have discovered in the intervening years. In addition, it contained an entirely new chapter, "Quarrels of the Artists," based on unpublished documents offered by Rodo Pissarro, the fourth of Camille Pissarro's five sons, and a veritable treasure submitted by Mme Charles Cachin-Signac, which included such vital documents as letters from Seurat to Signac and the correspondence between Signac and Camille Pissarro. This chapter is presented here in English in its entirety for the first time. Except for factual material more recently brought to light, little else has been added here. Since this is the last text on Seurat supervised and even guided by Félix Fénéon, it appeared essential not to insert alterations that might conflict with what had met his approval.

With solemn determination, Fénéon rejected all suggestions that he write his memoirs. Again and again he replied to those who urged him to prepare a record of his life (among whom I was a repeated proposer) that he did not care to leave any traces in the pages of History. Yet, despite his desire, those pages carry his name. Had he put down all that he knew, he might have prevented others from spinning tales around his rich and varied existence. As a result, he must now "pay" for the silence and discretion to which he so fervently aspired. Yet, there was an admitted contradiction in Fénéon's attitude, for despite his oft-expressed desire to be completely forgotten by the new generations, he patiently answered many of my questions, thus helping me clarify numerous points involving Seurat and, indirectly, his own role as the painter's friend. Though anxious not to give the impression of boasting of Fénéon's paternal friendship, I cannot help but feel that I was possibly the ultimate—oh, how inadequate and juvenile!— member of the restricted entourage through which he maintained contact with both the past and the future.

In the method of investigation that is currently called "The New Scholarship," it has become fashionable to study Seurat's work for evidence of social, class, and family tensions of the emerging urban world, notably the radical political messages

in his acknowledged masterpiece, *A Sunday Afternoon on the Island of La Grande Jatte*. This has led to examinations of such questions as to whether, in contrast to the Sunday populace of *La Grande Jatte*, Seurat's earlier *Bathers* (which once belonged to Fénéon) does not represent workers on a Monday, or whether Seurat dehumanized and transformed human individuality into a critical index of social malaise. While the publications that propose such interpretations are duly listed in the bibliography, they are not reflected in the text.

If, as a witness (perhaps the last, having now reached Fénéon's age at the time I first met him), I may contribute a final recollection to these investigations, it is that fundamentally Fénéon remained an anarchist all his life. But anarchism lost its pungency after the First World War, and his sympathies turned toward the Communist Party, though whether he was officially a member I cannot say. His old friend Signac shared many of his views without joining the party. More than once Fénéon discussed with me his intention of leaving his collection to Soviet Russia, to what was then Stalin's Soviet Russia. The collection consisted of many small panels by Seurat (among them three studies for *The Models* eventually acquired by the Musées Nationaux), as well as countless drawings by him, and of signal works by Bonnard, Matisse, Modigliani, and of course Signac, Luce, and Henri-Edmond Cross.

Whether Stalin's pact with Hitler, which enabled the Führer to invade France, had any effect on Fénéon, I cannot say. By then I was in a French internment camp and Fénéon was recuperating in the south from a grave operation. The fact is that when Fénéon died in 1944 at the age of eighty-three, France was occupied by the Nazis and governed, if one may call it that, by Pétain. Delivery of his bequest, even had he maintained his provisions, was disrupted by world events. What I can vouch for, however, is that Fénéon, avowed friend of the Soviets though he was, not once mentioned to me any connection whatsoever between Seurat's work and Karl Marx.

In its present form this book owes much to the editorial skills of my friend Irene Gordon, who has not only revised the translation of 1943 but has also brought the bibliography up to date.

John Rewald
New York, March 1990

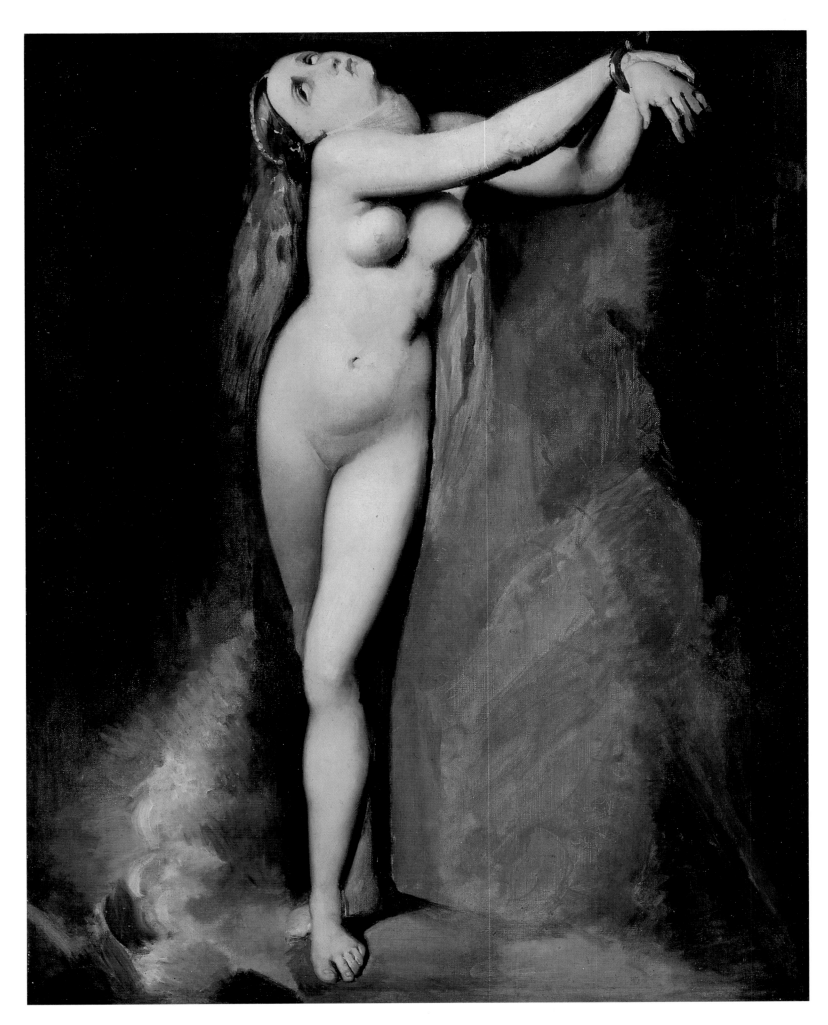

Angelica Chained to the Rock (after Ingres). c. 1878

Beginnings

Georges Seurat was born on December 2, 1859, in the rue de Bondy, located in La Villette, the northeast quarter of Paris, where his father was a bailiff. The limitations of the pious, somewhat bigoted, petty bourgeois family in which he was brought up, if not wholly favorable to the boy's artistic development, do not seem to have seriously interfered with his interests. He pursued the customary studies of a French youth of his class, with the addition, at the age of sixteen, of enrollment in a municipal school of design near the church of Saint Vincent-de-Paul in his home district. Here the main emphasis was on copying the dusty plaster casts of antique sculpture that cluttered the studios of the period. The school was run by the sculptor Justin Lequien, a winner of second honors in the Grand Prix de Rome, who—as one of Seurat's schoolmates would later observe—taught his pupils the art of drawing noses and ears after lithographic models.[1] It was at this school that Seurat, a serious, disciplined, and somewhat reserved young man, met Edmond Aman-Jean. They soon became fast friends and in 1878 entered the Ecole des Beaux-Arts together, where they studied under Henri Lehmann, a pupil of Ingres.

The alert intelligence of the two young men soon rebelled against the narrowness of the official studios, where a degenerate classicism was painfully elaborated by narrow-minded professors who at best were merely adequate both as

teachers and artists. Led by a natural curiosity and a taste for the difficult, Seurat began to seek other pastures, thus resisting the academic conceptions that could be so fatal to youthful aspirations. Encouraging his friend to read the books he himself liked—the Goncourt brothers were his gods just then—Seurat engaged Aman-Jean in endless artistic and literary discussions.[2] For a long time he was completely devoted to Ingres, whose ideas were transmitted to him—considerably coarsened—by Lehmann.[3] The influence of Seurat's enthusiasm for Ingres can be seen in his studies from models, especially in certain copies after the master, and in compositions that also show the influence of Puvis de Chavannes.

His earliest dated drawings, from 1874, mostly copies (of illustrations; of a statue of Vercingetorix, the martyred Gallic opponent of Caesar; of works by Alphonse de Neuville), done before he entered design school, are competent though not lively. Under professional tutelage young Seurat soon moved toward better models and a freer style. He began to make copies of Holbein's drawings, of his portrait of Sir Richard Southwell, for example. He made a sketch of Poussin's hand, based on the celebrated self-portrait in the Louvre; a copy in oil of Ingres' *Angelica;* line drawings of the figure in Ingres' *Source* and also of figures after drawings by Raphael. While these works were executed with the aim of achieving mastery of line, Seurat was deeply interested in the theory of complementary colors, which inevitably led him to Delacroix.

A good student, dutiful, orderly, but not particularly brilliant,[4] Seurat visited museums regularly and spent much of his time in the libraries where he studied engravings and photographs when he was not poring over such works as Chevreul's treatise on the principles of harmony and contrast of colors, or *The Grammar of Painting and Engraving* by Charles Blanc. For a long time he mulled over certain passages of these works, for example, the following observation by Blanc: "The Orientals, who are excellent colorists, when they have to tint a surface smooth in appearance, make the color vibrate by putting tone upon tone."[5]

In November 1879, while still absorbed in these studies, Seurat left the studio in the rue de l'Arbalète that he shared with his friend Aman-Jean to serve his required term in the army at Brest in a regiment of the line. For a year he lived facing the coast and soon came to feel a secret intimacy with the spacious horizons and vast reaches of the sea. Whenever release from military routine allowed, he filled his notebooks with impromptu sketches, sometimes in colored pencil, catching the pose of a comrade, noting the movements of a

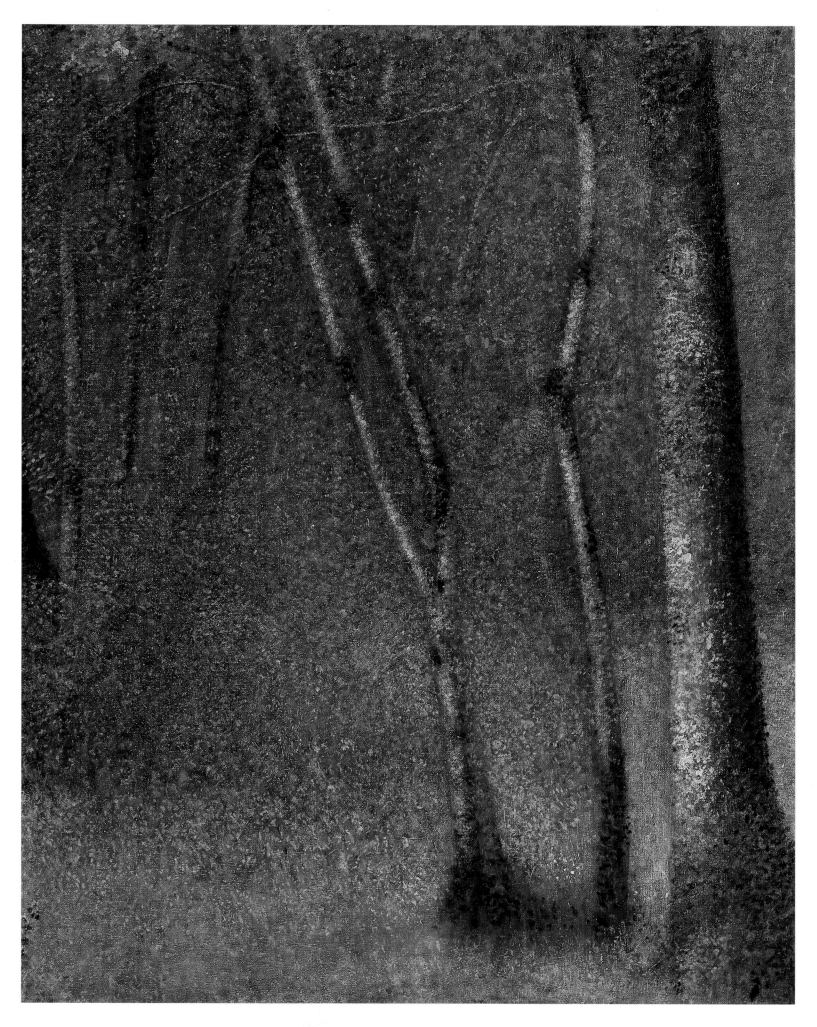

Forest at Pontaubert. 1881

passerby, studying this gesture, that detail.[6]

On his return to Paris in November 1880 Seurat moved into a studio at 19, rue de Chabrol. He now began to draw intensively, concentrating on the adjustment of light and shadow, which so often blur details. He invented new outlines by means of which he enclosed familiar forms and, by ridding them of any accidental quality, achieved an unsuspected poetic expressiveness. Renouncing line as a means of definition, he began to compose in tonal masses. On the rough surface of his drawing paper his pencil blocked in areas of shadow, allowing the intervening white spaces to build form. By means of perfectly calculated modulations and contrasts,

Study after Delacroix's "Fanatics of Tangier." 1881

he presented unforeseen perspectives. Suppressing light and color, he brought them to life again in velvety blacks and elusive whites, creating a new world in which shadows engender plastic bodies, transparencies are full of mystery, and the grays that move between black and white reveal an intense life. Harmonic lines swell and recede, forms are blurred or become precise, and light glows under the dense weaving of his pencil strokes.

Seurat devoted the years 1882 and 1883 almost exclusively to drawing. His first exhibited drawing, a portrait of his friend Aman-Jean, was accepted by the Salon of 1883, although his other entries were refused. It won him a favorable comment by the critic Roger Marx, who saw in the portrait "an excellent study in chiaroscuro, a drawing of merit, which cannot be the work of a nonentity."[7]

While continuing to draw, Seurat now began to study the art of Eugène Delacroix. He made frequent pilgrimages to the

Nude Study. 1877

Study of a Leg. c. 1875

The Hand of Poussin (after a portrait of Poussin in the Louvre). c. 1877

Seated Man. c. 1881

Harvester. c. 1881

The Orange Merchant. c. 1881

Woman Strolling. c. 1882

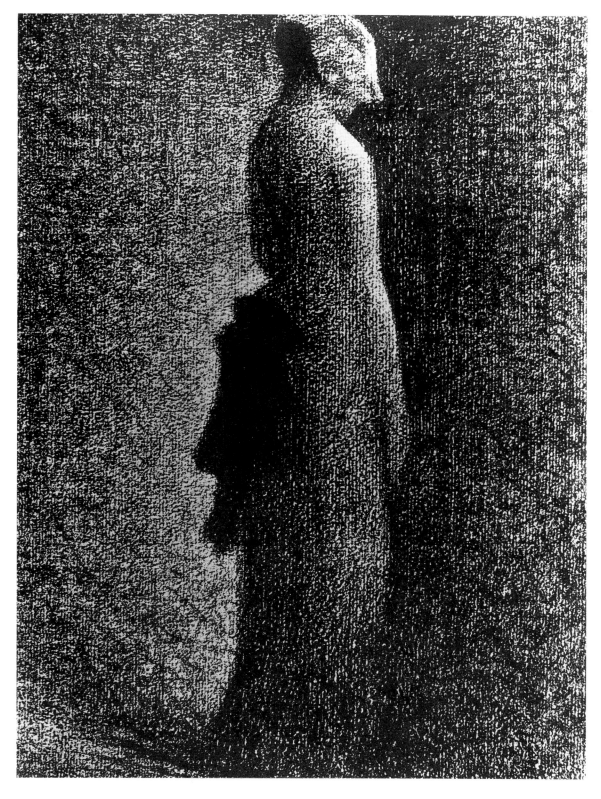

The Black Bow. 1882–83

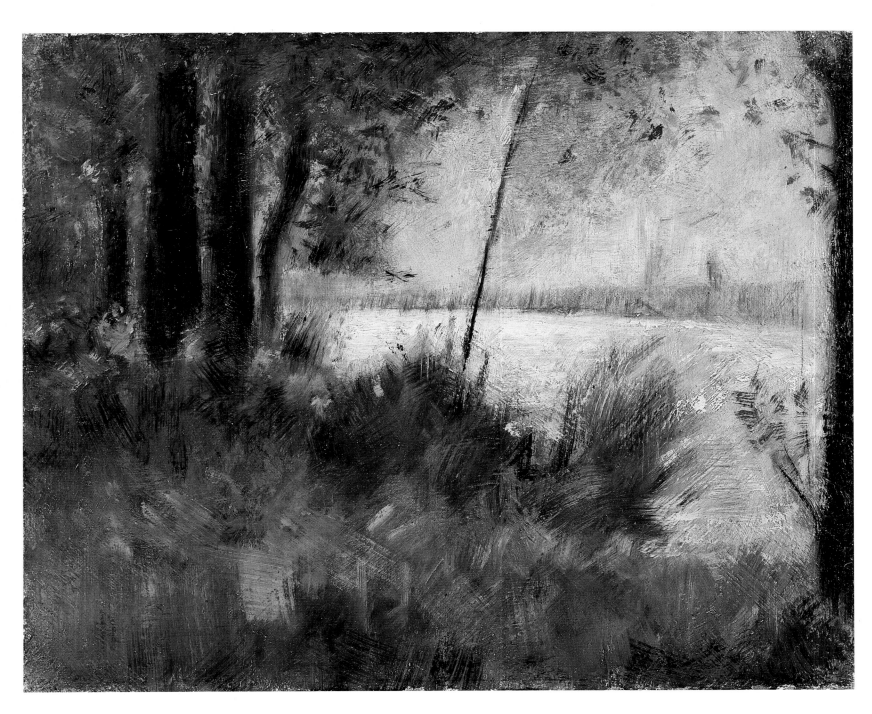

Grassy Riverbank. 1881–82

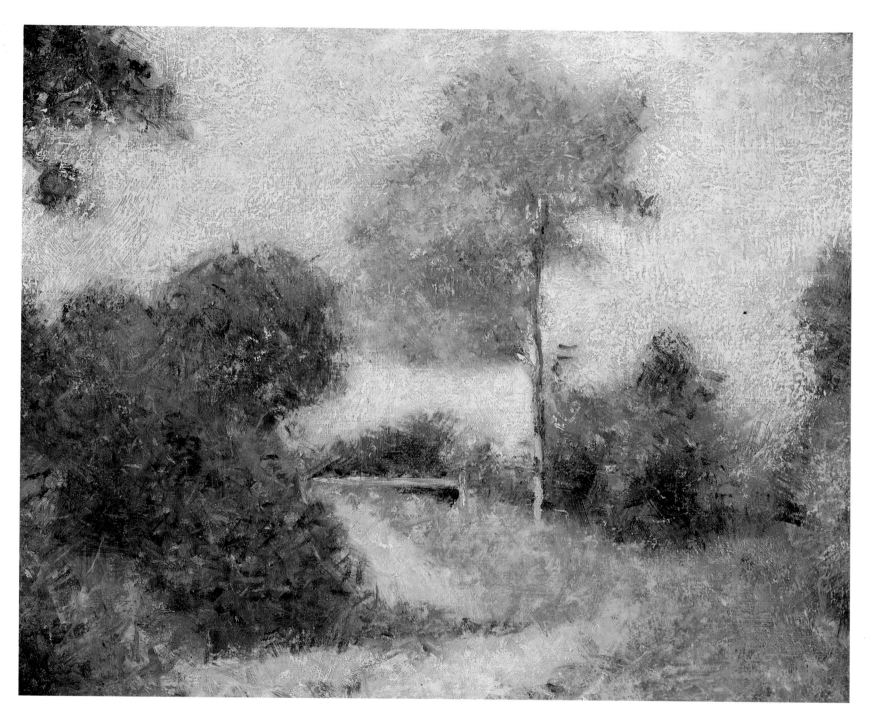

The Clearing. c. 1882

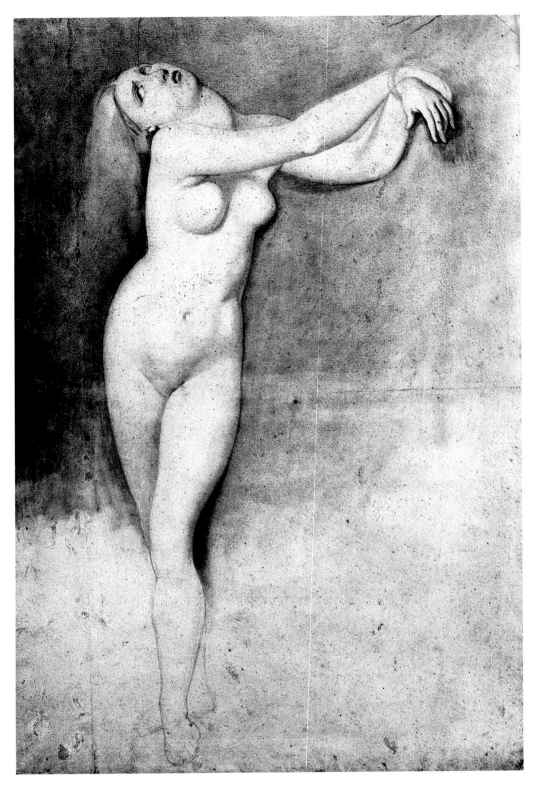

Study after Ingres' "Angelica Chained to the Rock." 1878

chapel of the Holy Angels in the church of Saint-Sulpice and quickly became conversant with the master's technique. It did not take him long to arrive at conclusions that had already been formulated by Charles Baudelaire:

It is obvious that the larger a picture, the broader must be its *touch;* but it is better that the individual touches should not be materially fused, for they will fuse naturally at a distance determined by the law of sympathy which brought them together. Color will thus achieve a greater energy and freshness.[8]

And he began to see other relations that had been noted by Baudelaire:

Everyone knows that yellow, orange, and red inspire and express the ideas of joy, richness, glory and love; but there are thousands of different yellow or red atmospheres, and all the other colors will be affected logically and to a proportionate degree determined by the atmosphere which dominates. In certain of its aspects the art of the colorist has an evident affinity with mathematics and music.[9]

Seurat had already found in Blanc's *Grammar of Painting* an allusion to the relation of music and color, and this suggestion struck him all the more forcibly, for his methodical mind saw new possibilities. Blanc had written that "not only can color, which is under fixed laws, be taught like music. . . . From having known these laws, studied them profoundly, after having intuitively divined them, Eugène Delacroix became one of the greatest colorists of modern times."[10] Blanc also insisted on the effects of optical mixture, effects already observed in Delacroix's paintings by Baudelaire. Analyzing a nude in a ceiling decoration, Blanc noted:

By the boldness with which Delacroix had slashed the naked back of this figure with a decided green, which, partly neutralized by its complement rose, forms with the rose in which it is absorbed a mixed and fresh tone apparent only at a distance, in a word, a *resultant* color which is what is called the optical mixture.[11]

Seurat was too infatuated with scientific research to refrain from synthesizing the laws of harmony and color into precise formulas that would be applicable to the visual arts and comparable to theories of music. The theory of complementary and contrasting colors led him to the study of those "mathematical" aspects of painting of which Baudelaire had spoken so prophetically. And now he found the confirmation of these theories in the works of Delacroix. He observed in the *Women of Algiers* orange-reds opposed to blue-greens or greens and yellows which, optically mixed, produced the exact luster of silk. In a note dated February 23, 1881, for example,

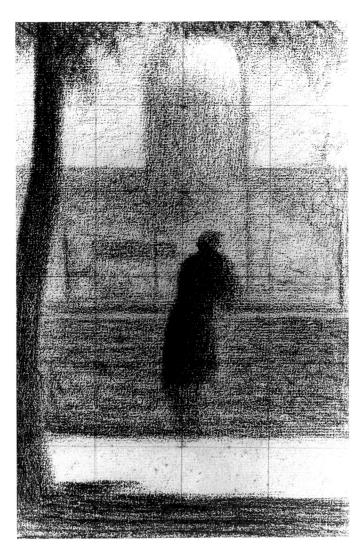

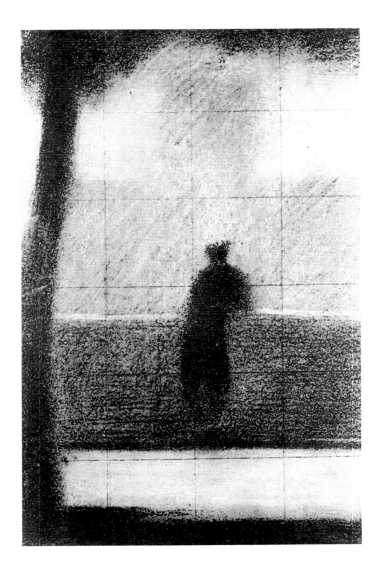

Study for "Man at a Parapet (The Invalid)." c. 1881

Study for "Man at a Parapet (The Invalid)." c. 1881

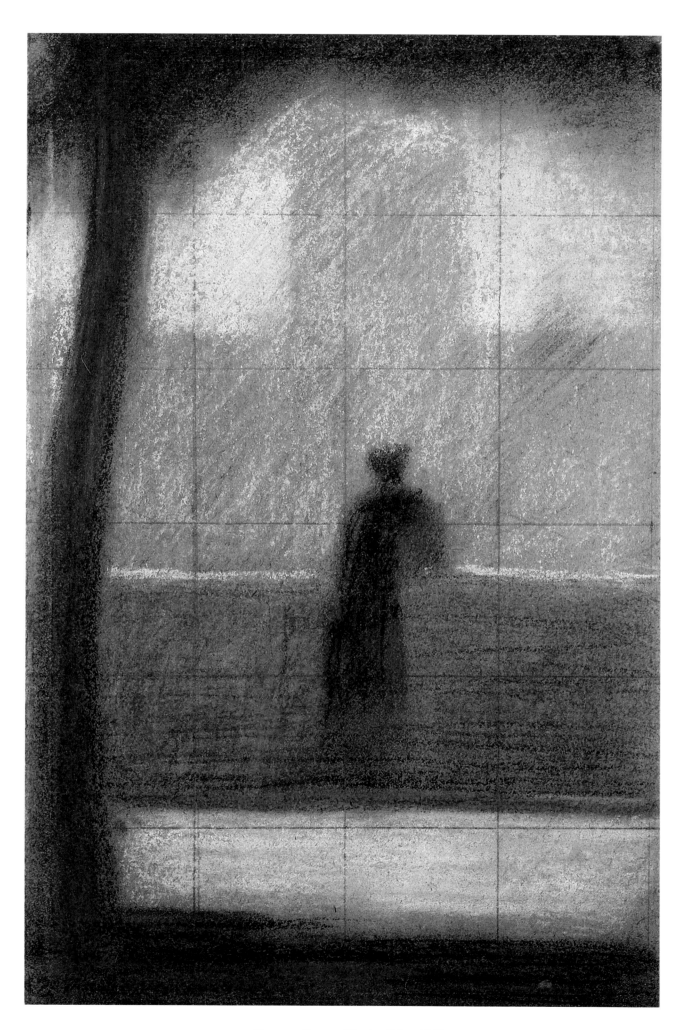

Man at a Parapet. (The Invalid). c.1881

he observed that in the *Fanatics of Tangier* "the flag is green with a touch of red at the center. Above, the blue of the sky, and the orange-white of the walls, and the orange gray of the clouds."[12]

With these observations firmly in mind, Seurat examined the work of other masters in the Louvre, and it was thus that he discovered the division of tones in Murillo and Veronese.[13] Chevreul's law of simultaneous contrast of colors provided the scientific basis for his researches. According to this law, "in the *simultaneous contrast of colors* is included all the phenomena of modification which differently colored objects appear to undergo in their physical composition and in the height of tone of their respective colors, when seen simultaneously."[14]

Chevreul had explained that if one looks at two objects at once and regards them attentively, each one will appear to have not only its own color, that is, what it would seem to have if it were seen in isolation, but also the shade arising from the complementary color of the color of the other object. In fact, in juxtaposition they will appear to be other than they "really" are.

The Impressionists, by representing objects and the air circulating around them, dissolving them in a luminous atmosphere, had already dealt a mortal blow to the old conception of "local color." They would have argued against Chevreul's conception that it is impossible to define the "real" color of an object since it is constantly exposed to the influence of everything that surrounds it. However, in introducing into their paintings the effects produced on each object by its neighbors and by the ambient light, the Impressionists had merely been faithful to insights based on instinct and observation, insights they had not tried to raise to the level of an exact science. But Seurat now set out to effect a reconciliation of art and science; he did not hide his intention of "starting anew everything they had done,"[15] as Cézanne had wished to "remake Poussin after nature." From 1882 on, according to Paul Signac, Seurat based himself on the laws of contrasts in his use of color and painted each element separately in soft tones. If there are few paintings in existence that date before this period, it is because at a later time Seurat seems to have destroyed whatever did not bear the mark of his first efforts toward a personal art. For the same reason, he never showed canvases painted before the *Bathers* of 1883–84.

In 1882 Seurat had begun to compose either with separate touches of the brush which fuse only at a certain distance, as in *A Forest Interior*, done in dots of a single color, or with the

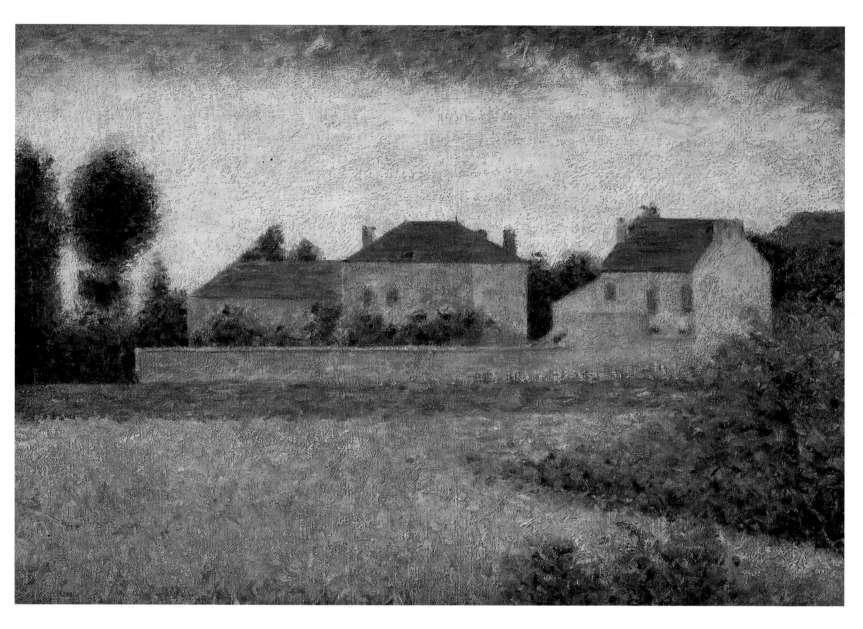

White Houses at Ville d'Avray. c. 1882

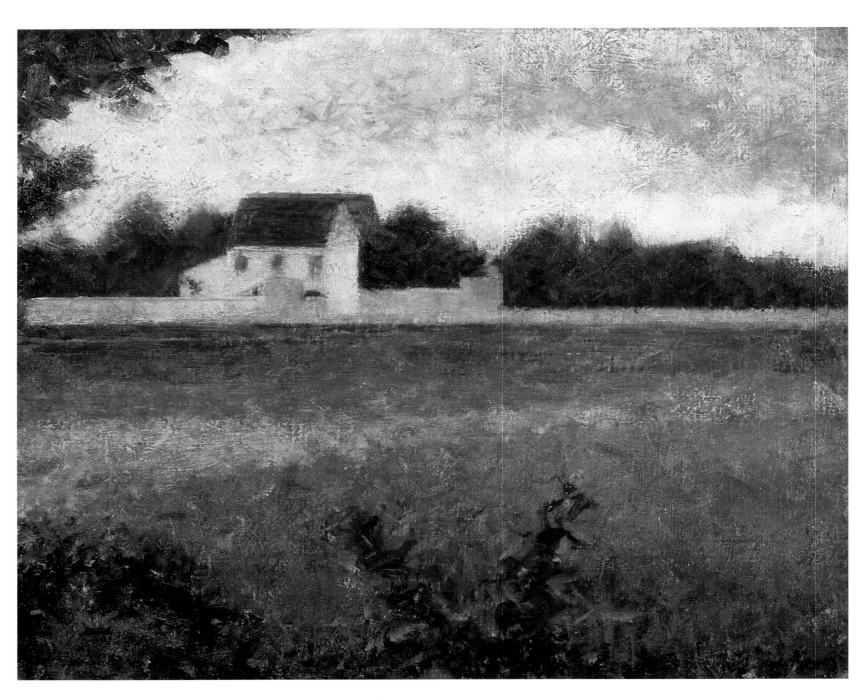

Landscape of the Ile-de-France. 1882

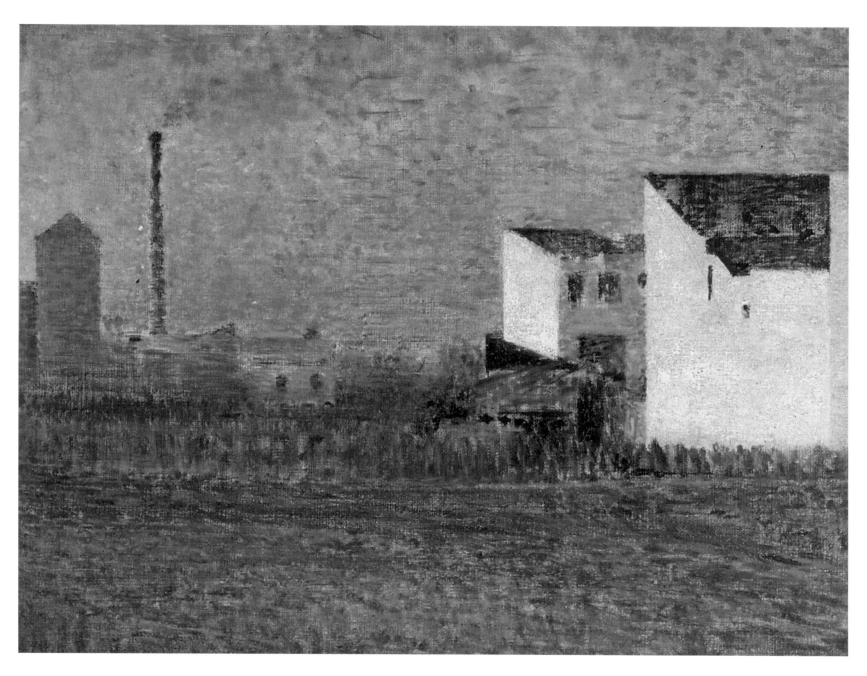

Industrial Suburb (La Banlieue). 1882–83

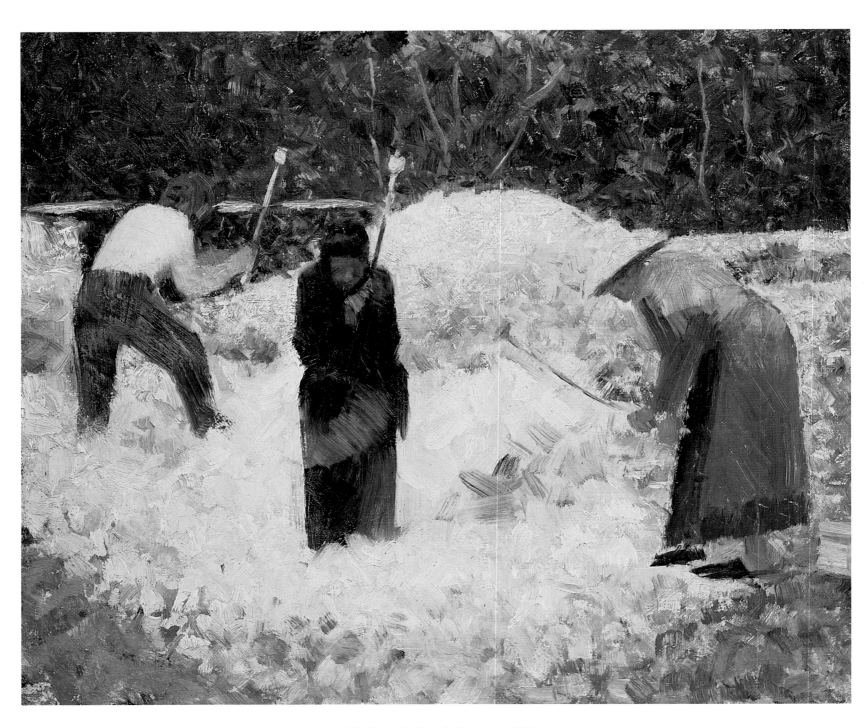

The Stone Breakers, Le Raincy. c. 1882

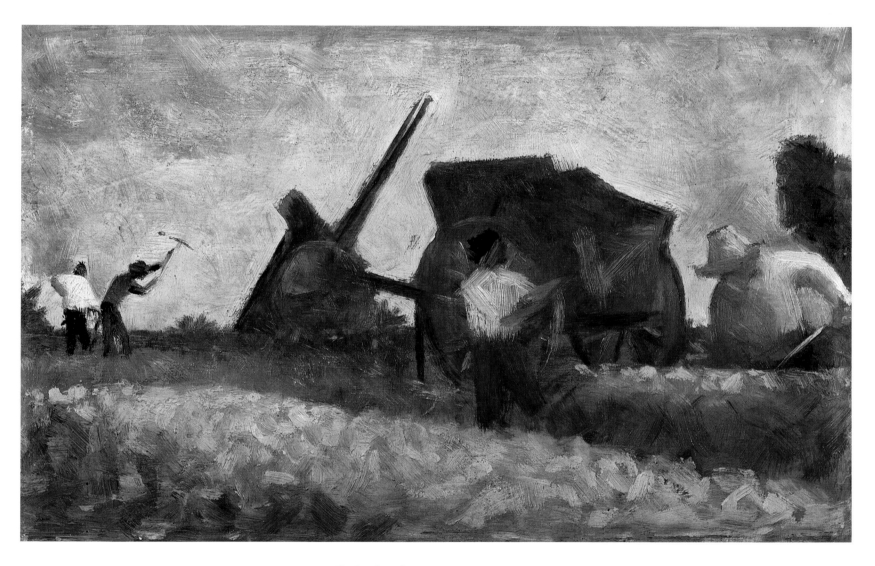

The Roadmenders (The Laborers). c. 1882

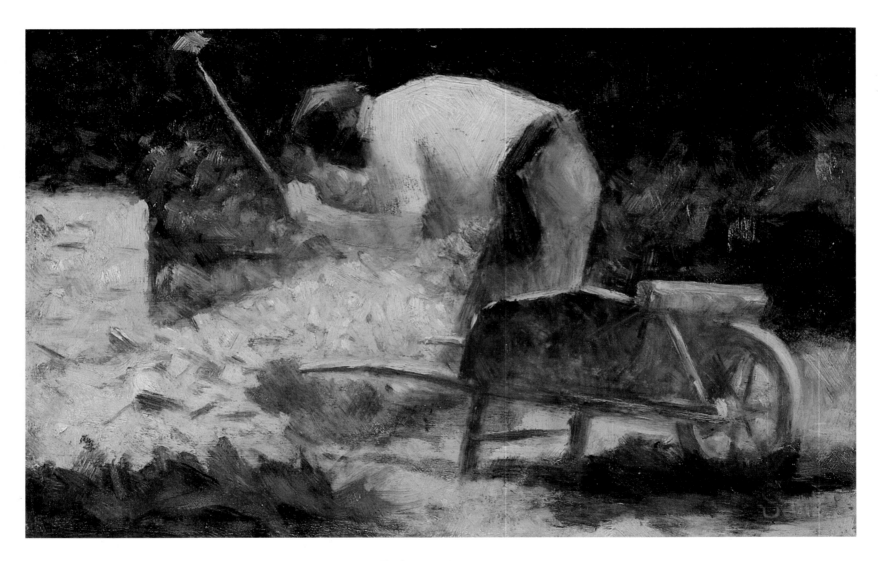

The Stone Breaker. c. 1882

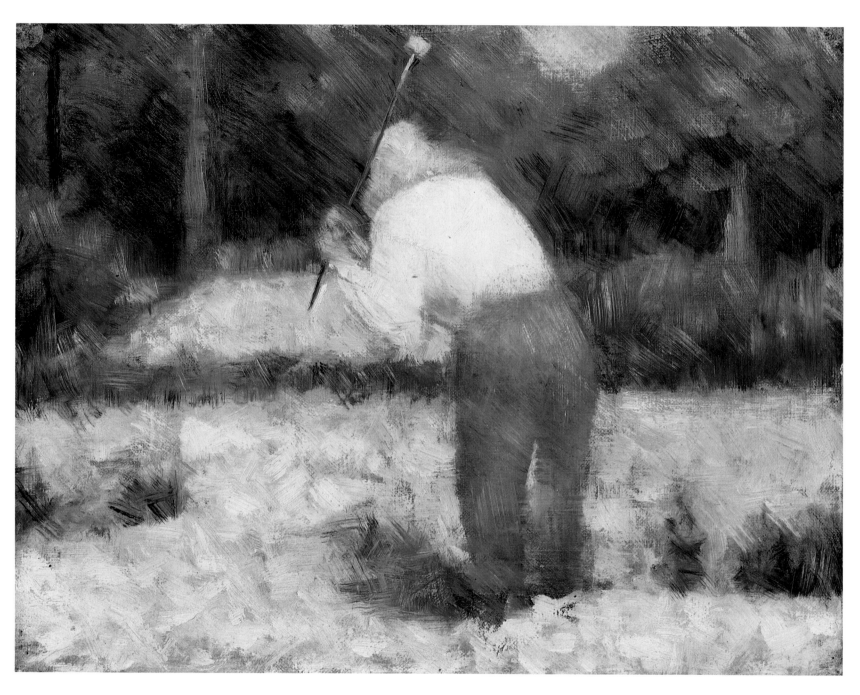

The Stone Breaker. 1882

large, sweeping strokes that recur in the many canvases of reapers, field-workers, and stone breakers. These latter paintings, of extraordinary luminosity, convey the subject by means of large masses of light and shade. The numerous brushstrokes scattered in every direction create an atmosphere that seems to vibrate. The critic who remarked in 1884 that Seurat applied "without awkwardness, and even with much accuracy, the method of multicolored strokes dear to Camille Pissarro"[16] forgot to add that the brushstrokes of the Impressionist master were determined by the forms and favored iridescence, whereas Seurat was using the method at this point to animate vaguely indicated masses and soften contrast by eliminating the precise delineation of contours.

However, there are other canvases in which his style is less lively, his color more austere, and in which the drawing appears to be more deliberate, as in some of the suburban landscapes.[17] In these paintings the artist seems to take pleasure in representing in an almost dry manner the rectilinear walls of isolated houses, the monotony of deserted fields, the absurd fragility of factory chimneys. Without any sentimentality he records—one might almost say accentuates—the melancholy of those places where the tedium of town and country intersect. But the balanced character of his composition, the harmony of light and shade, and the subdued palette combine to "ennoble" the site and create an almost monumental image.

If Seurat derived technical conceptions from Delacroix which enabled him to formulate a point of departure for his own efforts, he also found notions in the great Romantic that justified his own tendencies, as when Delacroix noted:

Nature is just a dictionary, you hunt in it for words . . . you find in it the elements that make a phrase or a story; but nobody would regard a dictionary as a composition in the poetic sense of the term.

Besides, nature is far from always being interesting from the point of view of the effect of the whole. . . . If each detail is perfect in some way, the union of these details seldom gives an effect equivalent to that which arises, in the work of a great artist, from the total composition.[18]

This principle, which beheld the natural world as a means rather than an end, found a willing adherent in Seurat. This view was profoundly opposed to what the Impressionist painters were trying to achieve, concerned as they were with catching the fugitive aspects of their subject and faithfully revealing "nature as seen through their temperaments." If from this point on he carefully prepared every detail of his pictures by way of drawings and sketches from nature, he was

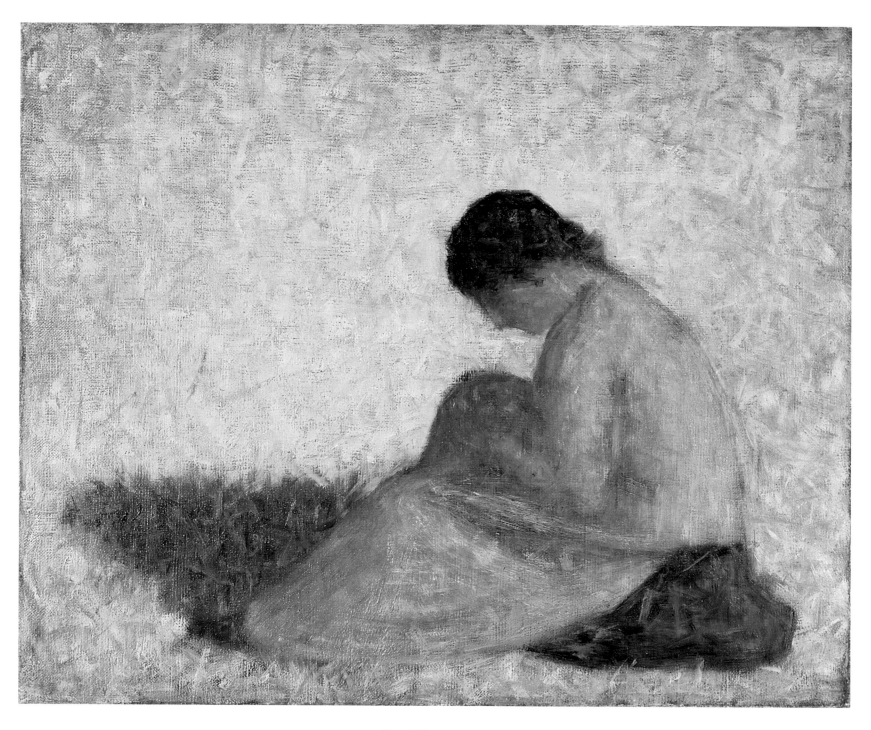

Seated Woman. 1882

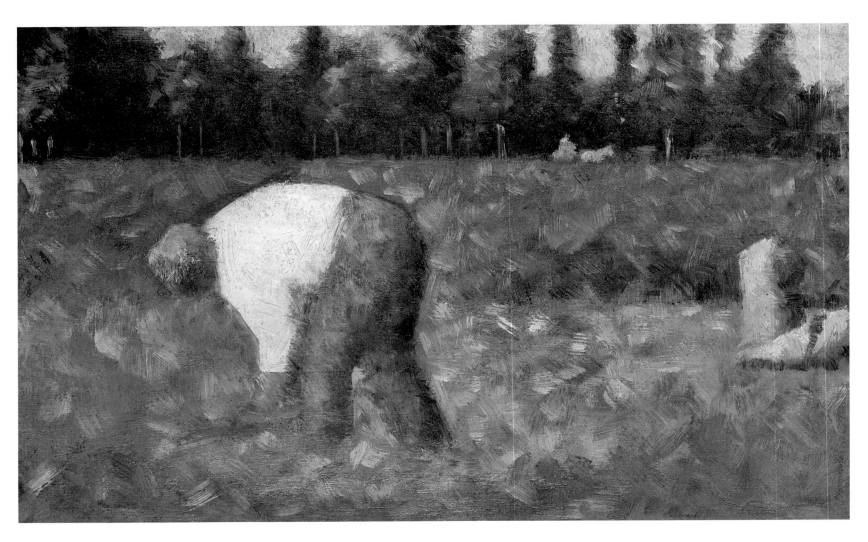

Peasant Laboring. 1882–83

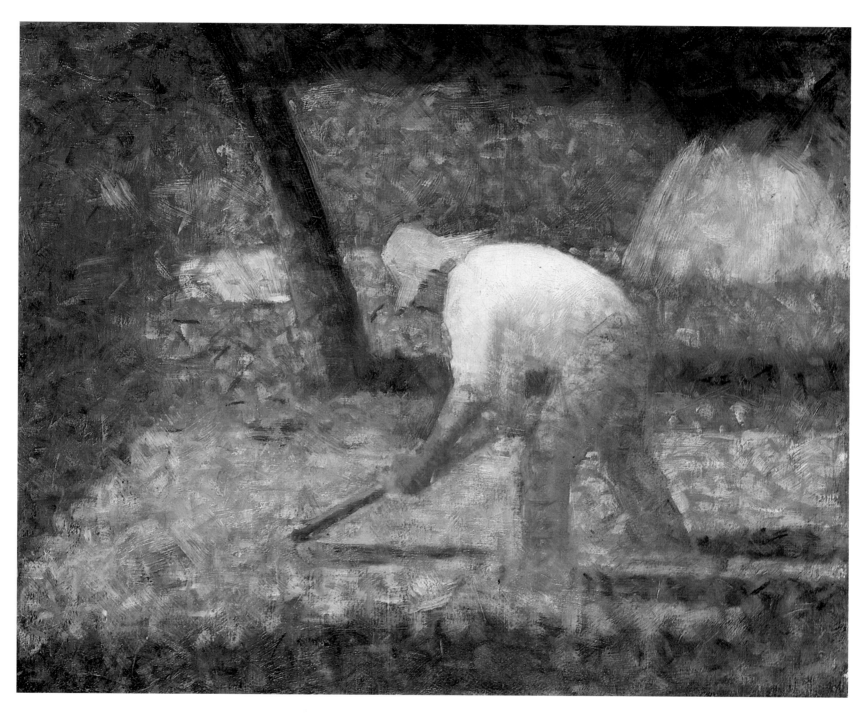

Peasant with Hoe. c. 1882

Landscape. 1882–83

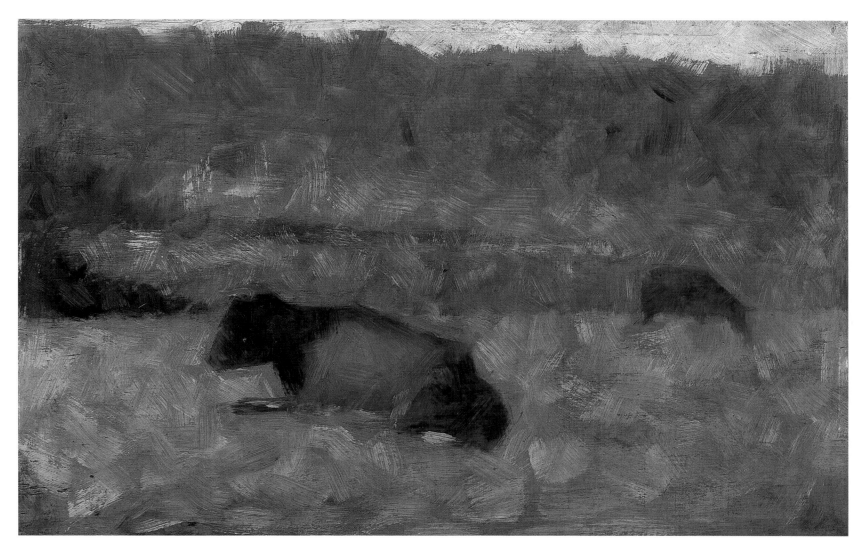

Cows in a Field. c. 1882

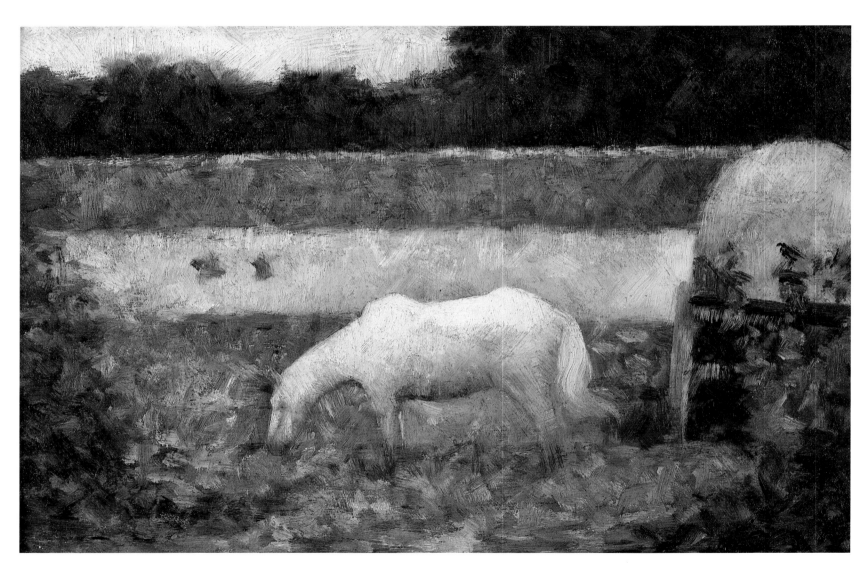

Landscape with Horse. c. 1882

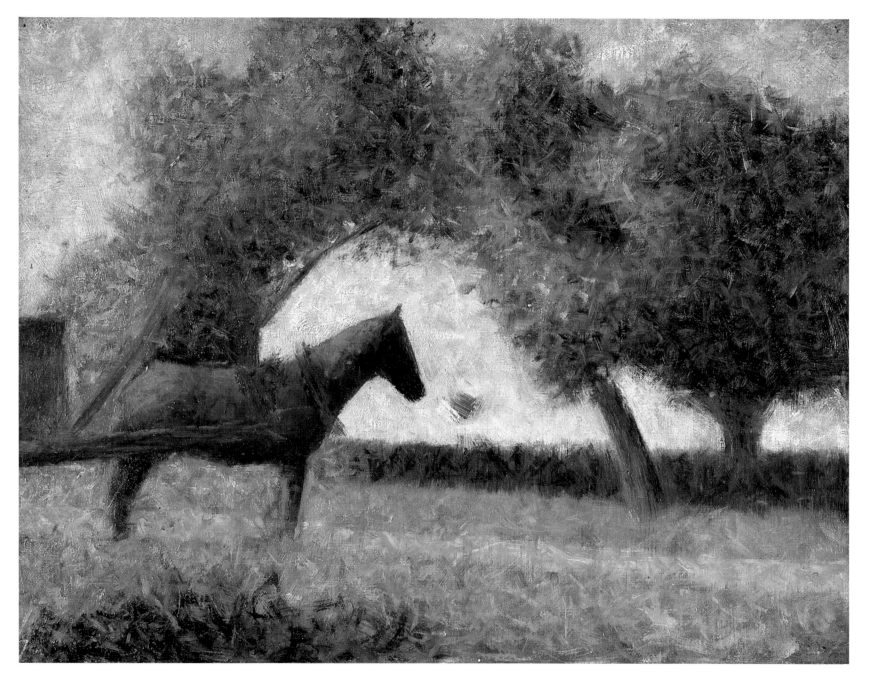

Horse. 1884

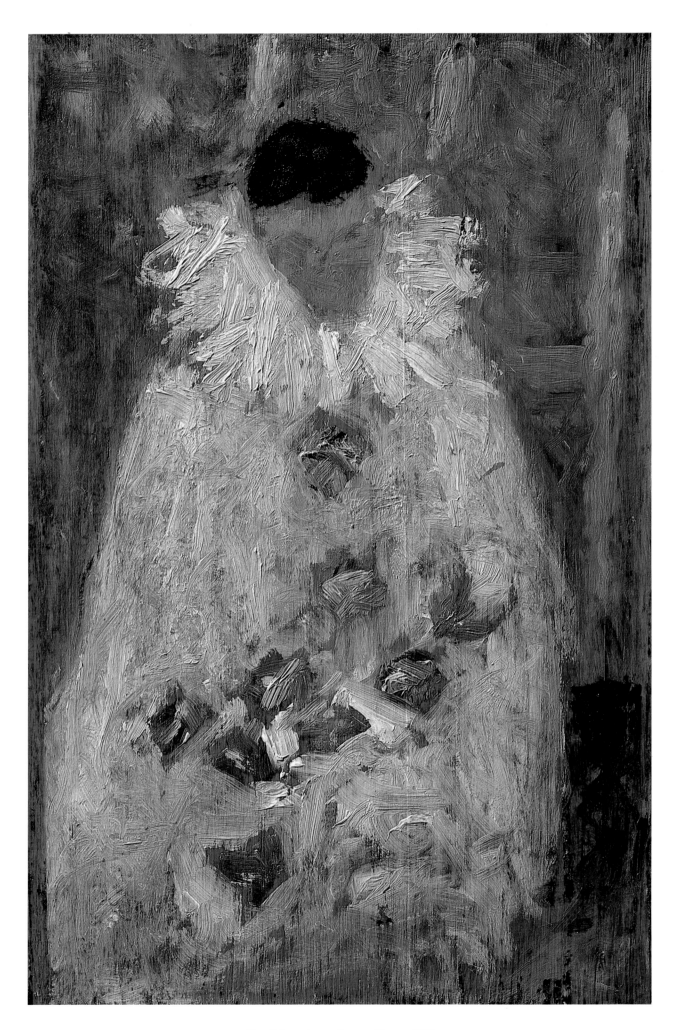

The Painter Aman-Jean as Pierrot. 1883

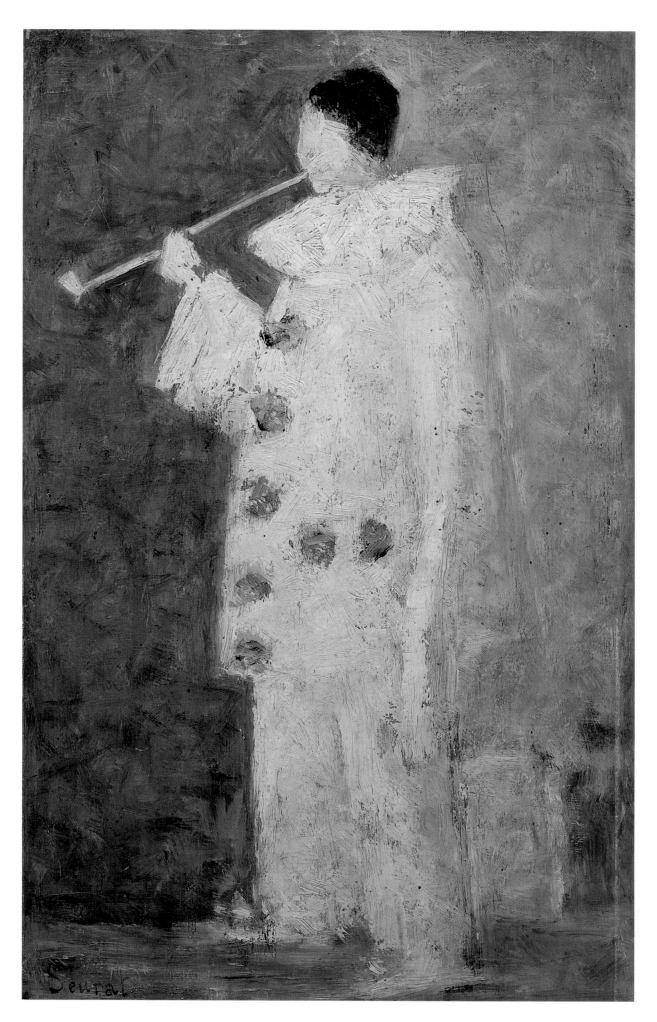

Pierrot with a White Pipe (Aman-Jean). 1883

Barbizon Forest. 1883

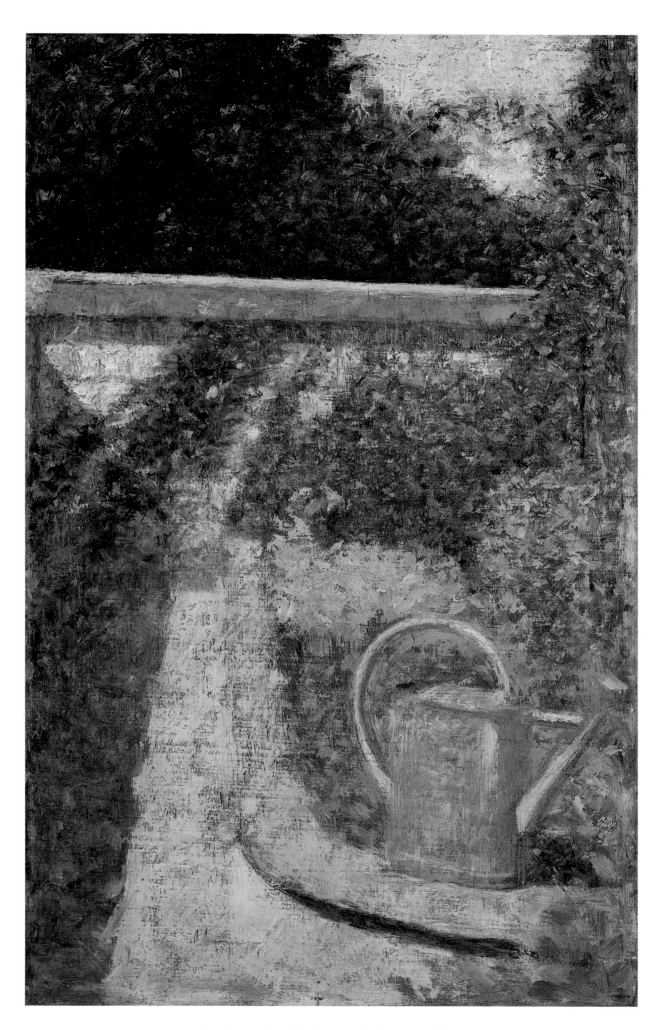

The Watering Can (The Garden at Le Raincy). c. 1883

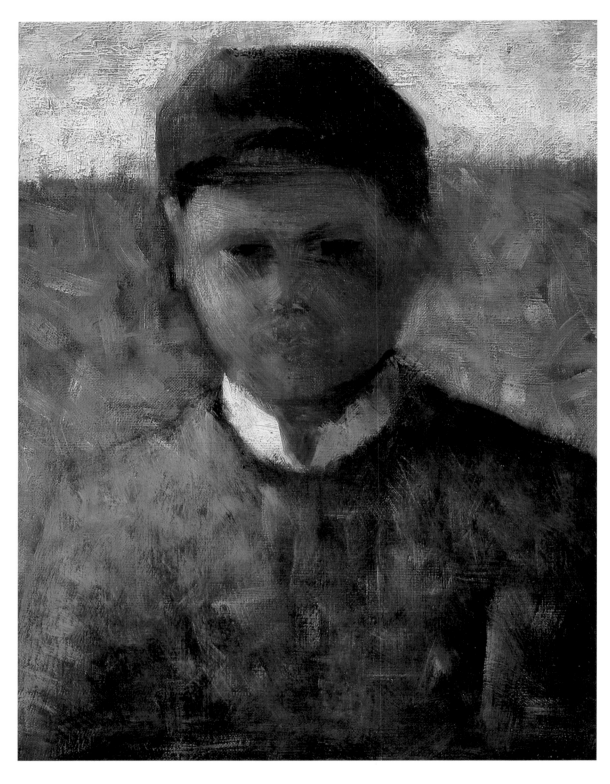

Young Peasant in Blue (The Jockey). 1882

nevertheless intent on subordinating his direct observations to the overall composition, each line and mass of which had to correspond to clearly determined intentions. As André Lhote has observed somewhere, in Seurat a continually alert sensibility was allied with a lucid intelligence infatuated with clear and invigorating formulas. His reason came into play naturally, effortlessly, as soon as his painter's instinct had paid its respects to nature; establishment of aesthetic structure unfailingly followed the perception of material fact.

Nothing better illustrates Seurat's attitude toward nature, and the confidence he had derived from his direct studies of it than the way in which he set to work, in 1883, on his first great painting, *Bathers, Asnières*, a composition alive with the suffocating heat of a summer day and all the well-being and lassitude generated by a blazing sun. It was at Asnières, just outside Paris, that he first made a number of what he called "croquetons," sketches from nature brushed rapidly on the little wooden panels in his painter's box. He chose the site and familiarized himself with the landscape; then he set human beings into it, apparently random figures but actually based on the subjects suggested to him by his numerous visits to the place. Thus he assembled all the data for his large canvas.

The little panels dashed off with quick strokes provided the elements he needed for his composition; he had only to eliminate what was secondary, suppress what was superfluous, and refine his treatment of the details after profound reflection. A rough sketch of some horses in the Seine contains in the distance a sailboat that reappears in the final picture; another sketch, a view of a grassy slope, presents the abandoned clothes that will appear beside a bather; a little panel of a group of people on the grass reveals the man stretched out on the ground and the bather dangling his legs; another gives us a first view of the boy in the straw hat sitting on the river bank. Then there are the drawings in which Seurat deals fully with the still life of clothing, the back of a child whose shoulders emerge from the water, and the posture of the boy hollooing. Some of these drawings were done in his studio from actual models.

Cunningly regulating the play of verticals and horizontals, Seurat carefully composed his picture, here painting the grass with large brushstrokes, elsewhere using small separate points to obtain the desired effect. Then he presented his work to the Salon of 1884. The jury once again demonstrated its total lack of understanding and, with even more than its customary severity, rejected Seurat's canvas as well as numerous others he submitted.

Man Painting a Boat. 1883

Salon des Indépendants

In a period during which private exhibitions by art dealers were almost unknown, the official Salons controlled the only opportunity artists had to show their work. Hence, to be rejected by the jury meant to be condemned to oblivion for at least a year, until the next Salon. In the spring of 1884 the painters deprived of this single means of bringing their work before the public decided to organize an exhibition of independent artists. It was clearly stipulated that "in principle, works of all members would be accepted" and that each artist would be permitted to exhibit two paintings. As soon as official authorization was received, a few modest posters announced on the walls of Montmartre and Montparnasse:

<div align="center">

SALON DES ARTISTES
INDÉPENDANTS
1884

AUTORISÉ PAR
LE MINISTRE DES BEAUX-ARTS
DE LA VILLE DE PARIS

BARAQUEMENT B,
COUR DES TUILERIES

DU 15 MAI AU 1ER JUILLET[1]

</div>

Some four hundred artists participated in this exhibition, held in a structure that had been erected as the temporary quarters of a post office. Most of the exhibitors had been

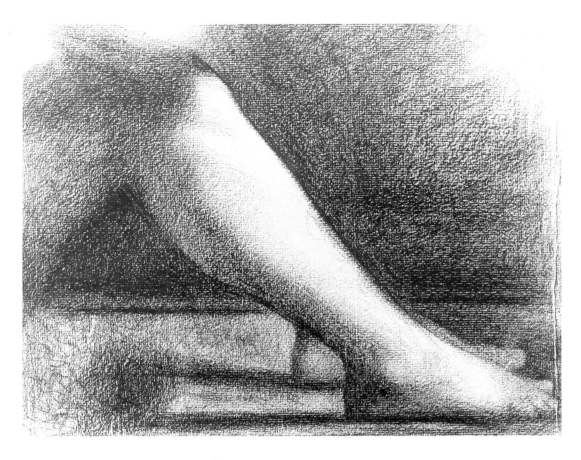

Leg (study for "Bathers, Asnières"). 1883–84

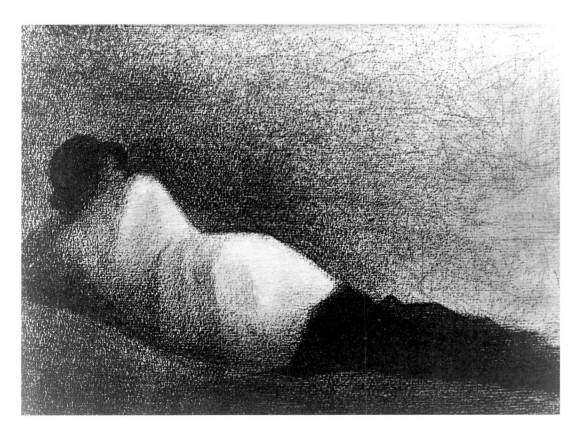

Reclining Man Listening (study for "Bathers, Asnières"). 1883–84

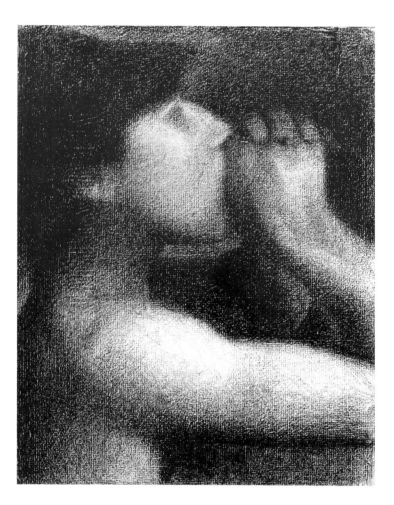

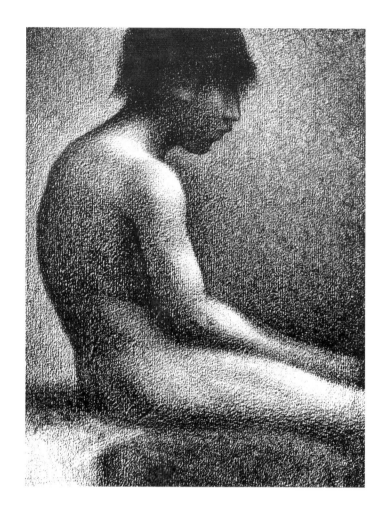

The Echo (The Call). 1883

Seated Nude. 1883–84

rejected by the Salon, but there were among them painters who did not want to submit their work to its jury. Among the exhibitors—unknown to one another—were Odilon Redon, with drawings and lithographs; Albert Dubois-Pillet, with a canvas, *Dead Child;* Charles Angrand, with landscapes; Henri-Edmond Cross, with *Corner of a Garden in Monaco,* painted in low key; Paul Signac, with *Pont d'Austerlitz* and a view of the rue Caulaincourt, done in the Impressionist manner; and Georges Seurat with *Bathers, Asnières.*[2] Seurat's large canvas was hung in the canteen, evidently judged unworthy of more prominent display. It was here that the painter first came face to face with the public and the critics. The exhibition opened on May 15 in the absence of Jules Grévy, president of the Republic, who had announced that he would attend.

The truth is that the exhibition did not arouse much public interest. Some newspapers did not even mention the event; others were content to ridicule the show, remarking, "Here they are, all of them, row after row, the rejected, the misunderstood, the fearful, the incoherent, the anemic, the unasked-for, fops and farceurs of painting" and citing the "Baigneurs of M. Sieurat [*sic*]" among other "curiosities."[3] Jules Clarétie, on the other hand, was quite disappointed and confessed in *Le Temps* that he had "anticipated more eccentricities, more oddities, more bizarre imaginings."[4] Paul Alexis, friend of Zola and Cézanne, who under the pseudonym Trublot regularly contributed lively reviews written in slang to *Le Cri du Peuple,* was extremely interested in painting, although very nearsighted. In his commentary he listed the three paintings that seemed to him most grotesque. The third he cited was "the *Bathers* (Asnières) by M. Georges Seurat, boulevard de Magenta. This one is a fake Puvis de Chavannes. What ridiculous bathers, men and girls [*sic*]! But painted with such earnestness that it is almost moving, and I am no longer tempted to rib it."[5]

However, there were critics who were not at all inclined to "rib" the exhibition. In *L'Intransigeant,* Edmond Jacques mentioned "M. Seurat, who hides a most excellent draftsmanship behind prismatic eccentricities and envelopes his bathers, waves, and horizons in warm tones."[6] And Roger Marx in *Le Voltaire* said of Seurat, "I was pleased to discover in his impressionist painting indications of important qualities, the mark of a temperament."[7] If not a great triumph, this first test won Seurat some sympathetic interest and brought him a new friend. That friend was Paul Signac.

Signac had been struck by Seurat's large canvas despite its unfavorable placement. He observed that it was painted

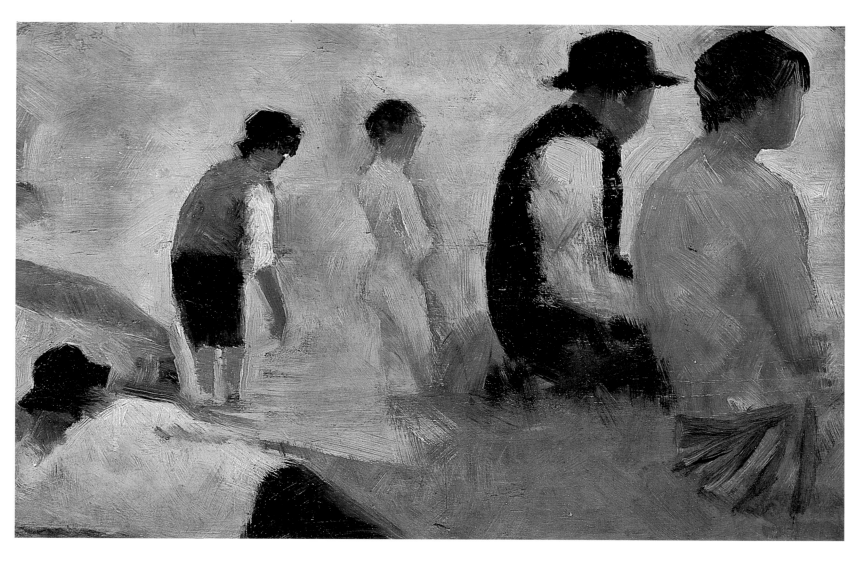

Five Men (study for "Bathers, Asnières." 1883

in great flat strokes, brushed one over the other, fed by a palette composed, like Delacroix's, of pure and earth colors. Because of these ochers and browns the picture was dimmed and appeared less brilliant than those the impressionists painted with a palette limited to prismatic colors. But the understanding of the laws of contrast, the methodical separation of elements—light, shade, local color, and the interaction of colors—and their proper balance and proportion gave this canvas its perfect harmony.[8]

In calling Seurat's entry an "impressionist painting," Roger Marx was delineating its free workmanship and clear tones, but Seurat's palette was utterly unlike that of the Impressionists, as Signac had grasped at once. He himself had shown paintings in this very exhibition that revealed preoccupations analogous to those of Seurat. But while the latter had turned first to Ingres and then to Delacroix in his search for a method, ignoring the Impressionists, Signac had chosen Claude Monet and Armand Guillaumin as his masters. In 1880 an exhibition of the work of Claude Monet had, as Signac would report later, "decided his career," and after his first efforts as an Impressionist painter, he had ventured to appeal to Monet, writing him:

Frankly, this is my position. I have been painting for two years, and my only models have been your works. I have been following the wonderful path you broke for us. I have always worked regularly and conscientiously, but without advice or help, for I do not know any impressionist painter who would be able to guide me, living as I am in an environment more or less hostile to what I am doing.

And so I fear I may lose my way, and I beg you to let me see you, if only for a short visit. I should be happy to show you five or six studies; perhaps you would tell me what you think of them and give me the advice I need so badly, for the fact is that I have the most horrible doubts, having always worked by myself, without teacher, without encouragement, without criticism.[9]

Whatever advice Monet gave Signac could not have been very precise, for it was Monet's custom to say to those who came to consult him: "I advise you to paint the best way you can, as much as you can, without being afraid to paint bad pictures. . . . If your painting does not improve of itself, then there is nothing to be done. . . . I can't do anything about it."[10]

Having adopted the Impressionists' scale of pure colors based on the spectrum and the little comma-like brushstrokes, Paul Signac, still eager to improve his painting, was struck by the methodical working out of the laws of contrast in Seurat's work. On the other hand, he felt that in order to develop further Seurat would have to abandon the palette of Delacroix for prismatic colors. The related character of their separate approaches

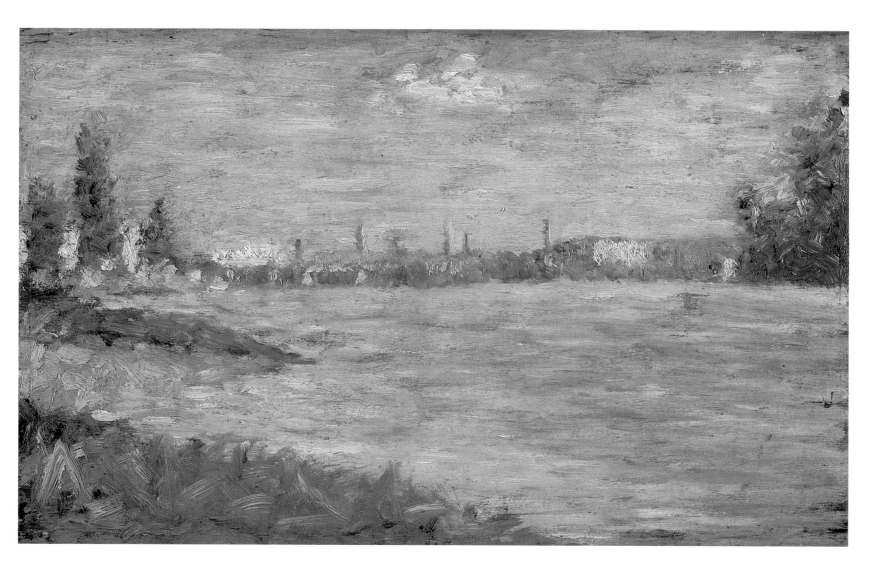

The River Banks (study for "Bathers, Asnières"). 1883–84

The Rainbow (study for "Bathers, Asnières"). c. 1883

The Seine with Clothing on the Bank (study for "Bathers, Asnières"). 1883–84

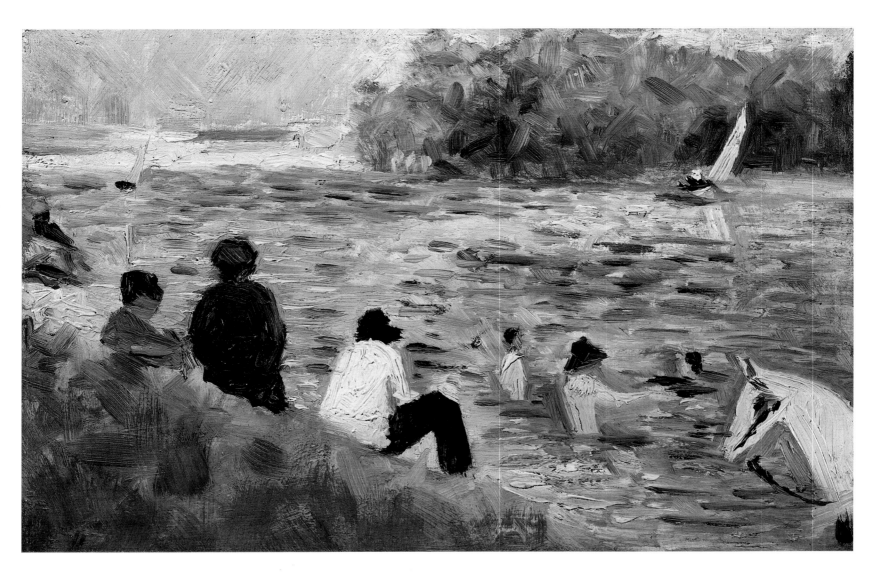

The Bathers (*study* for *"Bathers, Asnières*). c. 1883

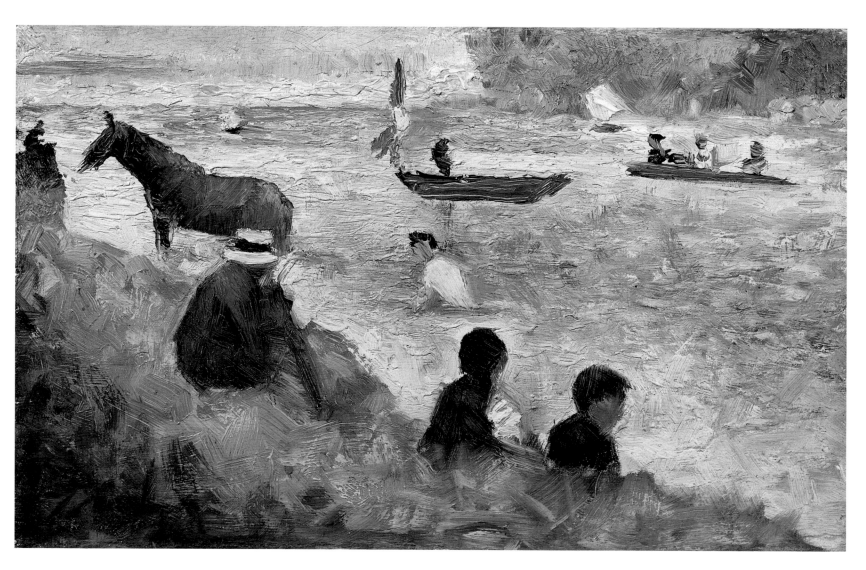

Horse and Boats (study for "Bathers, Asnières"). 1883–84

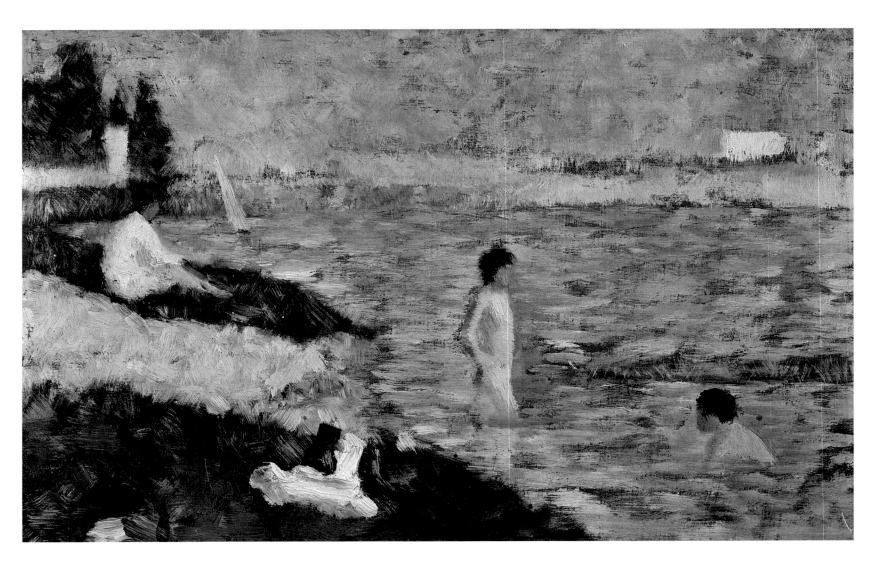

Boys Bathing (study for "Bathers, Asnières"). 1883–84

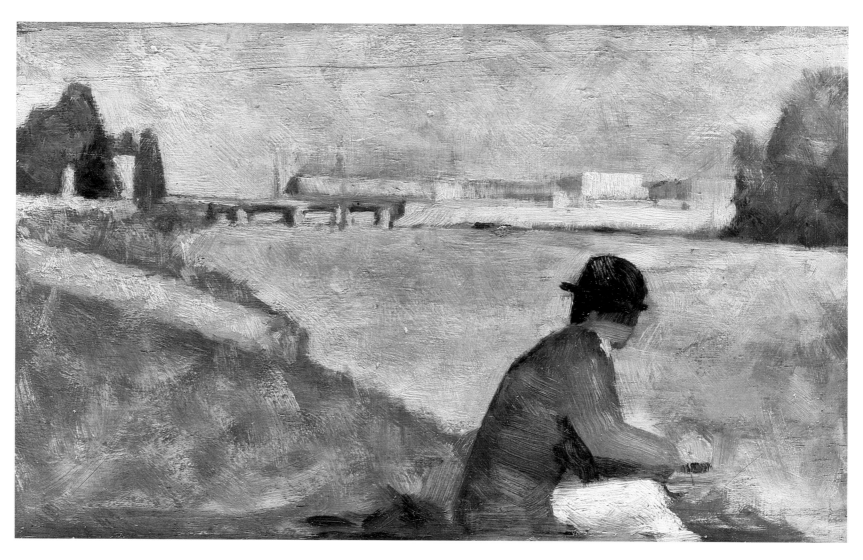

Banks of the Seine at Suresnes (study for "Bathers, Asnières"). 1883–84

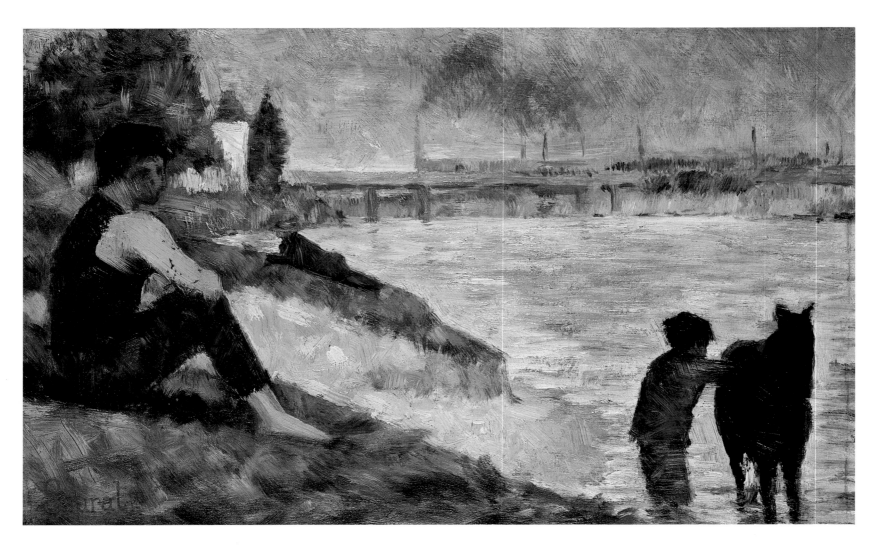

Study for "Bathers, Asnières." 1884

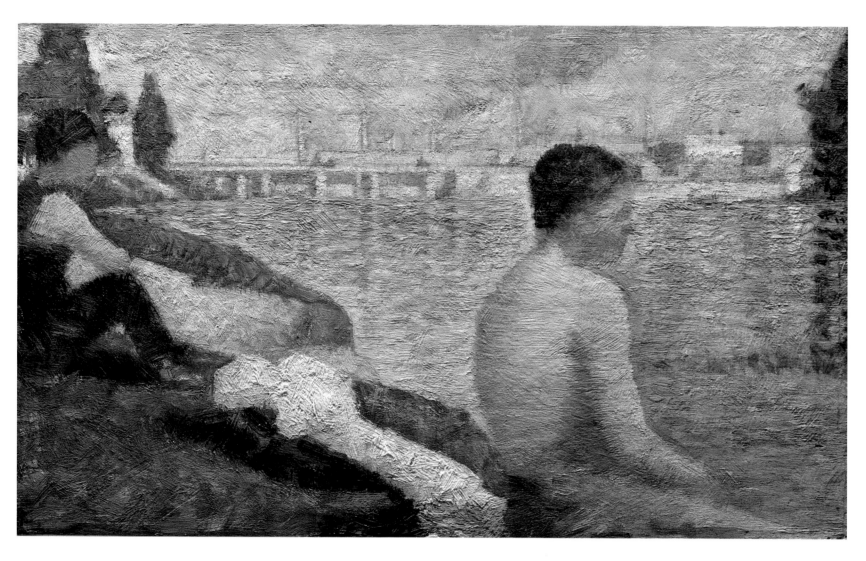

Seated Bather (study for "Bathers, Asnières"). 1883–84

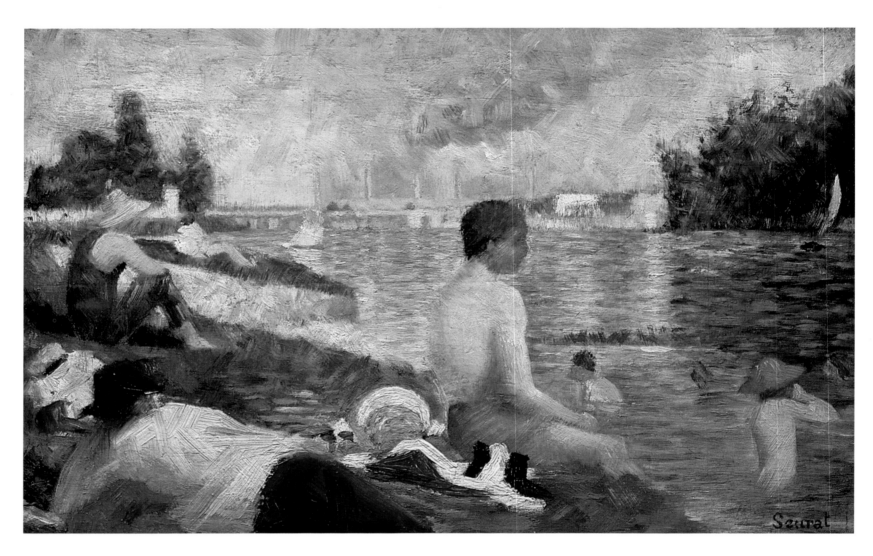

Final Study for "Bathers, Asnières." 1883–84

would soon make the two painters close friends.

Four years younger than Seurat, Signac had an outgoing personality. Audacious and not averse to controversy, with the ability to attract attention by both his sincerity and his talent, Signac reveled in the company of painters and the atmosphere of discussion. Wanting, like Seurat, to base his investigations on a scientific foundation, he went to see Chevreul at Les Gobelins in 1884 to learn the science of color from the theorist himself. Chevreul told him that thirty-four years earlier Delacroix had written him, expressing a desire to discuss the science of color and to question him about certain problems that continued to trouble him. They had agreed on a meeting, but his constant sore throat had forced Delacroix to remain indoors, and he had not kept the appointment. [11]

Although Delacroix had not arranged his palette according to scientific principles, Signac was able to derive from his work the following advice for colorists:

[Delacroix] proved the advantages of an informed technique, that logic and method, far from limiting the passion of the painter, strengthen it.

He revealed the secret laws that govern color: the harmony of similar colors, the analogies among contrasting colors.

He demonstrates how inferior a dull and uniform coloration is to the tones produced by the vibrations produced by the combination of diverse elements.

He indicated the potentialities of optical mixture, which permits the creation of new tones.

He advised colorists to eliminate as much as possible those colors that are dark, dim, or dirty.

He taught that one can modify and tone down a hue without dirtying it by mixing on the palette.

He pointed out the moral influence that color adds to the effect of a painting; he introduced them to the aesthetic language of tones and hues.

He incited them to dare everything, never to fear that their harmonies might be too brightly colored. [12]

In order to follow these precepts freely one had to abandon any hope of admission to the official Salon. Quite the opposite, it was imperative to create a base for a regular Salon des Indépendants. This was not an easy accomplishment for, as a friend of Seurat noted in recalling the spring of 1884:

It happened that the committee was composed of jolly good fellows, escaped from some vaudeville show, who bewildered the police commissioner by demanding one another's arrest and in the evening caning each other in the streets. Within a few days they had used up all the funds. On June 9 a general meeting of all members [presided over by Odilon Redon], convinced that no orderly account

could be expected from the committee, voted to remove them and agreed to found the Société des Artistes Indépendants, which second organization was duly constituted on the 11th before a notary. (Headquarters, 19, quai Saint-Michel, Paris. This society, the preamble states, stands for the suppression of juries and proposes to help artists present their work without restraints before the bar of public opinion.)[13]

During the many stormy meetings that took place before the constitution of the newly created society was drawn up, Signac met Seurat and aligned himself with him, as well as with Charles Angrand, Henri-Edmond Cross, and Albert Dubois-Pillet, who formulated the bylaws of the society. All took a very active part in the formation of the Society of Independent Artists and in fact became members of the committee. In the bosom of the society, linked by mutual aesthetic aims, they soon formed an intimate group. On Mondays they met at Signac's studio, frequently reconvening in the evenings at the Café d'Orient, rue de Clichy, and also at the meetings of the Independents who favored the Café Marengo, near the Louvre. Seurat rarely missed one of these gatherings, at which he sat smoking, mostly silent, always attentive. His chosen friends were Angrand and Signac, from whom he learned about the work of the Impressionists. Inspired by their mutual studies, Seurat adopted the simplified palette of the Impressionists, while Signac saw new possibilities in the methodical, balanced separation of elements followed by Seurat. The latter was at that time planning a large composition that would represent his new palette and technique, and he began to make careful studies of the landscape and crowds in the public park on the island of La Grande Jatte not far from the bank of Asnières where he had made his first sketches for the *Bathers*.

In December 1884 the new Society of Independent Artists organized its first exhibition in the Pavillon de la Ville de Paris on the Champs-Elysées. As it was late in the season, a very unfavorable time, few people came to see the exhibition where Seurat once more showed his *Bathers*, as well as nine sketches and a landscape of the island of La Grande Jatte, a first study for his new painting. His work was again noticed by the critic Roger Marx, who wrote in his review:

Among these independent artists there is one, Monsieur Seurat, who must be singled out. At the time of the Salon of 1882 I praised an excellent portrait of his, done in charcoal, which I was happy to see again. It is accompanied by a series of sketches and a landscape of striking atmospheric transparency, over which the lively light of a hot summer sun plays freely; all this is done in a sincere and candid style and reveals a depth of conviction which one regrets not to find among certain "converts to impressionism."[14]

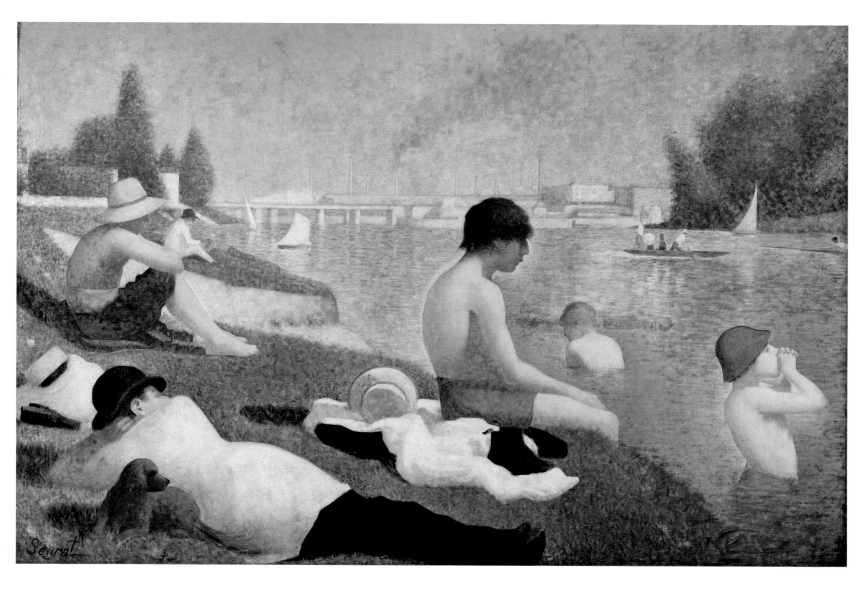

Bathers, Asnières. 1883–84

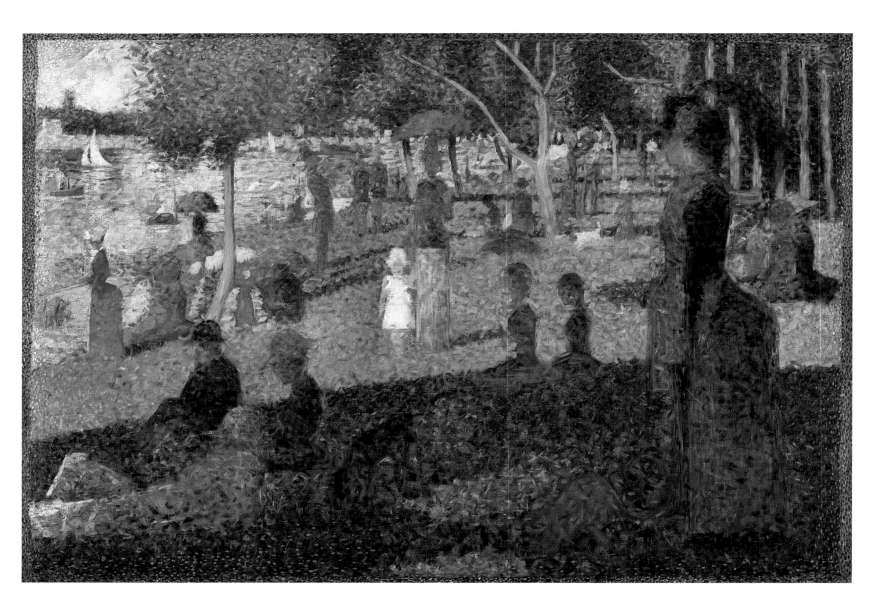

Final Study for "A Sunday Afternoon on the Island of La Grande Jatte." 1884–85

A Sunday Afternoon on the Island of La Grande Jatte

In 1885, while Seurat was painting in Grandcamp, a small fishing port on the channel coast—from which he would bring back a number of seascapes done in subdued tones suffused with a lyrical calm—Signac was working on the banks of the Seine, where he made the acquaintance of Armand Guillaumin. They often set up their easels side by side. It was in Guillaumin's studio that Signac, much moved, met Camille Pissarro. He interested the Impressionist master in his ideas and introduced him to Seurat. The two friends explained to Pissarro why they had resolved not to mix their colors on the palette but had chosen to employ tiny brushstrokes of pure color, permitting the mixture to occur optically. They also told him of their methodical observance of the laws of contrasting and complementary colors. Convinced that their technique promised a more rigorous control of his sensations and that it was also a new stage of Impressionism, of which he had been one of the initiators, Camille Pissarro, pupil of Corot, friend of Cézanne, Monet, and Renoir, unhesitatingly accepted the audacious "divisionism" of Seurat and Signac. Pissarro's oldest son, Lucien, born in 1863, the same year as Signac, was also won over, as was his friend and fellow student Louis Hayet.

In a letter to his dealer, Paul Durand-Ruel, Pissarro summed up the new theory that was to determine his practice from then on. What he wanted was

to seek a modern synthesis by methods based on science, that is, based on the theory of colors developed by M. Chevreul, on the experiments of Maxwell and the measurements of N. O. [sic] Rood; to substitute optical mixture for the mixture of pigments; in other words, the separation of tones into their constituent elements, for this type of optical mixture stirs up luminosities more intense than those created by mixed pigments.[1]

Now that the system had been elucidated, it remained to produce paintings whose aesthetic value would show better than any verbal argument the degree to which science could

serve the art of painting. Seurat, Signac, and Pissarro set to work. Seurat began the large composition he had contemplated for a long time, which, coming after the *Bathers*, was to represent his completely worked-out technique. The artist prepared for this painting, *A Sunday Afternoon on the Island of La Grande Jatte*, by making numerous drawings and sketches in oils, many more in fact than he had produced for the *Bathers*. But while that painting presented six principal figures in fixed attitudes, the new painting, some six and one-half feet high and ten feet wide, assembled some forty persons, seated or standing, clearly outlined in the full heat of the sun or enveloped in shade, as well as a number of animals and the river itself with its canoes and sailboats. This work occupied Seurat for almost two years, from the time he completed the landscape of La Grande Jatte already exhibited in December 1884 until the spring of 1886. During this time he not only painted the large canvas itself but also, before finishing it, completed some twenty drawings on the spot or from models in his studio, as well as some thirty paintings, for the most part rather small and rapidly executed. The exceptions are several large and fairly complete studies that were doubtless done in the studio. An enterprise of such scope is not only rare in modern art but is also unique among painters dominated by the Impressionist vision, which required from the artist a spontaneous expression of his sensations. While Monet, for example, strove to capture the most fugitive effects in a few hours, Seurat, a beginner of twenty-five, devoted two years to his conception and execution of a project of a magnitude almost unknown since the days of David and Ingres.

In attacking this immense project, Seurat followed the procedure described by Signac years later:

It seems that the first consideration of a painter who stands before the white canvas should be to decide what curves and arabesques will delineate the surface, what tints and tones will cover it. . . .

Following the precepts of Delacroix, the neo-impressionist will not begin a composition until he has first determined its organization. Guided by tradition and by science, he will adjust the composition to his conception, that is, he will adjust the lines (directions and angles), the chiaroscuro (tones), the colors (tints) to the expression he wishes to achieve.[2]

From his studies for the large canvas it would appear that Seurat began with the site itself. He had already painted the landscape in 1884 and had also made one important drawing of it. In animating the landscape with people and animals, he was no doubt inspired by those he had actually observed, but

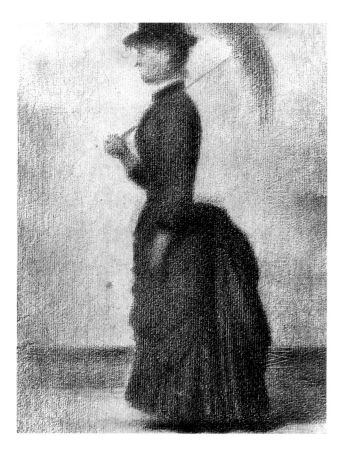

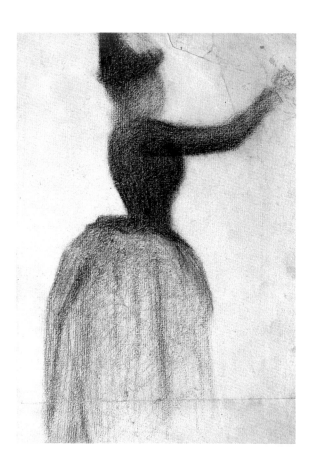

Lady with a Parasol (study for "La Grande Jatte"). 1884–85

Woman with Raised Arms. 1884–85

Young Girl Seated, Sewing. 1884–85

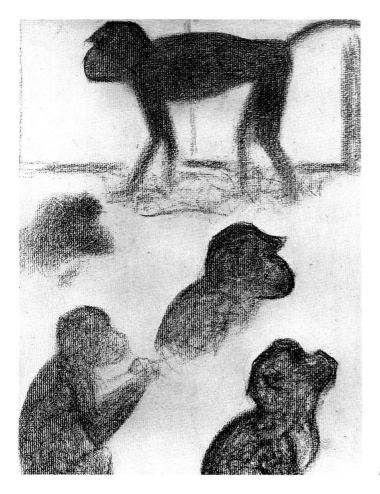

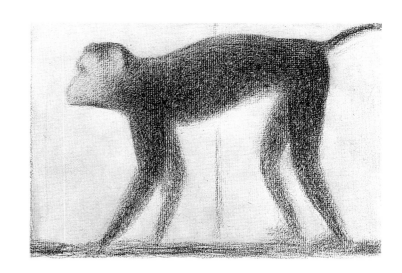

The Monkey (study for "La Grande Jatte"). 1885

Monkeys (sheet of studies for "La Grande Jatte"). 1884–85

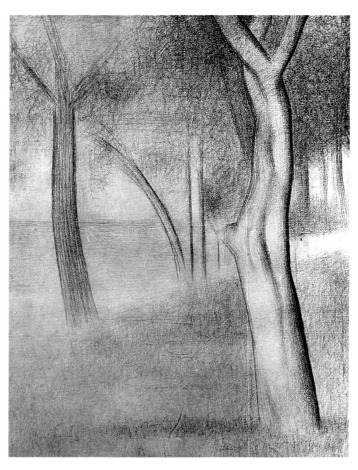

Study for center section of "La Grande Jatte." 1884

he subjected his impressions to the rigorous requirements of his composition.[3] His procedure was unaltered in this respect since the *Bathers*. He preserved, in more or less developed studies, persons seen by chance in the typical costumes and postures that can be observed in photographs of the time. When necessary, he had models pose in the studio until he finally determined the attitudes he wanted. Organized in vertical and horizontal planes, his composition of repeated perpendiculars is enlivened with parasols, bustles, sails, and such. All these lines, these limits of planes, are at the same time the apexes of angles in which light and shade confront each other. The problem was not simply to achieve a certain rhythm of lines, but above all to harmonize the human figures with the landscape. It was a problem that could be solved only by color. In determining which colors to select and what roles to assign them, Seurat now brought to bear all he had learned from his studies, meditations, and experiments.

Since "divisionism" does not demand dots of color, Seurat's "croquetons", done from nature in a few quick brushstrokes, are not executed in the pointillist manner, but they are always "divided," for despite the speed with which they were done, the touch is pure, the elements are balanced, and the laws of contrast are observed.[4] Signac related:

Confronting his subject, before touching his little panel with paint, Seurat scrutinizes, compares, looks with half-shut eyes at the play of light and shadow, observes, contrasts, isolates reflections, plays for a long time with the cover of the box that serves as his palette. Then, fighting against matter as against nature, he slices from his little heap of colors arranged in the order of the spectrum the various colored elements that form the color destined best to convey the mystery he has glimpsed. Execution follows on observation, stroke by stroke the panel is covered. . . .[5]

The colors Seurat used exclusively are those of the disk on which Chevreul brought together all the colors of the rainbow. The fundamental colors—blue, red, yellow, and green, according to Chevreul—can be related to one another by a host of intermediate colors in a circular system. Thus, blue, blue-violet, violet, violet-red, red, red-orange, orange, orange-yellow, yellow, yellow-green, green, green-blue, and blue again. Besides these, Seurat also used white, which, when mixed on the palette with these colors, permitted him to achieve an incalculable number of tints, from a color with just a trace of white in it to almost pure white, and he did not hesitate to mix, two by two, colors next to each other on the color scale. Near the thumb hole of his palette he invariably placed several bars of white, each of which was set aside for mixtures with one of the basic colors.[6]

Landscape with Dog (study for "La Grande Jatte"). 1884–85

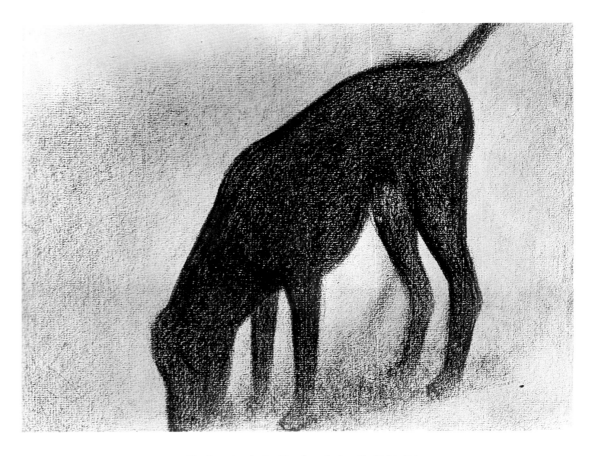

The Dog (study for "La Grande Jatte"). 1884–85

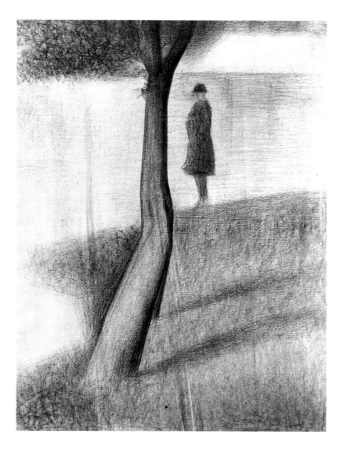

Man and Tree (study for "La Grande Jatte"). c. 1884

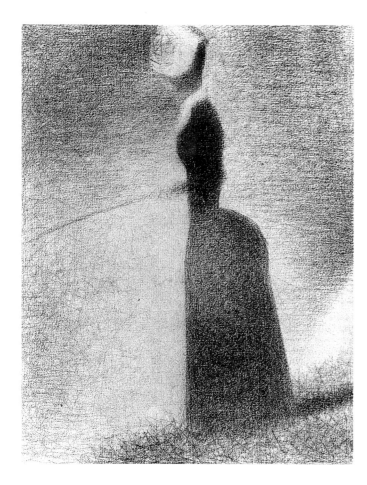

Lady Fishing (study for "La Grande Jatte"). c. 1885

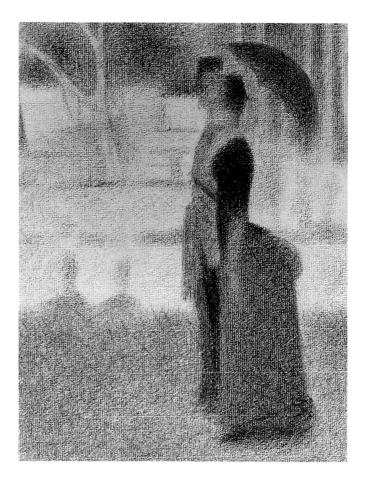

Couple Walking (study for "La Grande Jatte"). 1884–85

The Island of La Grande Jatte. 1884

A Sunday Afternoon
on the Island
of La Grande Jatte

Study for "La Grande Jatte." 1884

RIGHT:
A Sunday Afternoon on the Island of La Grande Jatte. 1884–85

Study for "La Grande Jatte." 1884–85

Study for "La Grande Jatte." 1884

Woman Strolling with Parasol (study for "La Grande Jatte"). 1884

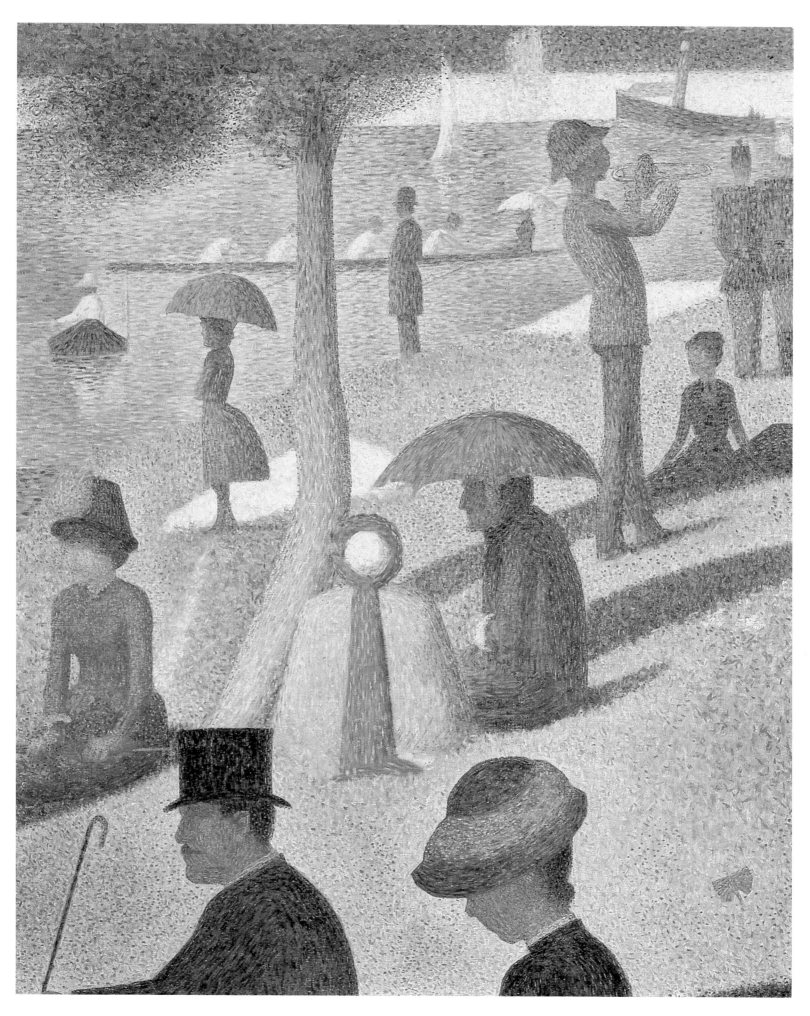

Detail of *A Sunday Afternoon on the Island of La Grande Jatte*

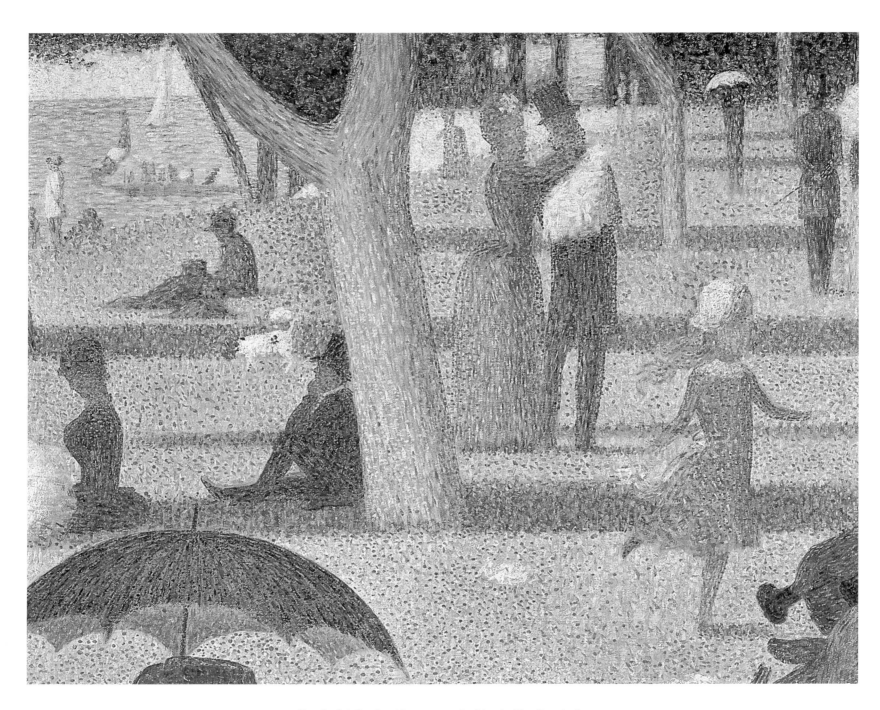

Detail of *A Sunday Afternoon on the Island of La Grande Jatte*

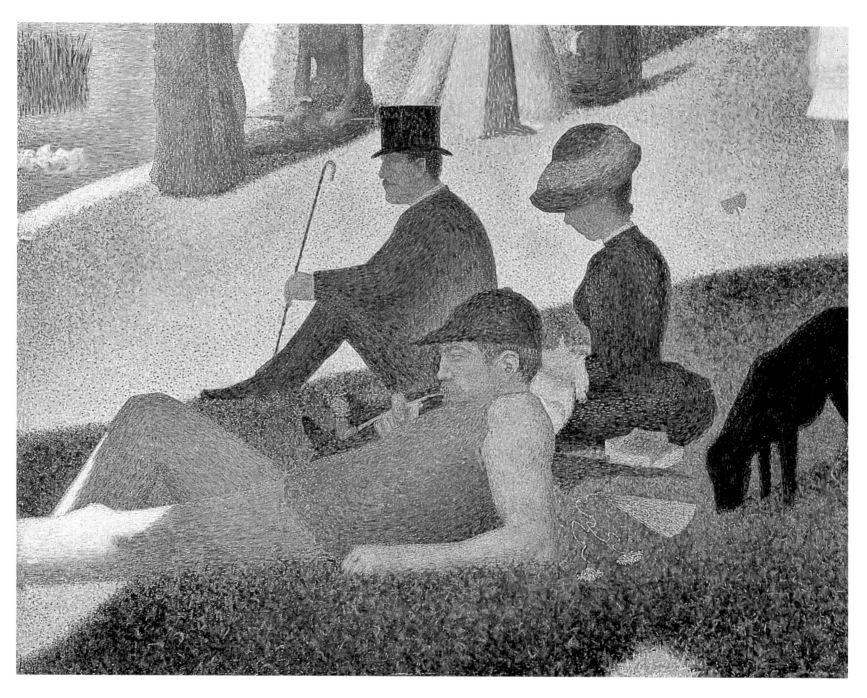

Detail of *A Sunday Afternoon on the Island of La Grande Jatte*

It was with such a palette that Seurat executed his large composition in his "divisionist" technique. "Divisionism," in the words of Paul Signac,

assures the benefits of luminosity, color, and harmony: by the optical mixture of pure pigments (all the colors of the prism and all their tones); by the separation of various elements (local color, light, and their interactions); by the balancing of these elements and their proportions (according to the laws of contrast, gradation, and irradiation); by the selection of a brushstroke commensurate with the size of the canvas.[7]

While preparing his composition in keeping with this technique and these new principles, Seurat nevertheless avoided any departure from his direct studies of nature. It was his complete grasp of the subject to the last detail that enabled him to represent it in such an orderly method and so complex a technique. A trifling episode related by Charles Angrand, a friend who often worked alongside Seurat on the island of La Grande Jatte in 1885–86, testifies to the careful precision with which he approached his subject:

As the rank summer grass was growing high on the bank and keeping him from seeing a boat that he had put in the foreground — and as he was complaining of this contretemps—I did him the service of cutting the grass, for I could see him getting ready to sacrifice his boat. Nevertheless, he wasn't a slave to nature, certainly not, but he was respectful of it, not being imaginative. His concern throughout was for the values, colors and their reactions.[8]

In the end, Seurat renounced the boat. But on another occasion, when he observed a woman walking along the bank with a monkey on a leash, he did not hesitate to incorporate the graceful creature with spiral tail, after studying the movements of the animal in a number of drawings. While his drawings generally concentrated on the silhouettes of the forms before him, the most important preparatory studies for the large painting lay in the "croquetons", the small wooden panels on which he registered his observations in color, often without too precise a rendering of the contours.

For several months Seurat went to the island of La Grande Jatte every day. The writer Maurice Beaubourg, who used to dock his canoe at the island, recalled:

Coming from Paris, one turned right, not far from the place where the water is not too deep for people to bathe on Sunday. . . . On the large inlet facing Courbevoie and Asnières, you often saw Seurat painting. . . . He confided to me dolefully that the boys who were bathing or roaming around, after taking a look at his picture and making nothing out of it, would pick up stones and shatter his canvas.[9]

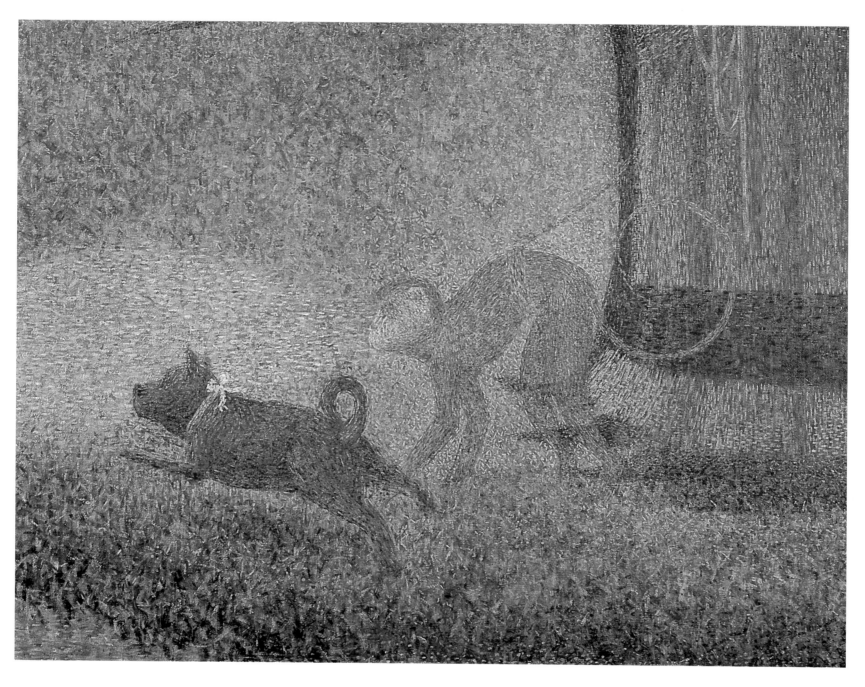

Detail of *A Sunday Afternoon on the Island of La Grande Jatte*

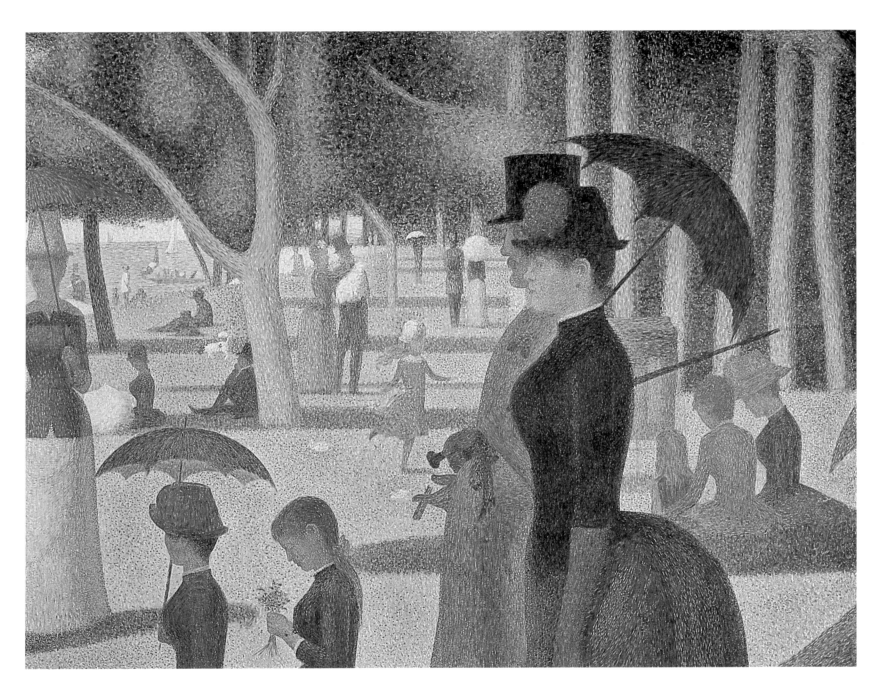

Detail of *A Sunday Afternoon on the Island of La Grande Jatte*

Seurat was so immersed in his painting that he even refused to lunch with close friends, lest this distract him from his work. He painted on the island in the morning and devoted his afternoons to working on his composition in the studio, hardly pausing to eat a roll or a chocolate bar. Standing on his ladder, he patiently filled his canvas with those tiny multicolored touches that from a distance give it the vibrancy and luminosity that are the secret of his work.

It seems, however, that Seurat did not cover his canvas exclusively by means of small dots. Apparently, which is also true of other of his paintings, underneath the tissue of dots there is another layer of pigment, brushed in broadly—as if he had first coated the canvas by applying the same technique he used on his small sketches. This explains why the white of the canvas is not visible between the circular touches of his brush.

While working, Seurat always concentrated on a single section of the canvas, having previously determined each stroke and color to be applied. Thus, he was able to paint steadily without having to step back from the canvas in order to judge the effect, which is all the more striking when one realizes that he intended his pictures to be seen only from a certain distance. His extreme mental concentration also enabled him to keep on working late into the night, despite the treacherous character of artificial lighting. But the type of light in which he painted was unimportant, since his aim was completely formulated before he took his brush and carefully arranged palette in hand. Nothing was left to chance, to some happily inspired brushstroke. Nevertheless, the work seems to have proceeded naturally and without any evidence of strain; it arrived at its final form without flaw or uncertainty. If the figures appear frozen in their postures, if the contours are extremely simplified, it is because Seurat summed up in these beings all the movements he had observed in nature. He thus achieved such monumental forms that his Sunday promenaders are stripped of whatever is comic in their dress or conventional in their gestures; they appear, so immobile yet so alive, not only as symbols of a season, a day, a specific time of day, as the title has it, but also as symbols of an entire epoch.

When his closest friends praised the canvas, Seurat simply remarked, "They see poetry in what I have done. No, I apply my method and that is all there is to it."[10]

Replying to Paul Adam, who admired the rigidity of the figures grouped in what seemed to him to be pharaonic files, and to Jean Moréas, to whom they recalled Panathenaic processions, Seurat, indicating how little the subject meant to him, noted, "I could just as well have painted, in another key, the combat of the Horatii and the Curiatii."[11]

Paris, Rue Saint-Vincent in Spring. c. 1884

The Eighth Exhibition of the Impressionists

For several years relations among the Impressionists had been strained by disagreements of every kind. After 1877 Cézanne did not appear in any of the exhibitions of the group. Sisley had not participated in the years 1879, 1880, and 1881; Monet and Renoir, eager "for entirely commercial" reasons, as Renoir explained, to show in the official Salon, abstained in 1880 and 1881. Degas had wanted to break with them, which had led Gustave Caillebotte to suggest to Pissarro that they break with Degas. Despite these difficulties, they appeared together in 1882. In 1883 their dealer, Durand-Ruel, held a series of one-man shows of the Impressionists. But in 1884 and 1885 there were no exhibitions at all.

At the beginning of 1886 Eugène Manet, brother of the painter (who had died three years before), and his wife, Berthe Morisot, met with Pissarro, as well as with Degas, Monet, Sisley, Renoir, and others, to urge the preparation of an eighth general exhibition of the Impressionist group. Pissarro, who had already introduced Gauguin to his colleagues and had previously insisted that Cézanne be permitted to show with them, responded by requesting that Signac and Seurat be invited. His request was strongly opposed. In early March 1886, Pissarro wrote to his son Lucien, who was then in England:

Yesterday I had a violent run-in with M. Eugène Manet on the subject of Seurat and Signac. The latter was present, as was Guillaumin. You may be sure I rated Manet roundly. — Which will not please Renoir. — But anyhow, this is the point, I explained to M. Manet, who probably didn't understand anything I said, that Seurat has something new to contribute which these gentlemen, despite their talent, are unable to appreciate, that I am personally convinced of the progressive character of his art and certain that in time it will yield extraordinary results. Besides, I am not much concerned with the appreciation of artists, no matter which. I do not accept the snobbish judgments of "romantic impressionists" to whose interest it is to combat new tendencies. I accept the challenge, that's all.

But before anything is done they want to stack the cards and ruin the exhibition. — M. Manet was beside himself! I didn't calm down. . . .

Degas is a hundred times more loyal. — I told Degas that Seurat's painting [*La Grande Jatte*] was very interesting. "I would have noted that myself, Pissarro, except that the painting is so big!" Very well — if Degas sees nothing in it, so much the worse for him. This simply means there is something precious that escapes him. We shall see. M. Manet would also have liked to prevent Seurat from showing his figure painting. I protested against this, telling Manet that in such a case we would make no concessions, that we were willing, if space were lacking, *to limit our paintings* ourselves, but that we would fight anyone who tried to impose his choice on us.

But things will arrange themselves somehow!¹

Despite Pissarro's optimism, things did not go well. The discussions with those he now called "romantic impressionists" — to distinguish them from "scientific impressionists" — were long and vehement and finally led to a schism. Monet, Renoir, Sisley, and Caillebotte withdrew. In addition to Redon and Emile Schuffenecker and a few other newcomers who had been invited, only Berthe Morisot, Mary Cassatt, Degas, Gauguin, Guillaumin, and of course Pissarro were willing to appear with Seurat and Signac. Pissarro insisted that his paintings, those of Seurat, Signac, and of his son Lucien all be shown in the same room so as to stress the common effort of these four. Degas wanted the word "impressionist" deleted from the announcements. The exhibition thus advertised merely as "Eighth Exhibition of Paintings" opened on May 15, 1886, at 1, rue Laffitte, at the corner of the boulevard des Italiens, above the Restaurant Dorée, and ran for a month.

Seurat sent five landscapes to this exhibition, among which were several views of Grandcamp, three drawings, and his painting of La Grande Jatte, listed in the catalogue as "Un Dimanche à la Grande Jatte (1884)."² Before the exhibition, artists and laymen had been intrigued by Seurat's large composition, which had been much discussed in the studios. It was in this spirit that a painter informed the Irish author George Moore on May 15:

To-day is the opening of the exhibition of the Impressionists. . . . At one end of the room there is a canvas twenty feet square [sic] and in three tints: pale yellow for the sunlight, brown for the shadows, and all the rest is sky-blue. A lady walks, I'm told, in the foreground with a ring-tailed monkey, and the tail is said to be three yards long.³

George Moore also relates in his *Confessions of a Young*

In the Street. c. 1885

Man how he and his friends went in a group to kick up a row before Seurat's painting:

We went insolent with patent leather shoes and bright kid gloves and armed with all the jargon of the school. "*Cette jambe ne porte pas*"; "*la nature ne se fait pas comme ça*"; "*on dessine par les masses*"; "*combien de têtes?*" "*Sept et demie;*" "*Si j'avais un morceau de craie je mettrais celle-là dans un bocal; c'est un foetus*"; in a word, all that the journals of culture are pleased to term an artistic education. We indulged in boisterous laughter, exaggerated in the hope of giving as much pain as possible. . . .[4]

And Signac recalls that on the day of the opening, the well-known painter Alfred Stevens

continually shuttled back and forth between the Maison Dorée and the neighboring Café Tortoni to recruit his cronies imbibing on the famous terrace and brought them to look at Seurat's canvas to show how far his friend Degas had fallen in welcoming such horrors. He threw his money on the turnstile and did not even wait for change, in such a hurry was he to bring in his forces. The monkey held on a leash by the woman in blue seemed particularly to rouse the high spirits of these boulevardiers.[5]

"A brilliant opening," *Le Figaro* announced, "a large crowd, mostly women, and hence many beautiful gowns."[6] This was its entire account of an exhibition at which exemplary works in a new style were shown for the first time.

The room in which *La Grande Jatte* was exhibited was too shallow, and the spectators, unable to see Seurat's painting from the distance he had intended, were much provoked by it. Among the few visitors attracted to Seurat's large canvas was the Belgian poet Emile Verhaeren, who later recorded his impressions:

It covered a whole panel, flanked by the *Bec du Hoc* and the *Harbor of Grandcamp*. The novelty of this art at once intrigued me. Not for an instant did I doubt its complete sincerity or profound originality; these were patent in the work before me. That evening I spoke of it to artists; they mocked me with laughter and ridicule.[7]

What added to the general confusion was the fact that the visitors were unable to tell the works of Seurat, Signac, and the two Pissarros apart. This is not so astonishing when one recalls that the critics themselves had on occasion confused the paintings of Monet and Sisley and could not even always distinguish between an oil painting and a watercolor. The novelty of the pictures produced by these painters working with an identical palette and employing a common method was too startling for a public seeing them all together for the first time to note subtle individual differences. The fact is that

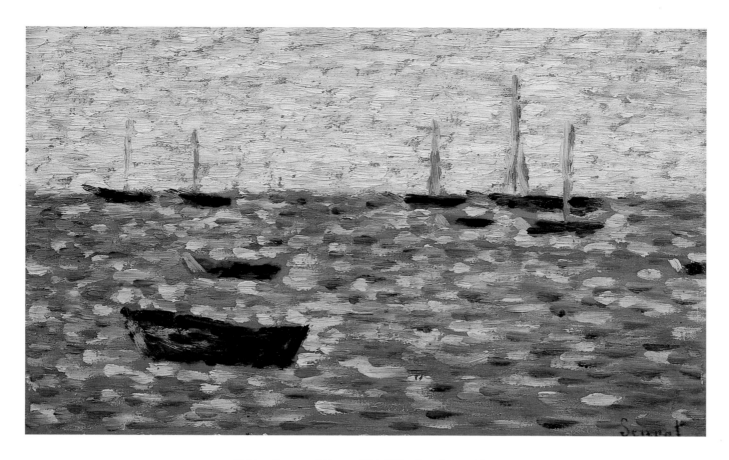

Fishing Boats and Barges, High Tide, Grandcamp. 1885

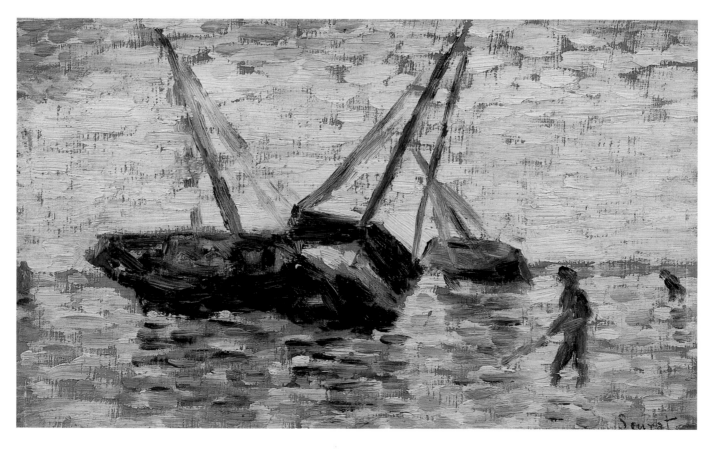

Beached Boats, Grandcamp. 1885

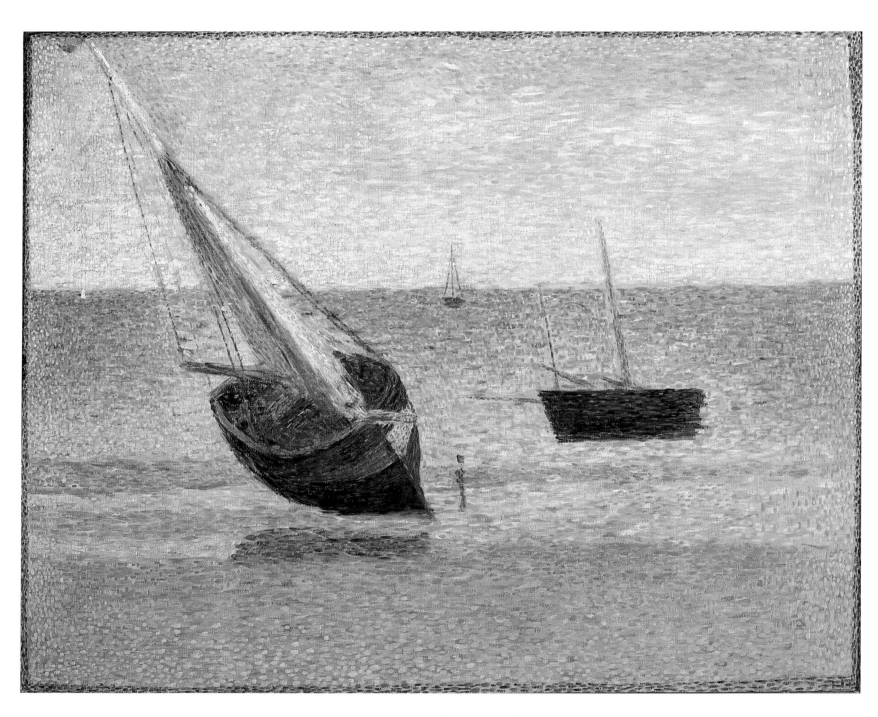

Boats, Low Tide, Grandcamp. 1885

personal qualities seemed to be obliterated by *La Grande Jatte*, which dominated the room. The lyricism of Signac and the naive rigidity of Camille Pissarro were ignored, and it was easy for the critics to claim that the new method completely eradicated the personalities of the painters who employed it.

Even George Moore, who was familiar with Pissarro's previous work, could not at first make out which were Seurat's paintings and which Pissarro's. Moore wrote:

Great as was my wonderment, it was tenfold increased on discovering that only five of these pictures were painted by the new man, Seurat, whose name was unknown to me; the other five were by my old friend Pissaro [*sic*]. My first thought went for the printer; my second for some *fumisterie* on the part of the hanging committee, the intention of which escaped me. The pictures were hung low, so I went down on my knees and examined the dotting in the pictures signed Seurat, and the dotting in those that were signed Pissaro. After a strict examination I was able to detect some differences, and I began to recognise the well-known touch even through this most wild and most wonderful transformation. Yes, owing to a long and intimate acquaintance with Pissaro and his work, I could distinguish between him and Seurat, but to the ordinary visitor their pictures were identical.[8]

Critics, with their disinclination for such careful study, would have been unfaithful to their traditional role if, on confronting this new type of painting, they had shown more understanding than a public composed of irresponsible youths, bewildered bourgeois, and amateur collectors. Marcel Fouquier wrote in *Le XIXe Siècle:*

M. Seurat, who has been heralded by people with good judgment, exhibits an immense canvas of which the only quality is its complete lack of seriousness. There is a jockey—who obviously lost a leg over the last course of hedges—and a woman leading a monkey on a leash, which are extremely "farcical," as the merry Trublot would say.[9]

There were many who thought the whole thing was a hoax, that the artist was merely "pulling the legs of honest folk," who consequently refused to take the canvas seriously. Even the avant-garde critic Octave Mirbeau, despite the arguments of his friend Pissaro, confessed that the picture disappointed and exasperated him: "M. Seurat is certainly very talented, and I do not have the courage to laugh at his immense and detestable painting, so like an Egyptian fantasy, and which, in spite of its eccentricities and errors, which I hope are sincere, shows signs of a true painter's temperament."[10]

The same hesitation between admiration of the painter and deprecation of his major effort was revealed by the literary

critic Emile Hennequin in *La Vie Moderne:*

M. Seurat has startled jaded eyes with a new technique, which we are not competent to evaluate. But if we limit our judgment to the general effect of the canvases, we must point out the extreme refinement of tones in his works, notably in the views of Grandcamp. . . . On the other hand, we cannot accept his *Sunday at La Grande Jatte,* for the tones in this painting are *crude* and the figures are set against the light like poorly articulated wax figures.[11]

While Mirbeau and Hennequin were unable to explain clearly the discomfort they felt in the presence of Seurat's huge composition, Renoir's friend Teodor de Wyzewa was the first to take a theoretical stand against this "new technique," which, according to him, lacked the vitality that is the principal feature of every work of art. In his aversion to the introduction of scientific methods into art, he did not scruple to question the sincerity of Seurat and his friends:

The impressionist paintings of Manet, Cézanne, and M. Degas, expressed with exemplary sincerity the new sensations, the new world our eyes experience. Now here the successors to these artists are trying to perfect the forms they created. They have found in the notes of Delacroix, in the scientific discoveries of Chevreul and Rood, the suggestion for a type of painting in which color impressions are ordered by the combining of little multicolored brushstrokes. But while they are occupied with amending the language, they have forgotten that the true end of art is the sincere and complete expression of vivid sensations. The works of these painters—Pissarro and Seurat are the most notorious—are interesting only as the exercises of highly mannered virtuosos. Their paintings are lifeless, for the painters have neglected sincerity, seduced as they are by external formulas.[12]

The Paris correspondent of the group of independent Belgian artists known as Les XX (Les Vingt), which had been formed by Octave Maus in Brussels in 1884 a few months before the founding of the French Groupe des Artistes Indépendants, was less severe if somewhat more hesitant. He concluded his report on the exhibition, written for the group's periodical *L'Art Moderne:*

Finally, at the end of the procession we come to an original around whom, in this exhibition of intransigents, the intransigents themselves do battle, some exalting him beyond measure, others criticizing him without any sense of proportion. This Messiah of a new art, or this cold mystifier, is M. Georges Seurat. A personality, certainly, but of what kind? If one were to judge him solely by the huge canvas that he titles *A Sunday at La Grande Jatte* . . . one might not take him seriously. The figures are wooden, naively

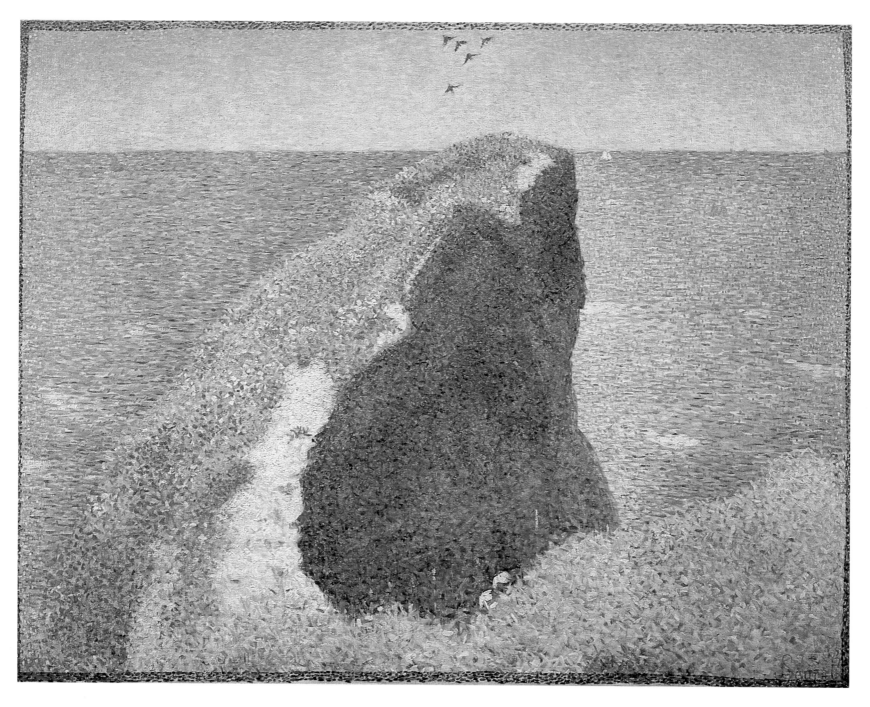

Le Bec du Hoc, Grandcamp. 1885

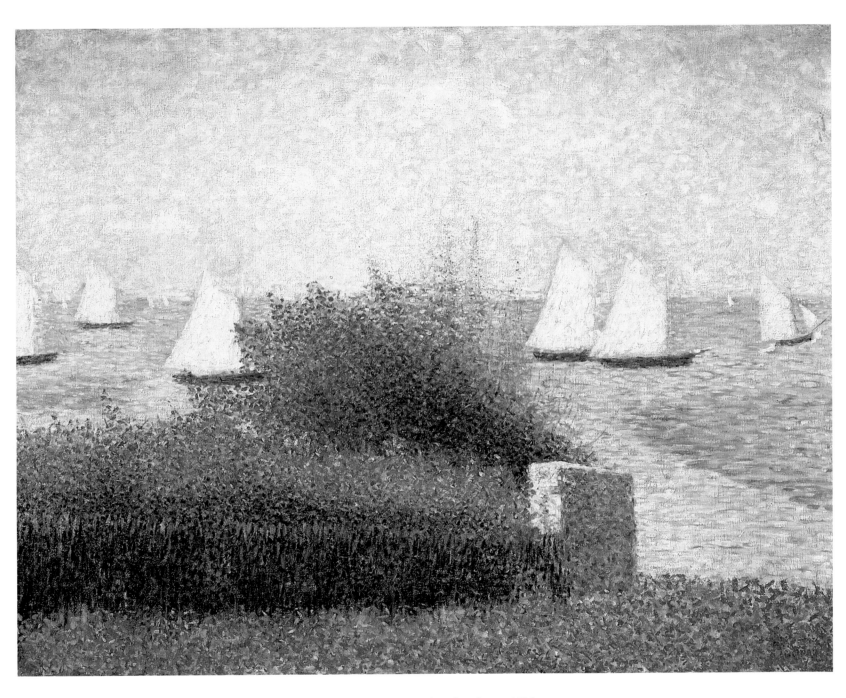

Boats Riding at Anchor, Grandcamp. 1885

modeled, like the toy soldiers that come to us from Germany in those fragile wooden boxes.

The composition is geometrical, painted from one end to the other with small brush strokes of identical size, a kind of minuscule stippling, one might take it to be embroidered on canvas with colored wools, or woven like a high-warp linen. In Brussels *La Grande Jatte* would create a scandal. Were it to be exhibited, there would be sudden cases of mental breakdown and apoplectic fits. (Therefore my dear Maus, it must be shown at Les XX next year. Comment of the proofreader, Ed. P[icard].) And yet, even in this disconcerting work, such depth, such accuracy of atmosphere, such glowing light!

A mystery? We don't believe it. Some landscapes painted by the same method . . . reveal an artistic nature that is singularly able to dissolve these phenomena of light, to penetrate its prism, to express by simple means but learned combinations the most complicated and most intense effects. We see in M. Georges Seurat a painter who is sincere, reflective, observant, whom the future will judge.[13]

Only one critic had the courage to express his admiration for the new painting without any reservation and without waiting for the future to decide: Félix Fénéon. In 1884 he had recognized the importance of the *Bathers*,[14] and now he devoted a long article to Seurat's new canvas in the review *La Vogue*. But instead of abandoning himself to facile enthusiasm, he attempted to do what no critic had yet done, to define clearly the new qualities and originality of the canvas, that is, to explain Seurat's new method by analyzing *La Grande Jatte*. The subject, he pointed out, involved the following elements:

a canicular [sultry] sky, at four o'clock, summer, boats flowing by to the side, a dispersed group of chance Sunday visitors enjoying the fresh air among the trees; and these forty-odd people fixed in a hieratic and simplified composition, rigorously drawn from the back, or full face or in profile, seated at right angles, stretched out horizontally, drawn up erect; as though by a modernizing Puvis. The atmosphere is transparent and singularly vibrant; the surface seems to flicker. Perhaps this sensation, which is also experienced in front of other paintings in the same room, can be explained by the theory of Dove: the retina, expecting distinct rays of light to act on it, perceives in very rapid alternation both the disassociated colored elements and their resultant color.[15]

Fénéon also explained the painter's method:

If you consider for example a few square inches of uniform tone in M. Seurat's *Grande Jatte*, you will find on each inch of this surface, in a whirling host of tiny spots, all the elements that make up the tone. Take this grass plot in the shadow: most of the strokes render the local value of the grass; others, orange tinted and thinly scattered, express the scarcely felt action of the sun; bits of purple introduce the complement to green; a cyanic blue, provoked by the

proximity of a plot of grass in the sunlight, accumulates its siftings toward the line of demarcation, and beyond that point progressively rarefies them. Only two elements come together to produce this grass plot in the sun, green and orange-tinted light, any interaction being impossible under the furious beat of the sun's rays. Black being a non-light, the black dog is colored by the reactions of the grass; its dominant color is therefore deep purple; but it is also attacked by the dark blue arising from neighboring spaces of light. The monkey on a leash is dotted with yellow, its personal color, and speckled with purple and ultramarine. . . .

These colors, isolated on the canvas, recombine on the retina: we have, therefore, not a mixture of material colors (pigments), but a mixture of differently colored rays of light. Need we recall that even when the colors are the same, mixed pigments and mixed rays of light do not necessarily produce the same results? It is also generally understood that the luminosity of optical mixture is always superior to that of material mixture, as the many equations worked out by M. Rood show.[16] For a violet-carmine and a Prussian blue, from which a gray-blue results:

$$\underbrace{50 \text{ carmine} + 50 \text{ blue}}_{\text{mixture of pigments}} \quad = \quad \underbrace{47 \text{ carmine} + 49 \text{ blue} + 4 \text{ black}}_{\text{mixture of rays of light}}$$

for carmine and green:

$$50 \text{ carmine} + 50 \text{ green} \quad = \quad 50 \text{ carmine} + 24 \text{ green} + 26 \text{ black}$$

We can understand why the impressionists, in striving to express luminosities—as did Delacroix before them—wish to substitute optical mixture for mixing on the palette.

M. Seurat is the first to present a complete and systematic paradigm of this new technique. His immense canvas *La Grande Jatte*, whatever part of it you examine, unrolls a uniform and patient tapestry: here in truth the accidents of the brush are futile, trickery is impossible; there is no place for bravura—let the hand be numb, but let the eye be agile, perspicacious, cunning.[17]

Years later, Gustave Kahn would observe that the turning point in the history of Impressionism came at the exhibition of 1886:

The appearance of Georges Seurat and the presentation of his new technique of pointillism initiated intense differences of opinion among the veterans. It is never pleasant for those who have struggled to attain a new truth to be faced with those who arrive after them and derive from them. This is only natural. After hard combat, life should be renewed. Seurat had ably cited his authorities and declared that Renoir's comma-like touch in his portrait of Mme Gustave Charpentier had led and would lead to the division of tones, the inevitability of which was emphasized in recent scientific works (Rood, etc.). This was nothing less than a profound change, a radical modification of the look of a painting.[18]

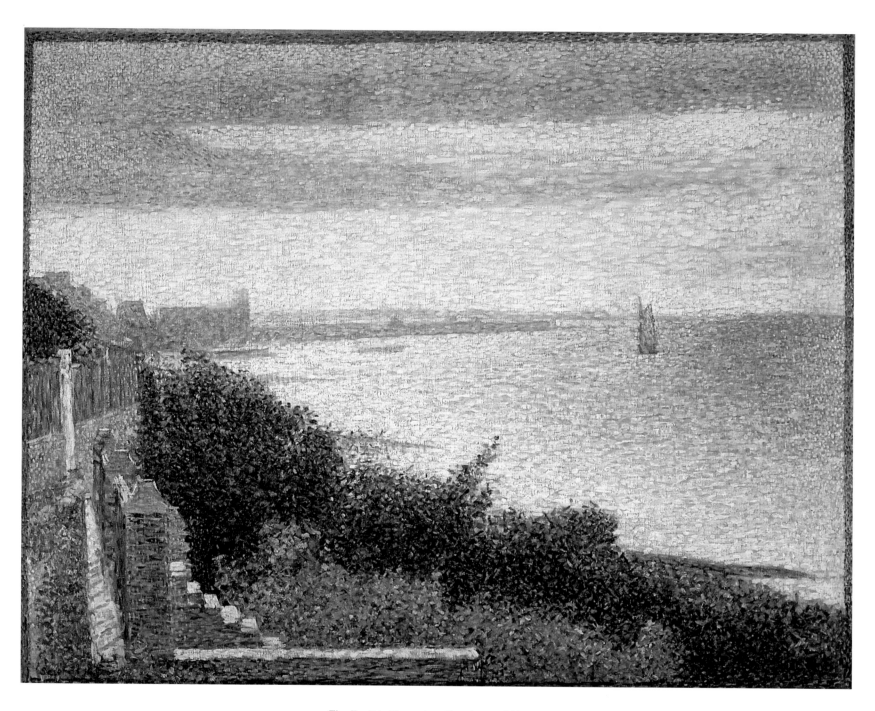

The English Channel at Grandcamp. 1885

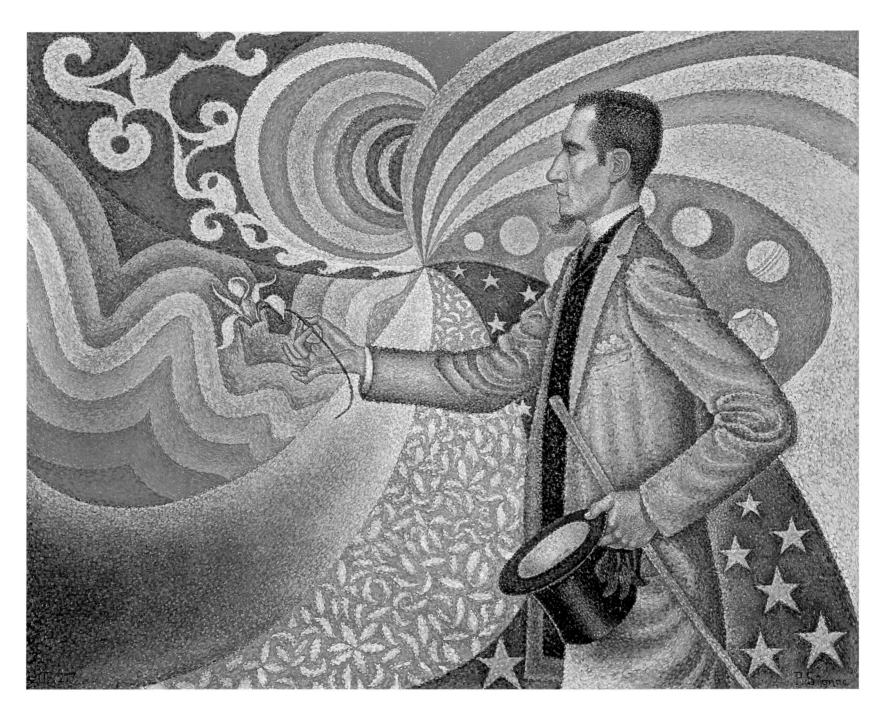

Paul Signac. *Against the Enamel of a Background Rhythmic with Beats and Angles, Tones and Colors, Portrait of M. Félix Fénéon in 1890*

Félix Fénéon and the Neo-Impressionists

Just as the nascent Impressionist painters had been championed by Emile Zola and Edmond Duranty, promoters of the Naturalist movement in literature with whose birth the emerging art had coincided, so it was now with the "divisionists," who, from the moment they appeared, would find their supporters among the Symbolist writers. The year 1886, so important in the history of painting, was equally decisive for the development of Symbolist literature. It was in this year that ideas crystallized and groups were formed. The first numbers of *La Vogue*, *Le Symboliste*, and *La Décadence* appeared in 1886. Jean Moréas published a manifesto in support of Symbolism; and Stéphane Mallarmé, Paul Verlaine, Jules Laforgue, Paul Adam, Gustave Kahn, and Félix Fénéon began systematically to propound and promote the new literary principles.

While united in their literary conviction, however, these authors did not all take the same view of painting. Mallarmé,

friend of Manet, represented the generation of the Impressionists, whereas Jules Laforgue—who was to die that very year—was just discovering their beauties. Some years later Mallarmé and Moréas would take up the cause of Gauguin, the only Symbolist artist to emerge from the Impressionist circle. Other members of the group admired Puvis de Chavannes or Gustave Moreau, attracted by the former's majestic simplicity or the latter's flowery hieraticism.[1] But Henri de Régnier, Gustave Kahn, Paul Adam, and Félix Fénéon were interested in Seurat and his friends. As Gustave Kahn explained:

We not only felt that we were leading a struggle for new ideas; we were attracted by something that seemed to parallel our own efforts: the kind of equilibrium, the search for an absolute departure that characterized the art of Seurat. . . .

We were sensitive to the mathematical element in his art. Perhaps the fire of youth had stirred up in us a number of half-certitudes which seemed strengthened by the fact that his experiments in line and color were in many respects exactly analogous to our theories of verse and phrase. The theory of discontinuity might very well have some relation to the theory of optical mixture. Painters and poets were mutually captivated by the possibility that this was the case.[2]

Among the Symbolist authors associated with Seurat and his friends, Félix Fénéon was the one who became closest to the painter. And what Zola had done for Manet and his circle, Fénéon now undertook for their successors, with less noise but no less fervor. He not only had the courage of his convictions but, as Remy de Gourmont would later remark, "He also possessed all the qualities of an art critic: the eye, the analytical mind, the style that makes visible what the eye has seen and intelligible what the mind has understood."[3]

Fénéon and his friends often met late in the afternoon in the office of *La Revue Indépendante*, edited by Fénéon and Kahn.[4] Paul Alexis, the merry Trublot, who was particularly chummy with Signac, reports that one could find there between five and seven o'clock

the white beard of Pissarro, the silence of Seurat, the absence of Mallarmé, occupied with other activities, sometimes Raffaëlli. Verlaine would have been there but for his bad leg, and George Moore, too, but he was in England. Jacques-Emile Blanche provided a note of fashionable brilliance, which was countered by the ebullient Signac, who addressed himself to the monocle that fled at the sight of Dubois-Pillet. . . . Antoine appears, followed by Luce and Christophe. And the strange gait of Charles Henry, an inventor, who passes by.[5] Félix Fénéon, the cool diplomat, arrives, looks around, and tells a story that would have made the Baron d'Ange

blush; he remarks in a musical and celestial voice on how painful it is to have to deal with inked sheets. He has just left the Ministry [where he was employed] for the art dealers with the same cold mien and almost dancing steps, under a silk hat, his Henry IV nose, and an umbrella whose handle erupts from under his shoulder, its ferrule menacing the ground.[6]

Everyone who has described Fénéon has spoken of his reserve and skillful diplomacy. Tall, always impeccably dressed, he was the proper English gentleman incarnate. His long face was set with the clear eyes of a skeptic, a prominent nose, a small pointed beard, and a large, vaguely sardonic mouth, for in his bearing there was an indescribable nuance of irony. His aristocratic features had a wholly intellectual beauty and seemed to forbid the expression of any emotion. His gestures were calm, polished, almost solemn. He spoke slowly and, without having any particular point in view, in a casual and abstracted manner got to the heart of the matter. Nothing banal ever crossed his thin lips, and each thought, clothed in precious words, was presented as though it were a pearl in a beautiful shell. It was he who remarked dryly of the Musée du Luxembourg, where Manet, Degas, and Pissarro were still conspicuous by their absence: "We should applaud a conflagration that would cleanse the Luxembourgian stables if there were not in that museum a collection of documents indispensable for future monographs on the stupidity of the nineteenth century."[7]

His painter friends did not fail to leave portraits of Fénéon. Signac portrayed him symbolically, with a cyclamen in his hand, in a canvas entitled *Against the Enamel of a Background Rhythmic with Beats and Angles, Tones and Colors, Portrait of M. Félix Fénéon in 1890*; and Toulouse-Lautrec reserved a place of honor for Fénéon near himself among the spectators on one of the two great decorations he painted for the booth of La Goulue at the Foire du Trône. The yellow, Mephistophelian head seen in profile, with a small pointed beard, is the man Lautrec liked to compare with Buddha, doubtless because of Fénéon's manner of speech and impassive face.

This imperturbable attitude was simply the mask that Fénéon had confected to hide the tenderness of his soul. As one of his friends described him, he was "at the same time calm and passionate, nonchalant and hardworking, skeptical and fervent, matter-of-fact and churning with interior lyricism."[8] Verhaeren often said, "I love Fénéon. I have seen him blush with pleasure in front of a beautiful picture." Fénéon always felt the urge to communicate to others the

pleasure he felt in front of a splendid work—whether a
painting, a poem, an essay, or a novel—to become the
promoter of ideas, of conceptions whose originality and value
he was often the first to recognize.

Possessor of a lively and immensely cultivated mind, linked
with all the avant-garde artists and writers of the late
nineteenth century, Fénéon played a role as self-effacing as it
was important. He contributed to all the "little"—and
frequently short-lived—magazines that espoused an
independent spirit. *La Vogue*, *Le Symboliste*, the series of *Les
Hommes d'Aujourd'hui*, *La Revue Indépendante*, *L'Art Moderne*
(published in Brussels), and *La Revue Blanche* owe him, if not
their very existence, at the least many pages written in the
admirably clear and concise style that served his extraordinary
intelligence and incorruptible observation. Wherever he went,
among editors, publishers, or in art galleries, Fénéon opened
doors to the young, to original talents he infallibly singled out
from the crowd. To countless painters and writers he gave
encouragement and advice, and also kindly criticism, delicate
and ironical at times but always just. The friendship that
linked him with Georges Seurat, born from the admiration that
began when Fénéon saw the first great canvases of the
unknown artist, was not terminated by Seurat's death and
apotheosis; it continued as a cult and an apostleship,
nourished by Fénéon's nobility of mind, intellectual courage,
and rare disinterestedness.

The articles that Fénéon published in 1886 in *La Vogue*
appeared toward the end of the year in a brochure entitled *Les
Impressionnistes en 1886*.[9] He clearly showed in this work that
whatever joined Seurat and Signac to their predecessors, it
was too slight to permit the new painters to be classified as
"Impressionists," despite their participation in the eighth
exhibition of the group. It was at this time that the term "neo-
impressionism"—doubtless coined by Fénéon—was first
applied to the artists who followed Seurat and divided their
colors as he did.[10] As Signac put it:

If these painters, better designated by the term *chromo-luminarists*,
adopted the name *neo-impressionists*, it was not in order to curry
favor (the impressionists had still not won their own battle), but to
pay homage to the efforts of their predecessors and to emphasize
that while the procedures varied, the ends were still the same: *light*
and *color*. It is in this sense that the term *neo-impressionists* should
be understood, for the technique employed by these painters is
utterly unlike that of the impressionists: that of the predecessors
being instinctive and instantaneous, theirs being deliberate and
permanent.[11]

It is to Félix Fénéon's credit that he was the first to juxtapose these two conceptions with impeccable logic and to define Neo-Impressionism in an article that was all the more compelling for the fact that his arguments were based on explanations provided by the artists themselves. This decisive article, titled "Le Néo-impressionnisme," appeared in the May 1, 1887, issue of *L'Art Moderne*, the Belgian publication edited by Octave Maus, Edmond Picard, and Emile Verhaeren. By way of a preface Fénéon explained in a few opening sentences that he would try to formulate "more thoroughly" than in his writings of the previous year "the importance of the reform" evolved by his friends. Having stated that the Impressionists had sought a sincere expression of modern life characterized by an "excessive sensibility to the reactions of colors, by a tendency to decompose tones, and by an effort to endow their canvases with intense luminosity," Fénéon insisted that their technique was "not yet precise: the Impressionist works present themselves with an aura of improvisation." He then continued:

Impressionism has known this rigorous technique since 1884–85. M. Georges Seurat was its inventor.

The innovation of M. Seurat, which was already implicit in certain works of M. Camille Pissarro, is based on the scientific division of the tone. Thus, instead of mixing the pigments on the palette in order to approximate the tint of the surface to be represented, the painter deposits onto the canvas the touches that represent the local color, that is, the color the proposed surface would assume in white light (essentially the color of the object when seen close up). This color, which he has not achromatized on his palette, he achromatizes indirectly on the canvas by virtue of the laws of simultaneous contrast through the intervention of other series of touches corresponding to:

1. The portion of colored light that is reflected on the surface without alteration (which will generally be a solar orange);

2. The feeble portion of colored light that penetrates beyond the surface and is reflected after having been modified by a partial absorption;

3. The reflection projected by surrounding objects;

4. The ambient complementary colors.

Paint applied not by a brushstroke but by the application of small colored spots.

Here are some advantages of this procedure.

I. These spots arrange themselves on the retina in an optical mixture. Indeed, the luminous intensity of the optical mixture is greater than that of mixed pigments. That is what modern physics means when it says that all mixture on the palette eventually leads to black;

II. The numerical proportions of colored specks being capable of infinite variety on a very small area, the most delicate transitions of modeling, the most subtle gradations of tints can be translated exactly;

III. This speckling of the canvas does not require any dexterity, it needs only—oh! only—an artistic and trained vision.

Having thus defined the theory and the technique, Fénéon went on to contrast the conceptions of his friends to those of their predecessors:

According to the first Impressionists, the panorama of sky, of water, of shrubbery varies from instant to instant. To cast one of these fugitive appearances on canvas, that was the aim. Hence, the necessity to capture a landscape in a single setting and a propensity to make nature grimace in order to prove conclusively that the moment is unique and will never recur.

To synthesize landscape in a definitive aspect that preserves the sensation implicit in it is what the Neo-Impressionists are trying to do. (Moreover, their method does not allow haste and requires work in the studio.)

In their scenes with figures there is the same rejection of the accidental and the transitory. As a result, the critics who love anecdotes complain: we are shown mannequins, not people. . . .

These same fellows, always perspicacious, compare Neo-Impressionist paintings with tapestry, with mosaic, and condemn them. Were this true this argument would be of little value; but it is illusory. Take two steps back and all these multicolored droplets fuse in undulating, luminous masses; the technique, one may say, vanishes; the eye is no longer seduced by anything but that which is essentially painting.

Since this uniform and almost abstract execution leaves the originality of the artist intact, even serves it, is it necessary to mention it? Indeed, to confuse Camille Pissarro, Dubois-Pillet, Signac, Seurat—this would be idiotic. Each of these imperiously insists on his distinctiveness—if only by his specific interpretation of the emotional sense of color, by the degree of sensibility of his optical nerve to this or that stimulus—but never by the monopoly of facile tricks.

Amid the crowd of mechanical copyists of superficialities these four or five artists impose the very sensation of life; this is so because objective reality is for them simply a theme for the creation of a higher, sublimated reality into which their personalities are transfused.[12]

With this article and with *Les Impressionnistes en 1886*, Félix Fénéon established himself as the knowledgeable and official interpreter of the group. He became the conscientious explicator of the views of his friends, and every line he was to write about them has the value of a direct testimonial.

Alfalfa Fields, Saint-Denis. 1885–86

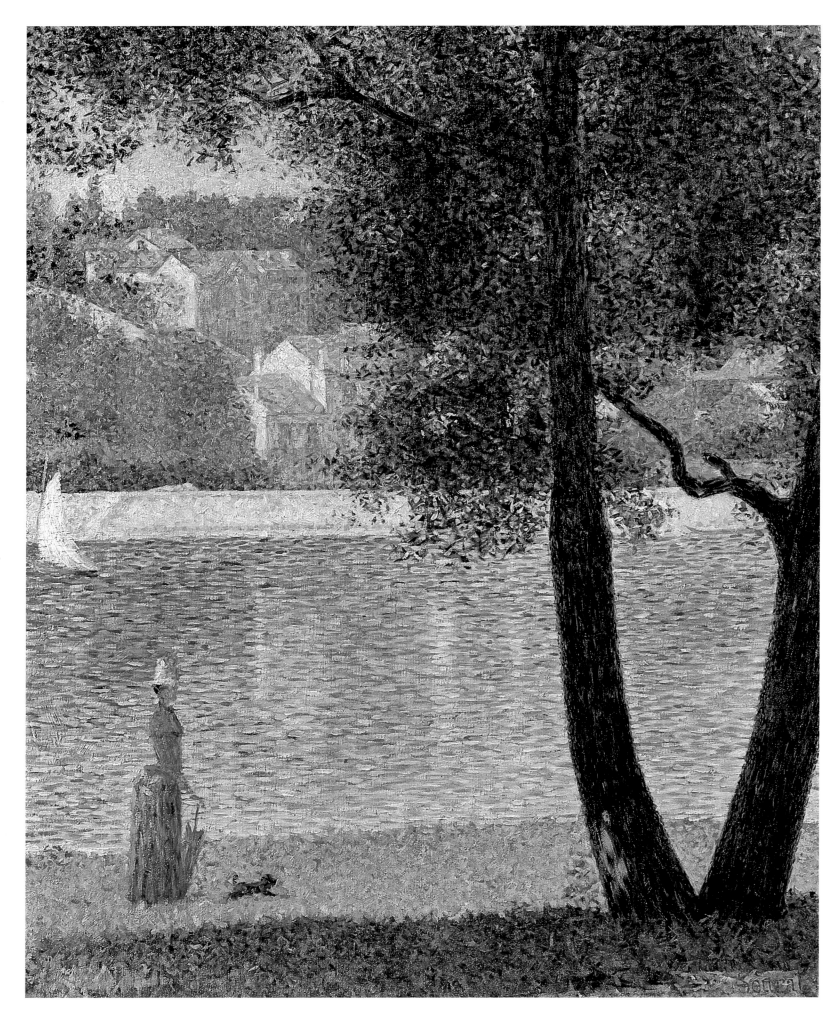

The Seine at Courbevoie. c. 1885

New Exhibitions: New York, Paris, Brussels

élix Fénéon's brochure *Les Impressionnistes en 1886* had historical significance beyond the sense of its title. It not only offered the first analysis of Seurat's art, but in emphasizing the triumph of system over intuition, it also presaged the dissolution of the Impressionist group. In fact, the Impressionists never again organized an exhibition after this eighth one, which was already incomplete. Disputes about the "divisionism" of Seurat and Pissarro finally brought about the breakup of the old comrades. The first exhibition of the group in which those who called themselves Neo-Impressionists participated was at the same time the last collective effort of the old-guard Impressionists.

At the very moment when the painters were assembling their works for their exhibition at the Maison Dorée, Paul Durand-Ruel, whose affairs had taken an almost disastrous

turn, received an invitation from the American Art Association. With courage steeled by desperation, he set about gathering a great number of paintings for an important exhibition in America, the first of its kind. The more or less official dealer of Manet, Renoir, Monet, Sisley, and Pissarro, Durand-Ruel yielded to the latter's insistence and agreed to include works by Seurat and Signac. In March 1886 Durand-Ruel left for New York with some 300 canvases intended for an exhibition that was announced simply as *Works in Oil and Pastel by the Impressionists of Paris*. In early April the *New York Daily Tribune* reported:

The coming of the French "impressionists" has been preceded by much violent language regarding their paintings. Those who have the most to do with such conservative investments as the works of Bouguereau, Cabanel, Meissonier, and Gerome [*sic*], have imparted the information that the paintings of the "impressionists" partake of the character of a "crazy quilt," being only distinguished by such eccentricities as blue grass, violently green skies, and water with the coloring of a rainbow. In short, it has been said that the paintings of this school are utterly and absolutely worthless. [1]

In order to soften the shock that the works of the Impressionists and of Signac and Seurat (the latter had sent his *Bathers* and several landscapes)[2] were likely to cause the American public, Durand-Ruel had included a few academic paintings. But contrary to expectations, the reaction of the public was not at all negative, and the exhibition was a succès d'estime. Durand-Ruel explained it: "Since I was almost as well-known in America as in France for having been one of the first defenders of the great painters of 1830, they came without prejudice to examine carefully the works of my new friends. It was presumed that these works had some value since I had continued to support them."[3]

The attitude of the American public also showed that the unceasing efforts of Mary Cassatt to interest her compatriots in Impressionist art had borne fruit. Some of her friends had even consented to add canvases from their own collections to the pictures assembled by Durand-Ruel, thus lending the exhibition the prestige connected with their names. As a matter of fact, people took so lively an interest in the show that it ran for a month longer than originally planned; its transfer in May to the National Academy of Design conferred on it a quasi-official status.

While the Parisian press had wrapped its ignorance in facile pleasantries and ridiculous theories, the American critics took a broader view of the paintings. Instead of pretending that the Impressionists did not know how to draw,

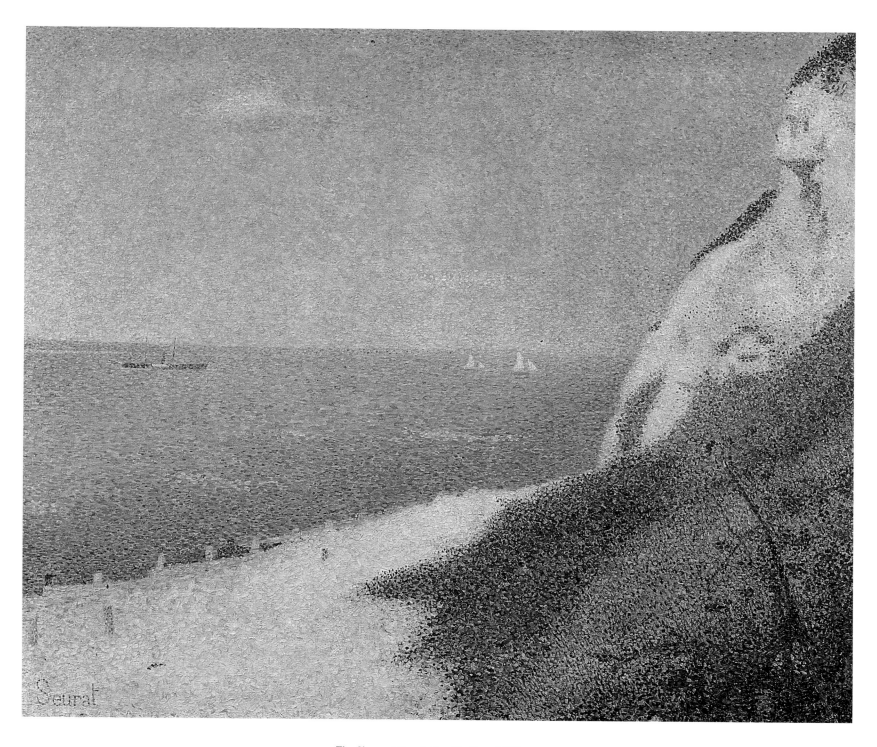

The Shore at Bas-Butin, Honfleur. 1886

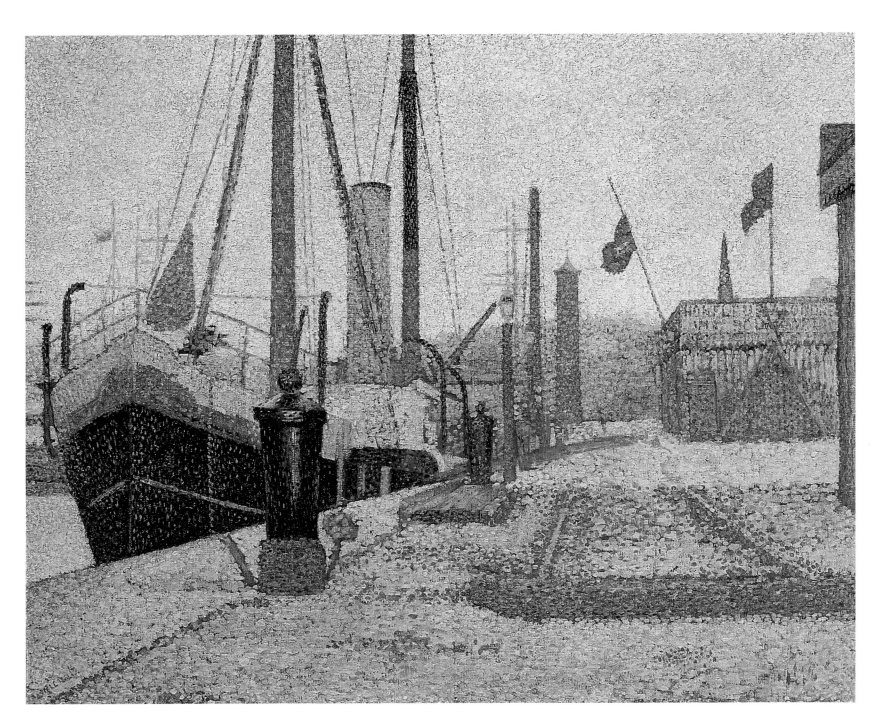

La Maria, Honfleur. 1886

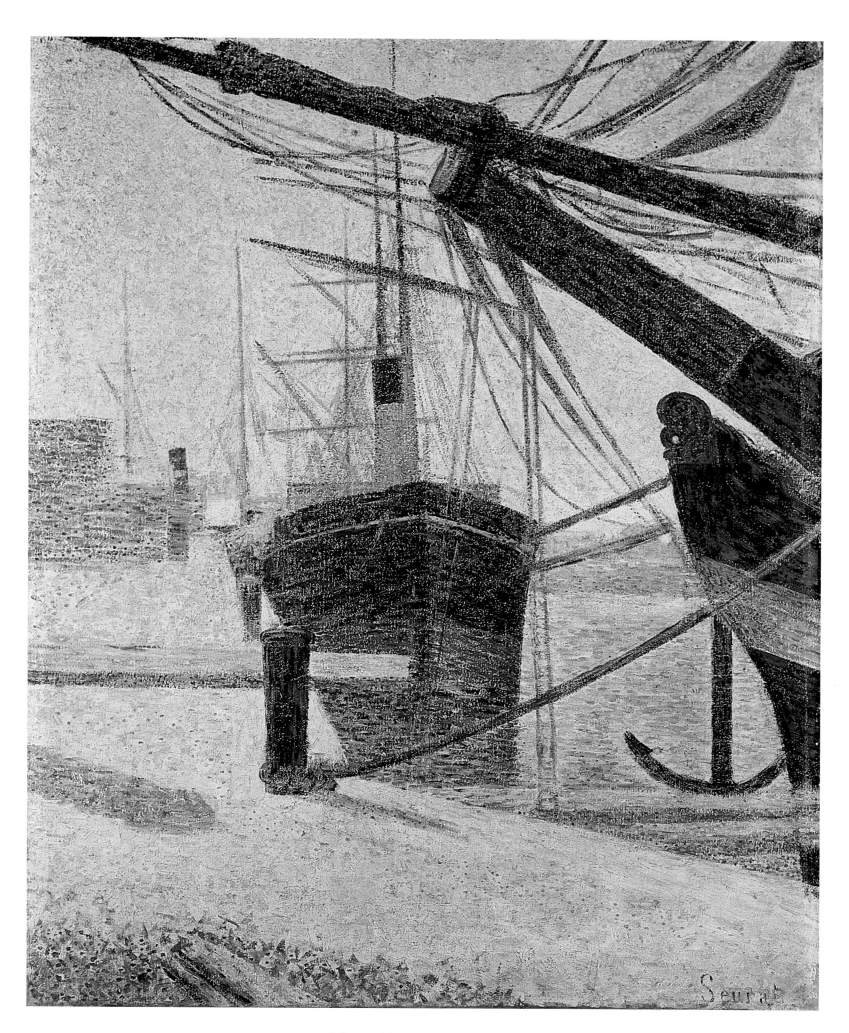

A Corner of the Harbor of Honfleur. 1886

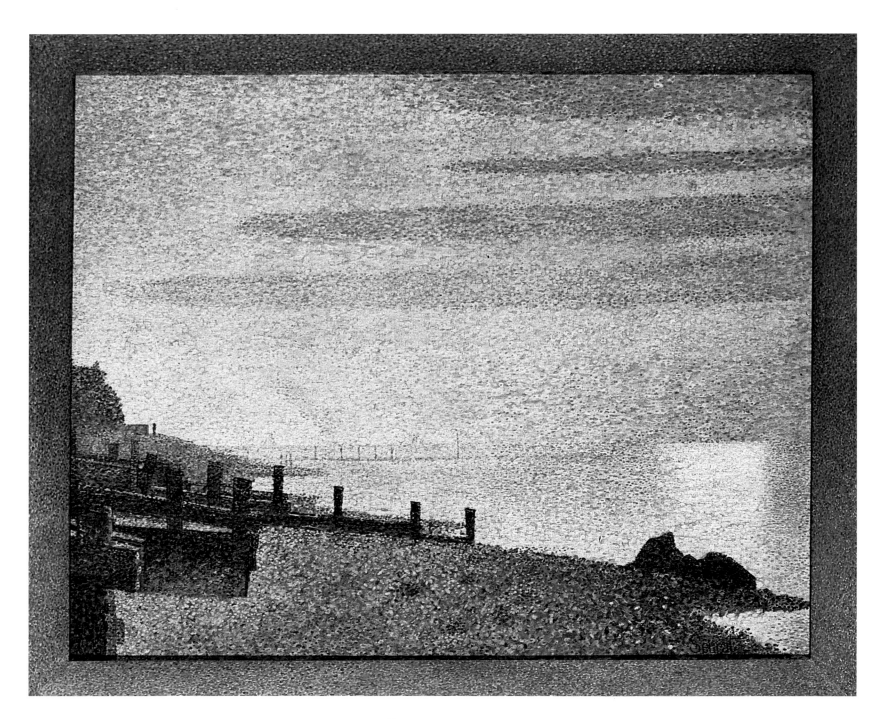

Evening, Honfleur. 1886

or that their "paint smears" were indications of impotence, they conceded from the first. The anonymous reviewer in the *Critic* noted: "It is distinctly felt that the painters have worked with decided intention, that if they have neglected established rules it is because they have outgrown them, and that if they have ignored lesser truths it has been in order to dwell more strongly on larger." The same writer observed:

Every visitor to the exhibition at the American Art Galleries during the past week has brought away with him an impression of strange and unholy splendor, or depraved materialism, according to the depth of his knowledge and experience. . . . It is seldom that what is virtually an entire school of art is transported bodily from one country to another; yet this has been done in the case of the impressionists. In this exhibition you may study the school from its superb beginnings in the earlier works of Edouard Manet—that latter-day Velasquez—down to the contemporary period, when color and composition have been borrowed from Japan, and the whole solar spectrum is found on a foot of canvas.

A listing of participating artists—Manet, Monet, Boudin, Renoir, Sisley, Pissarro, Caillebotte—with thumbnail characterizations ("the brilliant and startling talent of Degas") concluded with the observation that "in Seurat's large and uncouth composition, 'Bathers,' the uncompromising strength of the impressionistic school is fully revealed."[4]

Happily for Durand-Ruel, the moral success of the exhibition was coupled with a certain number of sales.[5] However, none of Seurat's works found an American buyer, and Durand-Ruel brought them back to France when he returned that summer.

Seurat was then at Honfleur, where he painted several seascapes, among them *Coin d'un bassin à Honfleur,* which he would send to the exhibition of the Indépendants. The Society of Independent Artists had not been able to organize an exhibition during the previous year, but this summer of 1886 it mounted a month-long showing, again at the Tuileries, which opened in late August. In addition to the Honfleur canvas and several seascapes done in 1885 at Grandcamp, Seurat sent his *Grande Jatte* again.[6] In reporting the vernissage the correspondent of *Le Figaro* announced: "Not very interesting, this exhibition, from the point of view of art, but to be recommended to people who suffer from disorders of the spleen; we advise those of our friends who like to laugh to visit this exhibition. The room devoted to the 'intransigents' of painting is particularly unspeakable."[7]

Félix Fénéon again devoted an article to Seurat's technique,

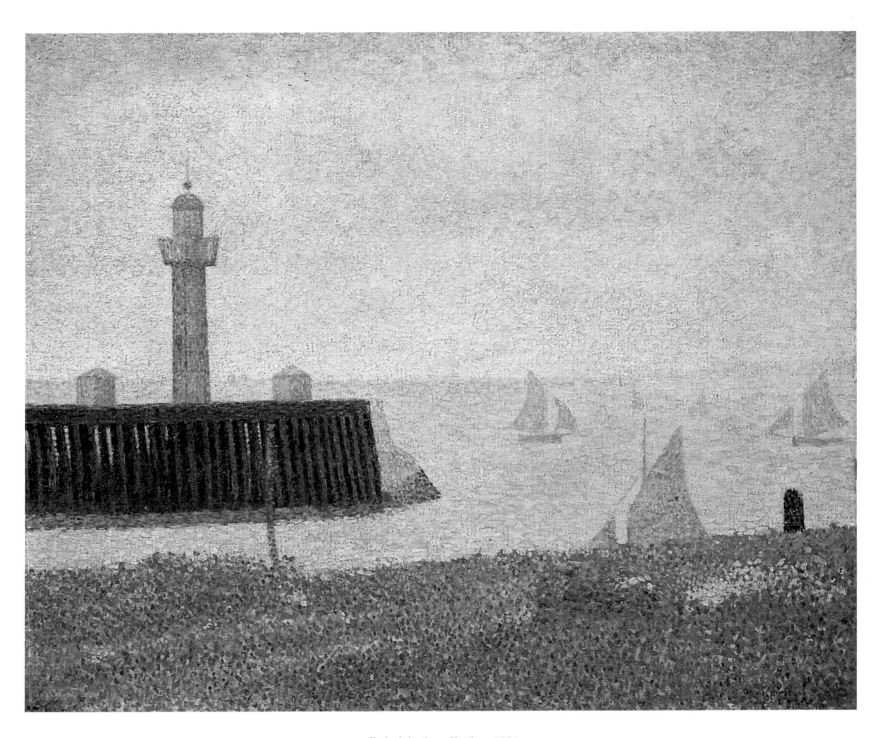

End of the Jetty, Honfleur. 1886

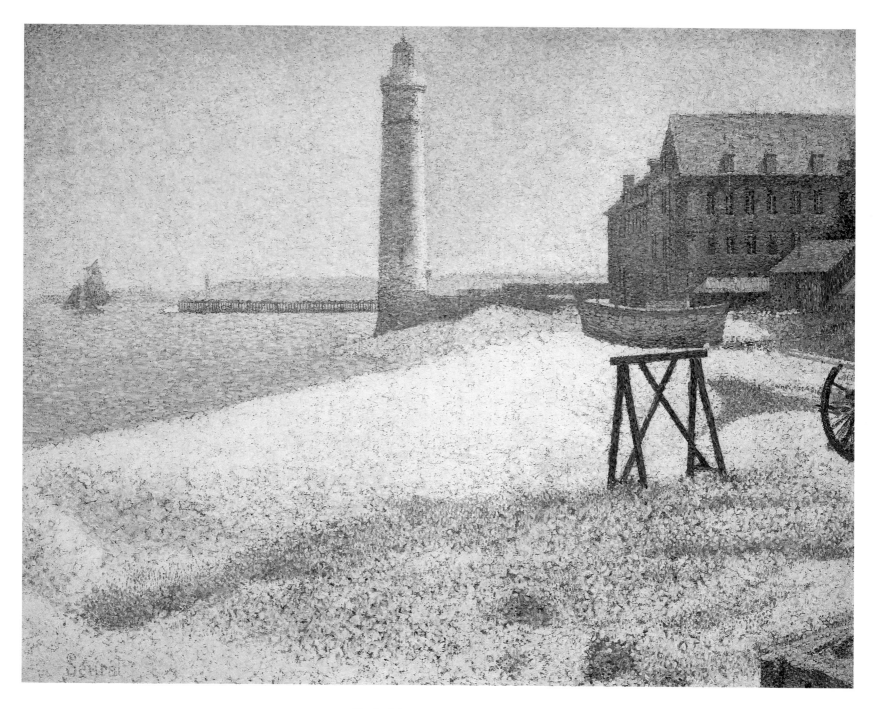

The Lighthouse at Honfleur. 1886

which appeared in *L'Art Moderne* of September 19, 1886. In this new piece he made a particular point of various technical problems. Camille Pissarro, having reviewed Fénéon's notes at the latter's request, wrote his son that he feared that these questions "are only too well explained and that the painters will take advantage of us."[8]

After repeating that the art of Seurat and his friends marked a step beyond Impressionism insofar as it made it

Study for "Le Pont de Courbevoie." c. 1886

possible "to construct a painting in a precise and rigorous manner," Fénéon added:

For the practitioners of this new painting every color surface emits varying degrees of tones which, like the interpenetrating crests of waves, diminish in intensity, and the painting is unified and synthesized in an overall, harmonic sensation.

The first efforts in this direction were made less than two years ago; the period of hesitation is over. From picture to picture these artists have affirmed their method, increased their observations, clarified their science. Some points have not yet been clarified. In the paintings of M. Pissarro, a colored surface not only casts its complementary color on neighboring surfaces but it also reflects some of its own color onto them, even when it is not brilliant, even when the eye does not see its reflection clearly. The position of M. Seurat and M. Signac appears to be less affirmative. And, for example, the woman in the foreground of *A Sunday at La Grande Jatte* stands in the grass and yet not one spot of green contributes to the formation of the tone of her dress.

Moving next to a discussion of problems arising from the chemical composition of different colors, which can eventually cause transformation and deterioration of the pigments, Fénéon pointed out that the Neo-Impressionist method of applying

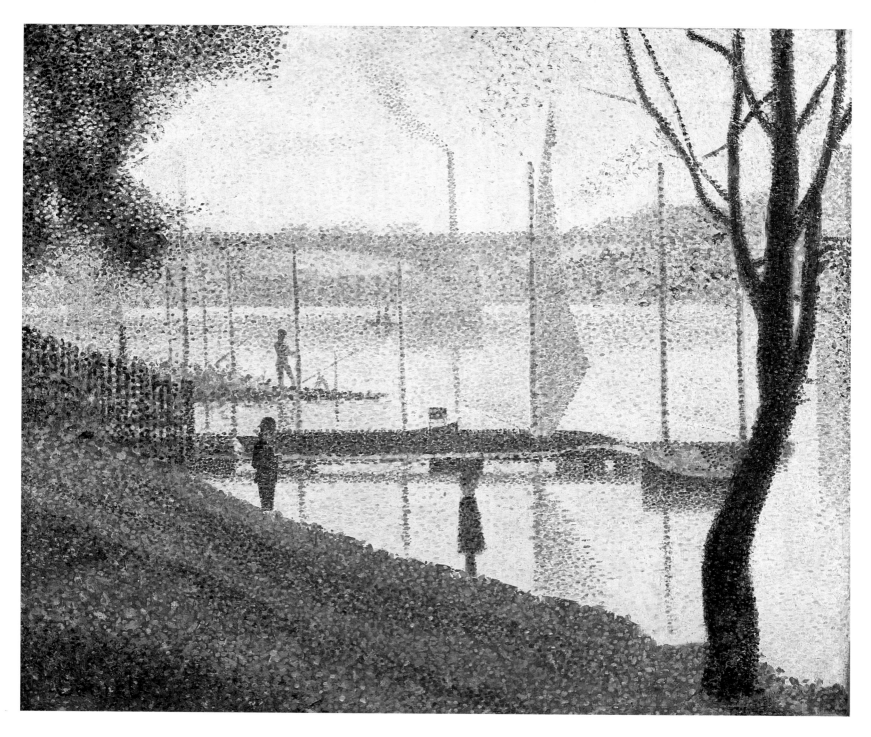

Le Pont de Courbevoie. 1886–87

colors on a dry surface avoids the crackling that results from the uneven drying of layers of superposed paint. He recommended putting paintings under glass to eliminate the dulling of colors that is inevitable with even the purest varnish. Addressing the question of the frame itself, he remarked: "With the abandonment of the gold frame, destructive of orange tones, Pissarro, Seurat, Dubois-Pillet, and Signac temporarily adopt the classic frame of the Impressionists, the white frame whose neutrality is friendly to everything near it, if it contains—to temper its crudity—clear chrome yellow, vermilion, and lake."

Reviewing the works of the various painters, Fénéon concluded with unconcealed satisfaction: "As for the recruits to impressionism, they will take the path toward the analyst Camille Pissarro and not that toward Claude Monet."[9]

Asked to show his paintings in Nantes in October, Pissarro once again used his influence on behalf of his young friends, and Seurat and Signac were able to show their works with his.[10] In the meantime Seurat and Signac had returned from their "summer campaign." Signac, who had worked at Les Andelys on the bank of the Seine, now prepared to explore Paris, while Seurat spent the fall of 1886 completing the canvases he had brought back from his summer in Honfleur. Some months earlier he had received an invitation from Octave Maus to show his paintings with the group of independent Belgian artists known as Les XX. Pissarro, Berthe Morisot, and several others were also invited. Seurat sent *La Grande Jatte* and six landscapes of Honfleur and Grandcamp.[11] In February 1887, accompanied by Signac, who was not participating, he went to Brussels to attend the opening of the exhibition. Signac promptly reported to Pissarro:

I just left the exposition of Les XX entirely exhausted.

An enormous crowd, a dreadful crush, very bourgeois, anti-artistic.

On the whole, a great success for us; Seurat's canvas could not be seen, impossible to get close to it the mob was so dense.

The exhibition hall is a magnificent gallery of the museum, very large with excellent light; one couldn't find any better.

Your paintings look very well, but unfortunately they are somewhat too isolated because there are so few of them and because of their small size. They disappear, lost among the large canvases that surround them. Just the same, they produce a great effect. The pointillist execution intrigues the people and forces them to think; they begin to understand that there is something to it. . . .

After all, the result is excellent for a town as idiotic and as anti-artistic as Brussels, where there is a small nucleus of people interested in art, and beyond that, nothing.[12]

As was to be expected, *La Grande Jatte*, better displayed than it had been in Paris, was from the first the center of attention and the subject of lively disputes. The reporter for *Le Moniteur des Arts* spoke of "farceurs like Seurat and Pissarro, who are not taken seriously by any artist and do not deserve to be. They can congratulate themselves on being welcomed with nothing worse than ridicule in Brussels."[13] Another correspondent observed that "it would be difficult to be more independent than M. Seurat or to paint with more disdain for the old stuff called drawing, color, and the organization of the picture."[14]

La Vie Moderne, the Paris periodical in which a skeptical study by Emile Hennequin had appeared some months previously,[15] published a review of the exhibition by Emile Verhaeren, who wrote enthusiastically about Seurat's contributions:

In the present show the clarion call is sounded by M. Seurat. *La Grande Jatte!* They press about it, insult it, mock it. The Goncourt brothers were right, "No one in the world hears as much rubbish as a painting on exhibition."

La Grande Jatte deserves a detailed examination.

It is so luminous that it is almost impossible once one has seen it to become interested in any adjacent landscapes. . . . An atmospheric purity, a total aerial vibration permeates it. The Seine, the green shade, the golden grass, the sky influence one another, color one another, interpenetrate, and produce a tremendous sensation of life.

M. Seurat is described as a savant, an alchemist, etc., who knows what? However, he uses his scientific experiments only for the purpose of controlling his vision. They give him an extra degree of sureness. Where is the harm? . . .

La Grande Jatte is painted with a primitive naivete and honesty. Standing before it, one is reminded of Gothic art. As the old masters, risking rigidity, arranged their figures in hierarchic order, M. Seurat synthesizes attitudes, postures, gaits. What the masters did to express their time, he attempts for his, and with equal care for exactness, concentration, and sincerity. He does not repeat what they did. He makes original use of their profound method in order to sum up the life of the present. The gestures of these promenaders, the groups they form, their goings and comings are *essential*. The whole work thus appears as the result of many casual observations. It has a great and glorious swing, and that is why enthusiasms are harnessed to it like prancing horses.

Even the public, which has rejected the major effort of the painter, is attracted to his smaller paintings: seascapes and harbors. Two canvases have been sold. . . . Never has anyone so successfully achieved with such precision the detail that is present in grandeur. The *Bec du Hoc* and the *Lighthouse of Honfleur* are at once minutely detailed and immense.[16]

Théo van Rysselberghe. *The Reading (Emile Verhaeren and Friends)*. 1903

Standing, from left to right: Félix Fénéon, Henri Gheon.
Seated, from left to right: Félix Le Dantec, Emile Verhaeren,
Francis Viélé-Griffin, Henri-Edmond Cross, André Gide, Maurice Maeterlinck.

Seurat and His Friends

The small group of Neo-Impressionists was soon augmented by new adherents in France and also in Belgium, where the exhibition of Les XX had made the work of Seurat widely known among artists. One by one Maximilien Luce, Léo Gausson, Hippolyte Petitjean, Théo van Rysselberghe, Henry Van de Velde, and others joined the circle that had been formed around Seurat by Signac, Cross, Angrand, Dubois-Pillet, Hayet, and Camille and Lucien Pissarro. Vincent van Gogh briefly experimented with the pointillist technique; Paul Gauguin and his friends Emile Schuffenecker and Maurice Denis also tried the method, using Seurat's execution but not observing the laws of contrasting colors.[1] While Van Gogh as well as Gauguin and his comrades, who never joined the Neo-Impressionist group, quickly abandoned the employment of dots of color, the others were convinced that Seurat's method would enable them to achieve greater harmony, to capture fugitive sensations and produce more luminous effects. Seurat was the uncontested leader of this small group.

Even painters who did not belong to his circle considered him as such. Van Gogh, for example, wrote his brother, "The leader . . . is undoubtedly Seurat."[2] And according to Emile Verhaeren:

All his friends, the painters and others, felt that he was the real force in the group. . . . He was the most persistent seeker, had the strongest will, was the greatest discoverer of the unknown. He had the power of concentration, was an integrator of ideas, a savage synthesizer forcing every chance remark to reveal a law, attentive to the least detail that might strengthen his system. . . . He never regarded his comrades-in-arms as being on the same plane with him.[3]

If Seurat was the leader of the Neo-Impressionists, Signac was their best propagandist. Indefatigable proselytizer, he never passed up any opportunity that allowed him to profess his convictions. When, for example, he read in Zola's *L'Oeuvre*, which first appeared in serial form in *Le Gil Blas* early in 1886, "The red of the flag turns to violet because it is silhouetted against the blue of the sky," he immediately wrote the novelist and pointed out his mistake. Zola obediently changed the text for the book version, substituting the formulation suggested by Signac: "The red of the flag turns to yellow, because it is silhouetted against the sky's blue, whose complementary color, orange, combines with red."[4]

Seurat himself was much less inclined to disseminate his beliefs and even complained of being "too much imitated." Pissarro, in his letter to Durand-Ruel explaining the new theory, was careful to add that it was "Monsieur Seurat, an artist of great ability, who first conceived the idea and applied the scientific theory after profound study. I have only followed him."[5] Insisting in this way on Seurat's priority, Pissarro tried to humor the latter's pride, which was extremely sensitive where questions of artistic merit were concerned. But even the candor and modesty of Pissarro could not prevent unfortunate episodes. When, in an article on Pissarro published in 1890,[6] Georges Lecomte, while not attributing the new method to the old painter, neglected to say *who* had initiated it, Seurat did not conceal his anger and chagrin.[7]

Jealous of his theories and even suspicious, Seurat, it appears, at one time actually hesitated to exhibit his work for fear that other painters would avail themselves of his discoveries. All those who knew him during this period report that he was extremely reserved and seldom participated in his colleagues' discussions. He listened without saying a word, except when directly addressed, but came alive when the problems of painting were broached, especially when *his* method was discussed.[8]

Taciturn and volatile, Seurat was perfectly aware of the role he played among his comrades, but at no time did he unduly emphasize it. He seems to have accepted his position as a

Paul Gauguin. *Still Life: Ripipoint*. 1889

Vincent van Gogh. *Interior of a Restaurant, Paris*. 1887

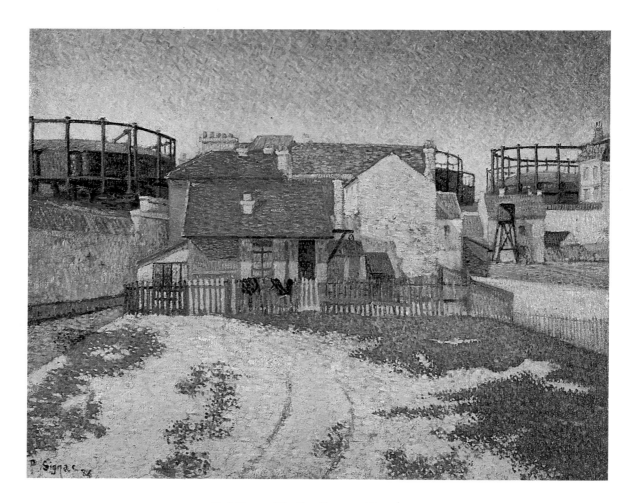

Paul Signac. *The Gas Meters at Clichy.* 1886

Camille Pissarro. *Charing Cross Bridge, London.* 1890

natural consequence of his intellect and his work. When he joined his friends' evenings at La Nouvelle Athènes, where Degas, Gauguin, Guillaumin, and Pissarro held forth, or at La Taverne Anglaise on the rue d'Amsterdam, where contributors to the review *La Vogue* held their meetings, it was as a silent witness to their debates. Occasionally he also appeared at Antoine's Théâtre Libre, rue Pigalle, where Alexis, Céard, Hennique, Lugné-Poë, and sometimes Edmond de Goncourt gathered in the evening. Antoine's entrance hall was embellished with some of Seurat's and Signac's works.[9]

The discussions that occupied Seurat's friends were devoted to three current topics: literature, painting, and politics. This was the period of anarchist manifestos and terrorist acts. Militant agitation permeated the working class as well as the intellectual groups. Fénéon, Pissarro, Luce, and Signac did not hide their sympathy for the extremists, but Seurat did not openly profess his political beliefs. It may be presumed, however, that he shared the views of his friends, for as Fénéon put it, "His literary and artistic friends and those who supported his work in the press belonged to anarchist circles, and if his opinions had differed radically from theirs, this fact would have been noticed."[10]

Participating only in those discussions that dealt with art, Seurat at such moments was heard with respect. He was completely serious and never lapsed into fantasy. His reserved attitude, his extreme lucidity, his penchant for contradiction gave weight to his words. But it was above all his canvases that were the luminous support of his theories. For although Seurat rarely brought his friends to his studio to show them the progress of his work, at exhibitions he enjoyed elucidating his paintings to them. Emile Verhaeren reported:

To hear Seurat making his confession before his year's work was to feel his sincerity and to be conquered by his eloquence. Calmly, with careful gestures, his eye never leaving you, and his slow and measured tones seeking rather didactic formulas, he showed you the results obtained, the clear proofs, what he called the *base*. Then he asked your opinion, took you as witness, awaited the word that would indicate that you had understood. He was very modest, almost timid, though you constantly felt his unspoken pride of accomplishment. He was hardly ever violent in his criticisms of others, and even pretended certain admirations which at bottom he did not feel, but at such times you sensed that he was condescending and without jealousy. He never complained about the success of others, even when such success was rightfully his due.[11]

While at times indulgent toward his colleagues, Seurat genuinely admired few of the great masters. According to Gustave Kahn:

His taste in older art leaned in the direction of the hieratic, as in the Egyptians and the primitives. He was particularly attracted by the most flexible works, like Greek friezes and the works of Phidias; his choices among the romantic masters and the landscapists were broad, but, save for Delacroix, without enthusiasm.

Among the old style impressionists, he stated freely that the three most important leaders, by virtue of their work and the influence they exerted upon other painters, were Degas, Renoir, and Pissarro.[12]

When Seurat became interested in another painter's work he would try to penetrate it and analyze it methodically, exactly as he had searched in his youth for signs of divisionism in the old masters at the Louvre. He was interested in the work of Monet, to which he had been introduced by Signac, and he went with Pissarro to the shop of Père Tanguy, the old dealer in pictures and paints, to study the work of Cézanne, whose qualities Pissarro never ceased praising. At Pissarro's suggestion Signac even bought a Cézanne landscape executed with straight-edged patches of color, and Seurat, too, began to wish that someone would finally organize an important exhibition of the works of the solitary of Aix.[13] On his part, in order to help Camille Pissarro, who had lost his entire clientele since adopting the new technique, Seurat persuaded his mother to buy a painting from the artist who was one of his staunchest admirers.

Seurat's interest in his contemporaries was not restricted to the members of his own small group and their precursors. He was interested in the work of Gauguin and admired its precise technique and sculptural quality. Seurat even owned a copy of a manuscript by Gauguin, an extract from an Oriental text on the coloring of rugs in which there were many shrewd observations on the gradations of tones; however, according to Seurat, the text was inadequate.[14] He was charmed by the gaiety and vitality of the posters of Jules Chéret, whom Fénéon had named "The Tiepolo of the Billboards," and he studied Chéret's drawing in an attempt to discover the aesthetic secrets of the poster maker's means of expression.[15] In every work he saw, in every article he read, Seurat sought confirmation of his theories.

Present at the meetings of the group, occasional participant, working actively with the others in organizing the successive exhibitions of the Indépendants, Seurat nonetheless remained a mystery to most of his associates. Among his friends he went his own dedicated, solitary way, and even his intimates knew little about him. Seldom communicative, he achieved a perfect separation of the man and the artist. His life was almost totally absorbed by his art; the little that remained was his

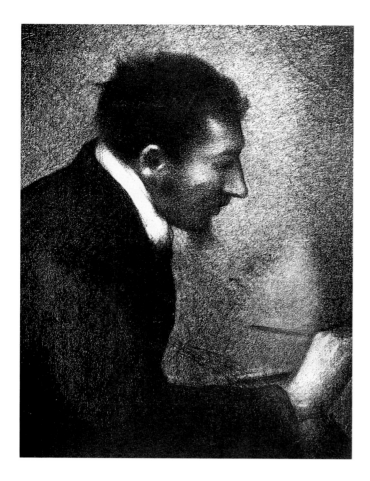

Portrait of Edmond-François Aman-Jean. c. 1883

Ernest Joseph Laurent. *Portrait of Georges Seurat.* 1883

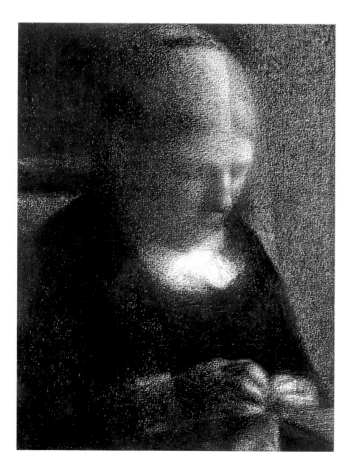

The Artist's Mother (Woman Sewing). c. 1883

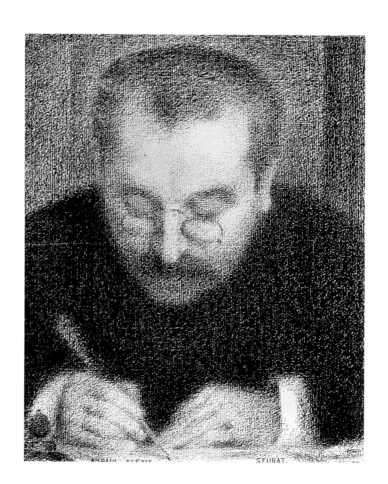

Portrait of Paul Alexis. 1888

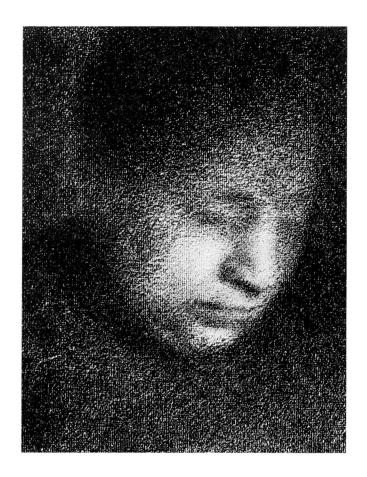

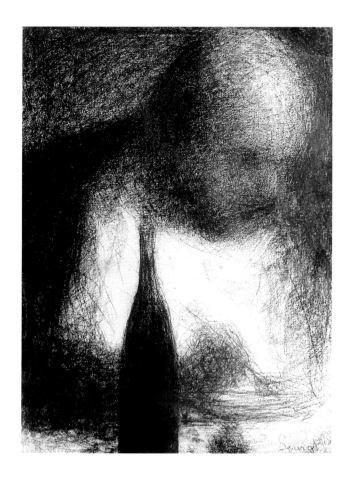

Madame Seurat Reading (The Artist's Mother). c. 1883

Man Dining (The Artist's Father). c. 1884

The Artist at Work. c. 1884

Man Reading on a Terrace (The Artist's Father). c. 1884

alone. Only after his death did his best friends learn of the companion with whom he spent his last years and who bore his son.

Seurat's friends do not agree about the painter's physical appearance. Aman-Jean maintained that Seurat was handsome and resembled Donatello's *Saint George*. To Lucie Cousturier he looked like an "executive." His classmate Rupert Carabin speaks of his "Christ-like" head. His "delicate yet massive profile" reminded Gustave Kahn of "Assyrian kings." Teodor de Wyzewa, struck by Seurat's "great height, long beard, and guileless eyes," compared him with "one of the Italian masters of the Renaissance"; Degas dubbed him "the notary," because of his always impeccable appearance. Signac asserted that he was well built, like a grenadier. Although Seurat was raised as a Catholic, to Van de Velde he seemed to be a typical French Calvinist. And Camille Pissarro remarked more than once that he was "colder, more logical, and more moderate" than any of the others in the group.[16] Lucie Cousturier recalled:

Seurat's physical appearance was what one would have anticipated from seeing the finely shaped, rigid, calm figures he created. It was in the stiff attitudes that hardened his full and lofty forms that he tempered the passionate impulses of his soul. No sudden movements shook his comely head set squarely on his shoulders, and no troubled expression disturbed his firm, regular features, framed in brown. But even a brief discussion of painting produced a fiery glance and a passionate voice impatiently struggling to affirm his beliefs.

Seurat, absorbing the tenderness of light from nature, was as gentle as his velvet eyes and dark brows proclaimed him to be, but he became suspicious and reserved if one probed the interior self that he cultivated in secret. Ordinarily disinclined to play a leading conversational role, he took complete charge of any discussion in which important aspects of painting were involved. At such times he emerged from his inner self like a she-wolf on the scent, but no one could follow him to his lair.[17]

Seurat's "lair" was his studio, where he painted in total solitude. When the weather prohibited outdoor sessions, he remained in his studio, going out to lunch "as rapidly as possible to the nearest restaurant, wearing a narrow-brimmed felt hat far back on his head and a short jacket. No one could have been more casual, but his height, the severe regularity of his features, and the contemplative calm of his glance conferred upon him a permanent air of gravity."[18]

But when at the day's end Seurat punctually left the studio on the boulevard de Clichy, near Signac's, to dine with his parents, he was faultlessly attired. Hating negligence and eccentricity, he dressed with the same meticulous care he

brought to everything he undertook. Those who saw him at the committee meetings and openings of the Indépendants, which he attended with religious regularity, never knew him to wear anything but black, with the stylish top hat sported also by his friends Fénéon and Signac. It was in this same black, or dark blue, that he appeared among his friends, on the boulevards he traversed between place de Clichy and boulevard de Magenta, where his mother lived, and in the familiar cafes.

Seurat's work did not have to end when his friends were gathering at La Nouvelle Athènes or La Taverne Anglaise, since he was able to paint by gaslight. When Mallarmé published a translation of Whistler's "Ten O'Clock Lecture" in *La Revue Indépendante* in 1888, Seurat was the only one not surprised by Whistler's statement that the painter's work could begin at the very moment artificial light is turned on. And he remarked to Gustave Kahn, "That is the insight of a great painter. Whistler is right."[19]

When a work in progress did not keep him in the studio, Seurat liked to spend his evenings at the fairs, circuses, or music halls. The fairs at Neuilly, at the Place du Trône, or at Saint-Cloud and the Cirque Fernando (later named Médrano), one of the five great circuses of Paris (where Renoir and Degas also made drawings), were his favorites, at least when he was not at the music halls La Gaieté Rochechouart, Le Divan Japonais (later favored by Toulouse-Lautrec), or Le Concert Européen. These music halls blossomed along the streets and boulevards of Paris during the years 1884–90 and competed by offering ingenious performers and other unexpected attractions. Seurat observed these boisterous and colorful spectacles with eyes more interested than entertained. His visits to these fairs, circuses, and cabarets produced many drawings, sometimes heightened with color, vibrant with the energy and mystery of a world existing outside reality, or rather belonging to an alien reality. All the grace and all the poverty, the false gaiety and the real joy of those beings who sometimes amuse themselves, and sometimes suffer while they amuse others, are reflected in the drawings and paintings they inspired. But Seurat's eye and mind avoid sentimentality as well as exuberance; only occasionally does his hand betray the slightest irony. The grotesqueness of these human puppets would have been shown with pity by Van Gogh, or emphasized by Lautrec, but Seurat, a sober although intense observer, sought in the swarming throngs of the sideshows and fairs only pretexts for masterful experiments in line and composition.

Late at night he returned to his barely furnished studio, not to his mother's place. His relations with his family remain a puzzle. Aman-Jean, who shared Seurat's studio after they left

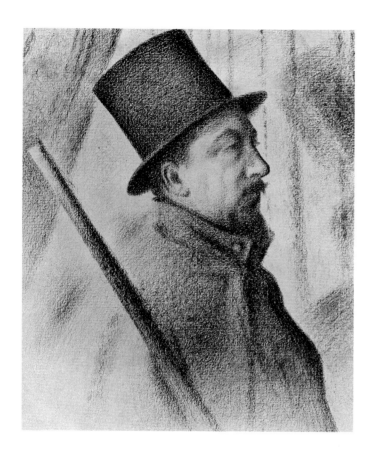

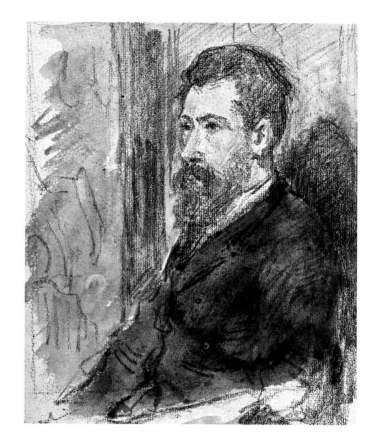

Portrait of Paul Signac. 1889–90

Maximilien Luce. *Portrait of Georges Seurat.* 1890

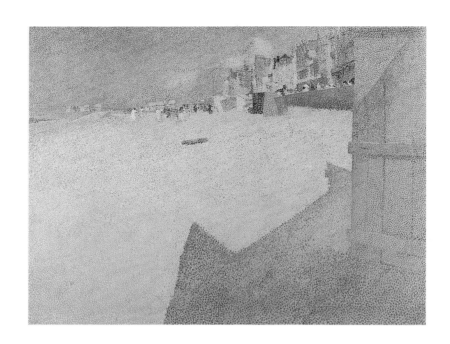

Henry van de Velde. *Blankenberghe*. 1888

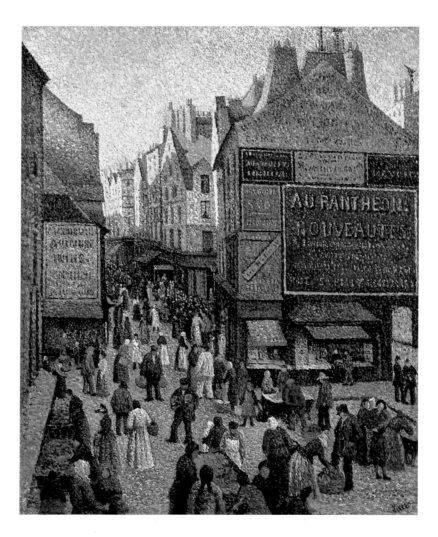

Maximilien Luce. *La Rue Mouffetard, Paris*. 1889–90

the Ecole des Beaux-Arts, related that he saw Seurat's mother once, his father sometimes. The latter, a man of peculiar habits, was usually at his house in Le Raincy, just outside Paris, where he devoted himself to strange religious practices. Only Paul Signac seems to have been admitted to Seurat's family, and in a letter to Félix Fénéon, in which he discussed the drawing *Man Dining*, he related:

You know that the man dining is Georges's father. I had dinner with him and Georges many times at Madame Seurat's on Tuesdays, the day this husband had chosen for discharging his conjugal duties. You also know that he had an artificial arm, not from birth—although his personality was eccentric enough to make such originality plausible—but as a result of some accident, while hunting, I believe. At the table he screwed knives and forks to the end of this arm and proceeded to carve with speed, and even efficiency, mutton, filet, small game, and fowl. He positively juggled these sharp, steel-edged weapons, and when I sat near him I feared for my eyes. Georges paid no attention to these acrobatic feats.[20]

Seurat seems to have made drawings of his father and mother from time to time; there is a drawing of a little boy for which his brother may have posed. It is significant that except for the drawing *Man Dining*, one cannot be sure of the identity of his models. Seurat would make drawings of his parents just as he would draw a woman crossing the street or a plasterer at work on a wall. Nothing in his life had meaning except insofar as it was relevant to his art.

If his relations with his family were limited, if his participation in the discussions of his friends centered on problems of art, if his dress was simple, correct, and highly impersonal, his studio furnishings, too, were restricted to the indispensable. Gustave Kahn described

a small, monastic room, it contained a low, narrow bed facing some of the older canvases, the *Bathers*, and some seascapes. In this white-walled studio hung his souvenirs of the Ecole des Beaux-Arts, a small painting by Guillaumin, a Constantin Guys, some works by Forain—paintings and drawings that had become habitual for him and, in their coloration, a familiar part of the wall—a red divan, a few chairs, a small table on which sat side-by-side some friendly reviews, books by young writers, brushes and pigments, and his horn of tobacco. Standing against a panel, covering it completely, the *Grande Jatte*.[21]

Completing these furnishings were several easels, a ladder, a small stove hardly adequate protection against severe cold, as well as several of his own studies and a poster by Chéret. A corner of this studio, with studies, *La Grande Jatte*, the stove, and a red bench, appears in the canvas *The Models* painted in 1887.

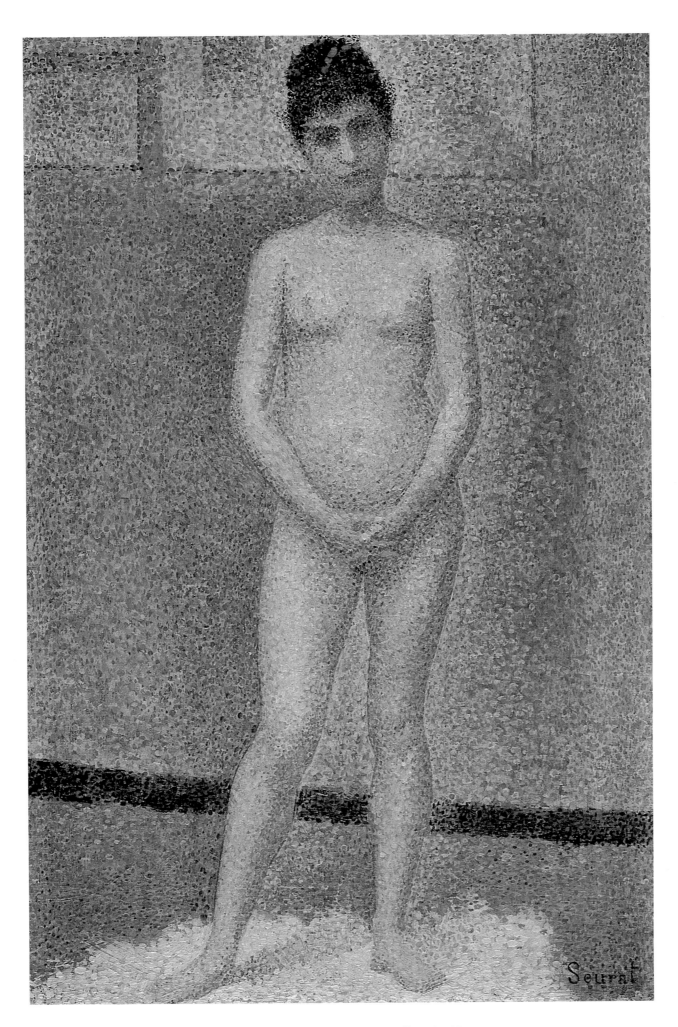

Model Standing (study for "The Models"). 1886–87

Artists' Quarrels

eticent and distrustful, Seurat fiercely avoided opening up, even to his comrades.[1] His letters to Signac, for example, are written in a style that is almost telegraphic. They relate facts, give certain news, and speak as little as possible of painting. "A quiet time," he announced to his friend, "no one in the streets in the evening (province). Slightly depressed. From August 22 to September 18, twenty-eight days. Dubois-Pillet very annoyed, may be reassigned. Serious. That's life."

On June 25, 1886, he wrote from Honfleur: "It has been fine here for the last five days. I hope to begin serious work soon. So far I've only made sketches to acclimate myself. If you find Les Andelys colorful, for me the Seine appears a

Model Standing (study for "The Models"). 1888

147

gray, almost nondescript sea, even under the strongest sun and a blue sky, at least during the last few days." A little later he took up his pen to say: "Nothing very interesting, am just keeping the home fires burning. . . . Have received only two letters. . . . The wind, and therefore the clouds, have inconvenienced me these past days. The steadiness of the first days should be returning. . . . Are your studies going well? Are there many? I do not doubt it. No need for you to answer. And then, what more to say? Well, that's all for today. Let's go out and get drunk on sunlight, it consoles me."

At the end of his summer in the country, he announced laconically: "Only six canvases; four of 25, one of 15, one of 10.[2] One considered as finished, the motif having been destroyed a long time ago (boats in a corner of the inlet). Two others worked up but still not satisfactory (beaches). A size 10 canvas, an overcast day, still needs work (end of jetty). The rest, a canvas of 25 and one of 15, are only roughed out. That's all I was able to do." On another occasion, referring to his work, he wrote: "Hopeless gesso-coated canvas. Don't understand anything anymore. All blobs—tiresome work."

Seurat did not speak much about his friends in his letters. "Lucien [Pissarro] makes chromos in the rue du Cherche-midi (tough luck)."[3] Or he mentioned that Dubois-Pillet "frequently meets Guillaumin on the embankment (courtesies)." His relations with Guillaumin, a friend of both Pissarro and Signac, were rather strained. "Guillaumin harbors a slight aversion toward me. . . . The other day at Vetzels' he lambasted Fénéon (article) because he chose to speak of Dubois-Pillet and perceive him at the avant-garde of impressionism. Having read badly, Guillaumin said to me, 'Dubois-Pillet is no more at the avant-garde *than you or Signac.*' Anxious to keep my mouth shut, I dove into a magazine article. It would seem that rank is established according to age. Guillaumin was evidently egged on by Gauguin. . . ."

Seurat's bitterness toward the older generation of Impressionists was great. He resented the "devil-may-care impertinence" of Degas, as Signac put it, and the coldness of Monet. He was irritated especially by the fact that Gauguin and Guillaumin treated him with a certain condescension, the more so as he considered them only more-or-less skillful imitators of the real Impressionists.

Pissarro remained the only one of the "old school" to join the scientific Impressionists, but his efforts to rally his erstwhile pupils Gauguin and Guillaumin had been in vain. "I am not surprised that Guillaumin and Gauguin no longer follow you to the Indépendants," Pissarro wrote Signac in August 1886.

It seems that Gauguin is much less embarrassed at this moment. . . . I hope that with success he will be less sectarian. . . . Nothing calms superheated personalities like a good business deal! As to my old friend Guillaumin, I am sorry for him. He sees intrigue in our struggle. That is absurd. We do not need this. We have only to present ourselves with our optical mixture for the crowd to bark or for sympathies to flow to us.

Seurat himself began to grow weary of seeing each of his works become the center of discussions that quickly deteriorated into an exchange of reproaches and suspicions, arguments running aground in seas of prejudice or complacency. On the other hand, he watched with some anxiety as the circle of his friends swelled with new converts, and he observed, not without regret, the efforts made by these recruits to appropriate his theories and his technique. When Seurat wanted to stop exhibiting so that no one could copy him, Pissarro wrote to his son Lucien in February 1887: "His caution is so great. But we, or rather I, can see no disadvantages in it, since I consider nothing *secret* in painting beyond the artist's own artistic personality, which is not easily swiped!!!"[4]

The question of caution naturally became even more delicate when it involved explanation of the new theory to friendly critics, who at times ran up against Seurat's total silence. In April 1887, Pissarro wrote to Signac:

For a moment I was a bit embarrassed by M. Félix Fénéon's request for information on our working methods and some observations on the analyses of color. It isn't easy—not wanting to draw the curtain of mystery too far aside on the one hand, and, on the other, not being able to refuse M. Fénéon, who has been such a friend to us. I wanted to say only what the public could understand. I was terribly inadequate. I even believe that my observations did not arrive in time for correction at the printer. . . . What I regret most (I was late in answering) is the advice I gave him to generalize as much as possible about the artist's personality, except for one thing that I thought it necessary to emphasize, and that was not to fail to give first place to Seurat when it came to designating the initiator of the scientific movement.[5]

Nevertheless, Fénéon's article did not truly displease Pissarro, for he only encountered, with his habitual modesty, "too many bouquets for the doyen who, in fact, did but follow." In all his letters and actions there is an almost touching desire to avoid offending Seurat. Thus, on June 16, 1887, he wrote to Signac:

Yesterday I visited Seurat's studio. His large canvas [*The Models*] is progressing. It is already of a lovely harmony. It is evidently going to be a very beautiful thing, but what will be very surprising is the

execution of the frame. I have seen a beginning of it. It is obviously unavoidable, my dear Signac. We shall be obliged to do likewise. The painting is not at all the same with white or anything else around it. One has absolutely no idea of the sun or gray weather except through this indispensable complement. I am going to try it out myself. Of course, I shall exhibit the result only after our friend Seurat has established the priority of his idea, as is only fair!

But, despite all these precautions, Seurat's sensitivity was never entirely appeased. He knew well enough how to keep silent when it was convenient, but he forgot nothing. Perhaps he was rancorous in spite of himself, for he was meticulous to a fault, and nothing that interested him escaped his attention or was erased from his memory. More than once his friends were astonished to see how difficult it was for him to forget the slightest injury. Aware of his sensitivity, they came close to fearing him, since even the most well-intentioned could not always avoid unfortunate incidents. In 1886, for example, a journalist had described Seurat as a "newcomer, a student of Pissarro." The young painter was never able to pardon this comment; even though he knew that Pissarro had had nothing to do with it, he set himself to demonstrating to the art critics in his circle that it was *he* who had been followed by Pissarro, a fact the older artist had always readily affirmed. But the results of this campaign would soon exceed its original aim.

On August 13, 1888, Arsène Alexandre published an article on the Neo-Impressionist movement in the journal *Paris* in which he concluded that "a little bit of science does not do any harm to art," but that too much may. Having thus formulated his reservations, Alexandre stated:

The artists who use the small touch are brimming with convictions, and several have great talent. It is sufficient, for example, to cite the elder Pissarro, who rallied to the new school and still manages to do fine things; or else, Seurat, the true apostle of the lentil, the one who planted it, who watched it grow. Seurat, in sum, the man of prodigious efforts, who risks almost being deprived of the paternity of the theory by misinformed critics or unscrupulous comrades.[6]

Signac naturally became incensed at this last remark, which, as he wrote Pissarro, "questions our honesty and which I cannot let pass. I am writing to Seurat to ask whether it was he who suggested this phrase to Arsène. . . . I expect a *frank* reply. In any case, you will have to admit that if Seurat had not wept like a coward on Alexandre's shoulder, that man would know nothing of our excellent comrade's petty jealousies."

Seurat's reply was not long in coming. It is dated Sunday, August 26, 1888:

Interior of the Artist's Studio (study for "The Models"). 1886–87

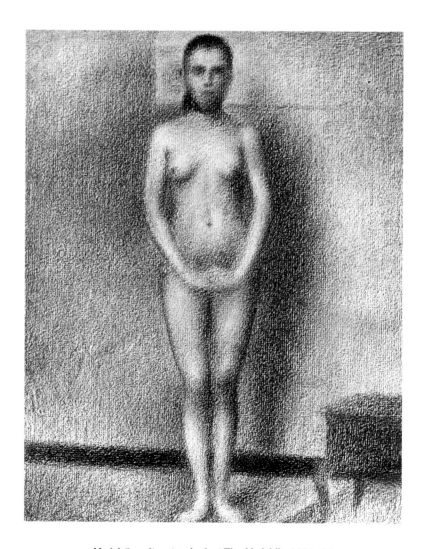

Still Life with Hat, Umbrella, and Clothes on a Chair (study for "The Models"). 1886–87

Model Standing (study for "The Models"). 1886–87

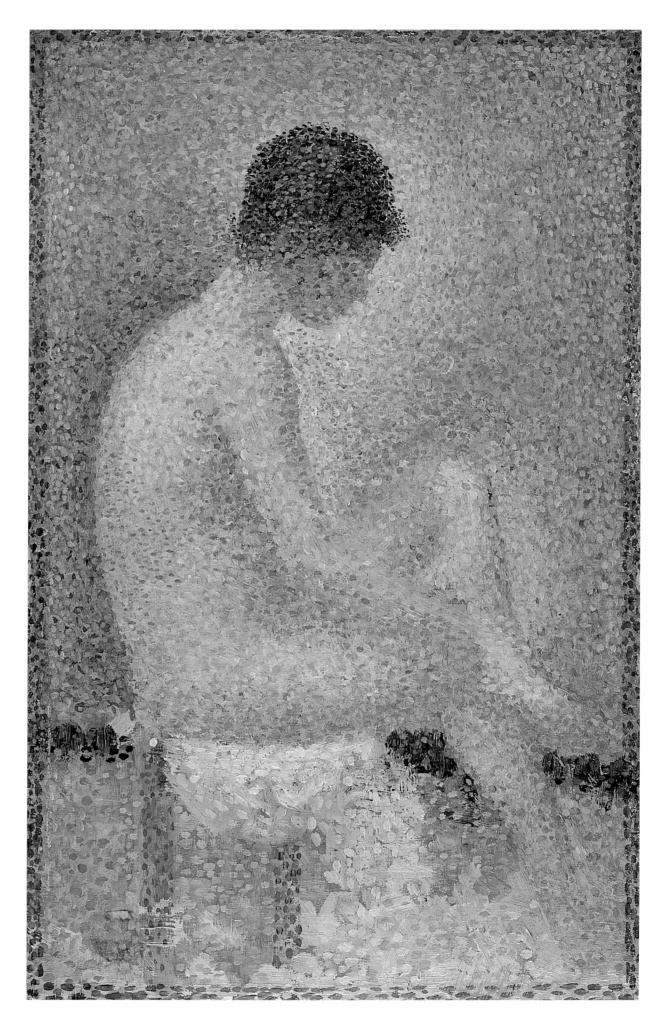

Seated Model in Profile (study for "The Models"). 1886–87

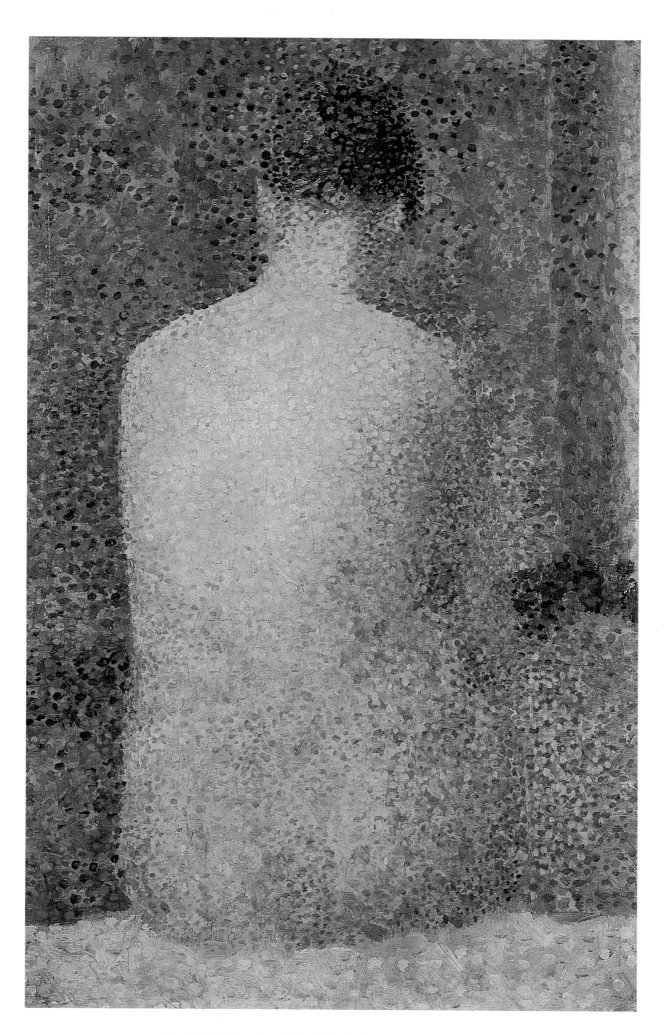

Seated Model Seen from the Back (study for "The Models"). 1886–87

My dear Signac,

I know nothing of that article except the phrase quoted in your letter. Had M. Alexandre told me, "I am going to write this," I should have replied, "But you are going to offend either Signac or Pissarro, or Angrand, or Dubois." I do not want to offend anyone. I have never told him anything but what I have always thought: the more of us there are, the less originality we shall have, and when everyone practices this technique it will no longer have any value and one will look for something new, as is already happening.

It is my right to think this and to say it, since I paint in this way only in order to find something new, an art entirely my own.

That is all I may have told him. As for the beginning of the phrase, that must refer to an article in *Le Matin* in which I was treated as a student of Pissarro. . . . That I do not permit, since it is false. I must have indicated that to him.

This is a regrettable business for which I am not responsible. M. Alexandre came to me more than a year ago. I exhibited with you in a special room, which I should not have done if I had the thoughts about my comrades that you attribute to me.

I do not look at personalities, but at facts.

Cordially,
Seurat

In the margin of the letter are the words, "Anyway, I do not talk much." On a scrap of paper attached to the letter: "I have never (a) called anyone 'unscrupulous comrade.' (b) I still consider Fénéon's pamphlet as the exposition of my ideas on painting."[7]

Seurat's explanation did not immediately succeed in calming Signac's indignation, but Pissarro judged the incident more philosophically:

Really, if Seurat is the instigator of the article you bring to my attention, one might think that he has lost his mind. . . . Was it not enough to have taken the greatest precautions from the very beginning, with Fénéon, Durand-Ruel,[8] and everyone concerned with the new painting to leave to Seurat all the glory of having been the first in France to have the idea of applying science to painting? Today he wants to be the sole proprietor! . . . That's absurd! . . . But my dear Signac, we should give Seurat a patent if that flatters his pride. . . . In short, all of art is not in scientific theory. If Seurat had only that, I confess he would interest me only moderately. Is it not possible to create masterpieces with black and white alone? And you, my dear Signac, do you think that this is the basis of your talent? Fortunately not. Then do not let yourself be influenced by these barkers. Be calm, quietly continue your work and let the jealous ones howl. You have what it takes to make art. . . .

But this is disturbing from another point of view. For the future of our "impressionist" art it is essential that we keep aloof from the

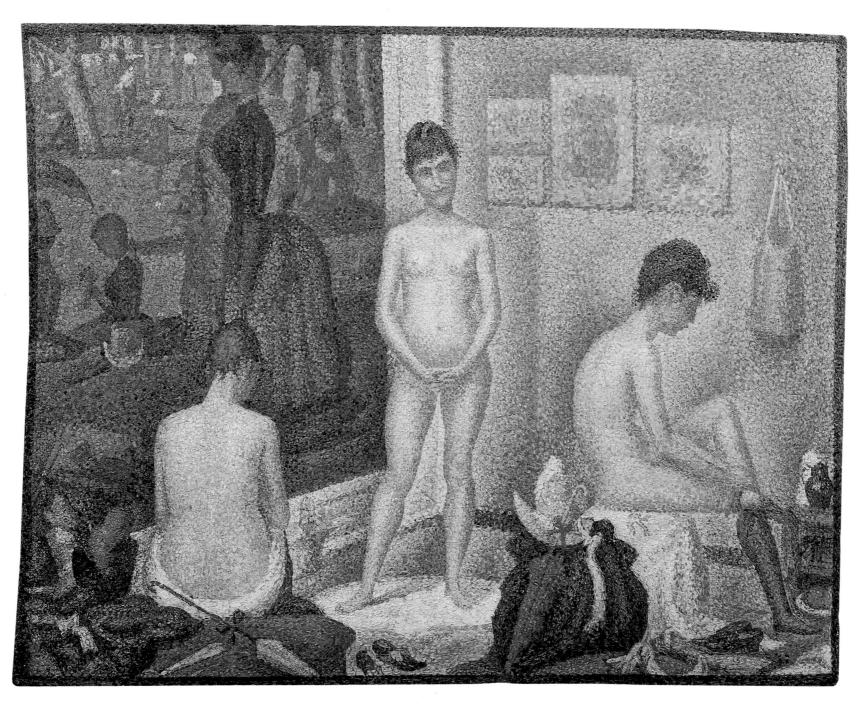

The Models (small version). 1888

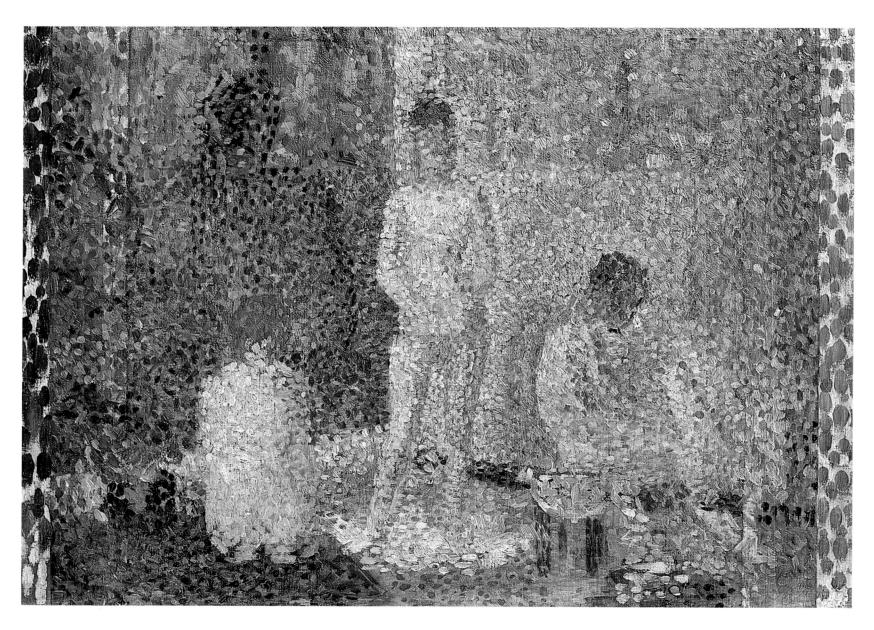

Complete Study for "The Models." 1886–87

Ecole [des Beaux-Arts] influence of Seurat. You yourself have foreseen it. *Seurat is of the Ecole des Beaux-Arts*, he is impregnated with it. . . . Let us be careful then for there is the danger. This is not a question of technique or science, it is a question of our tradition; we must safeguard it.

Thus, apply the science that belongs to everyone, but keep for yourself the gift you have, to feel as an *artist of a free race*, and let Seurat resolve the problems that evidently have their usefulness. That will be his lot. But to create is something higher!

These disagreements and grudges were nevertheless quickly forgotten by the friends as soon as Seurat showed them his new works. If they were sometimes wounded by his manner, they remained faithful in their admiration of his art. Before Seurat's canvases Pissarro and Signac in particular always regained their respect for the man whose unyielding rigidity perhaps concealed a singular timidity that manifested itself as pride. They forgave, or better still, understood, and could not deny Seurat their affection for very long. But other members of the small Neo-Impressionist group could not always rise above questions of self-esteem. While they struggled with the rigors of Seurat's method, they suffered from the scorn he showed for those who followed him without making an original contribution; instead of being sustained by his advice, in the end they felt themselves surrounded by a barely veiled hostility. It was thus that Louis Hayet, the young friend of Lucien Pissarro, wrote early in 1890 to Signac:

When I found myself becoming involved with the [neo] impressionist movement I thought I saw a group of intelligent people assisting each other in their research, with no other ambition: pure art, and I believed in that for five years. One day, vexations followed vexations and made me think. I thought about the past and about this group that I had taken for a select band of seekers. I saw it divided into two camps, one seeking, the other debating and sowing discord (perhaps unintentionally), with but one goal in mind, the steeplechase. . . . And these reflections made me lose all confidence. Unable to live in doubt and unwilling to suffer eternal torment, I decided to isolate myself.

In the midst of these quarrels, controversies, and misunderstandings, Seurat seemed unshakable. But if he refused to modify his attitude, he nevertheless came to understand that it was his duty to formulate his ideas clearly. Pissarro was right; there were no secrets in art. It would be best if he himself were to provide the necessary clarifications and establish once and for all his uncontestable priority. Thus, in the summer of 1890, after reflecting at great length and drawing up several drafts, Seurat set down on paper the principles of his aesthetic.

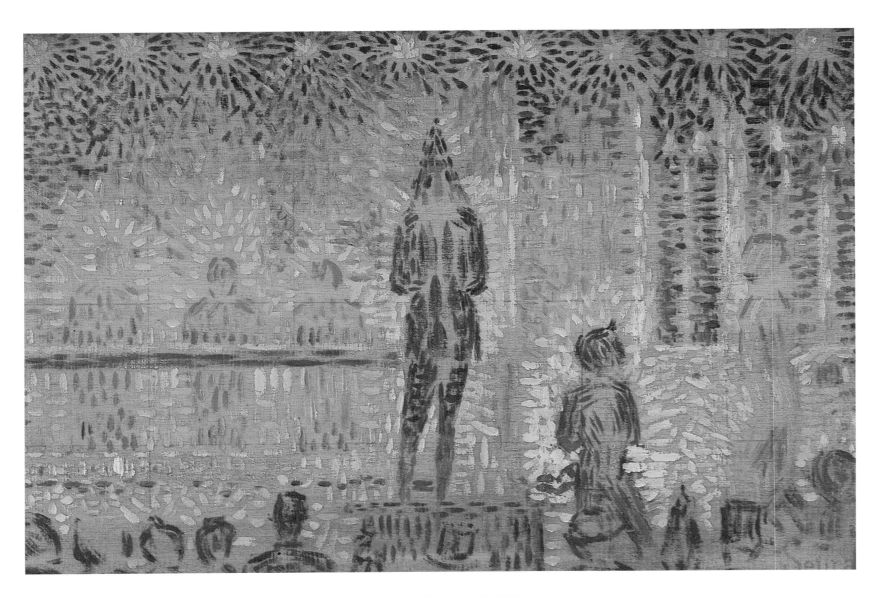

Study for "The Sideshow". 1887

Seurat's Theories

In a conversation with Gustave Kahn, Seurat defined painting as "the art of hollowing out a surface." At the same time he explained that while a science of aesthetics could not be the sole basis of painting, since there were personal elements in art, even of technique, which only the painter himself could recognize and deal with, he was nevertheless convinced of the absolute need to base his theories on scientific truths.[1]

While Seurat the painter cannot be separated from Seurat the investigator, certain of his statements may be considered as emanating from the one rather than the other. It was Seurat the painter who declared that he could paint only what he saw, who asserted that drawing was the fundamental element of painting and that harmony of color flowed from harmony of line. But it was Seurat the investigator who sought to establish the laws of color and the expressive potential of line.

For Seurat the theorist the art of hollowing out a surface became a science that he studied in scholarly writings and sought to apply in his paintings. During the years that followed the completion of *La Grande Jatte* he systematically attacked all the themes of painting. Only still lifes are absent from his work, and even these can be found in sections of his large canvases. Having studied the movements of people out of doors in *La Grande Jatte* and in landscapes that depicted nature in repose, Seurat addressed, in turn, passive nudes in the studio (*The Models*); the portrait (*Young Woman Powdering Herself*); active figures out of doors under artificial light (*The Sideshow*), and active figures indoors under artificial light (*La*

Chahut and *The Circus*). Animation is suffused with ennui or joy (there is no sadness in Seurat's paintings) and is governed by strict rules, by the play of line and color whose laws Seurat studied at length. Without yielding in any way to the literary or the picturesque, in these canvases Seurat rehabilitated the subject, which had been abandoned by the Impressionists. The words Fénéon used to describe Signac's works, "exemplary specimens of a highly developed decorative art that sacrifices anecdote to arabesque, classification to synthesis, the fugitive to the permanent, and confers on nature—weary at least of her precarious reality—an authentic reality"[2] could as easily

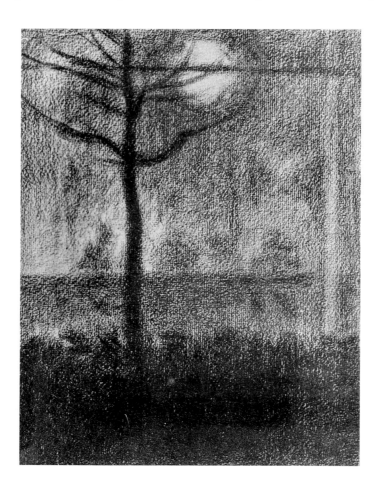

Tree (study for "The Sideshow"). 1887–88

have served as a characterization of Seurat's achievement.

If Seurat never let himself be caught in the "charming traps" set by nature, if he had the strength to renounce all details for the sake of a grand simplicity, it was because cold reason, prompted by a lack of imagination, thrust him toward the essential. "When they want to feel in a certain way," Paul Adam observed, "they modify nature according to their will."[3] This will—sometimes literary with Gauguin, turned mainly toward observation of the motif with Cézanne—was directed with Seurat toward line and ornament enlivened by tints and tones. As Signac said, "It is by the harmony of lines and

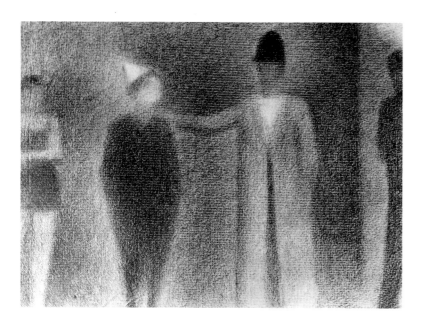

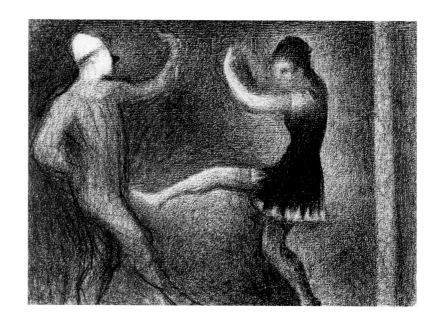

Couple Dancing. c. 1889

Circus Scene (study for "The Sideshow"). c. 1887

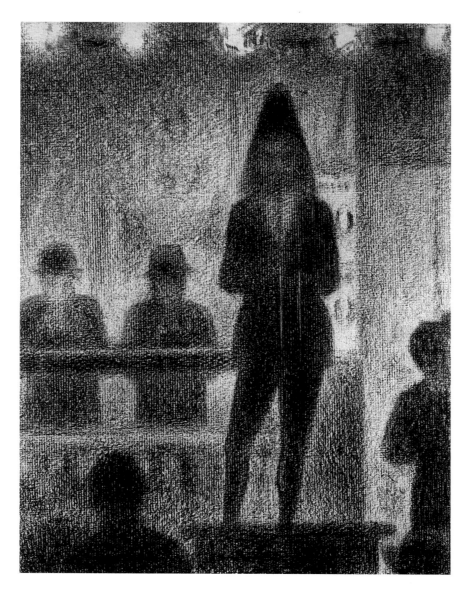

Trombone Player (study for "The Sideshow"). 1887–88

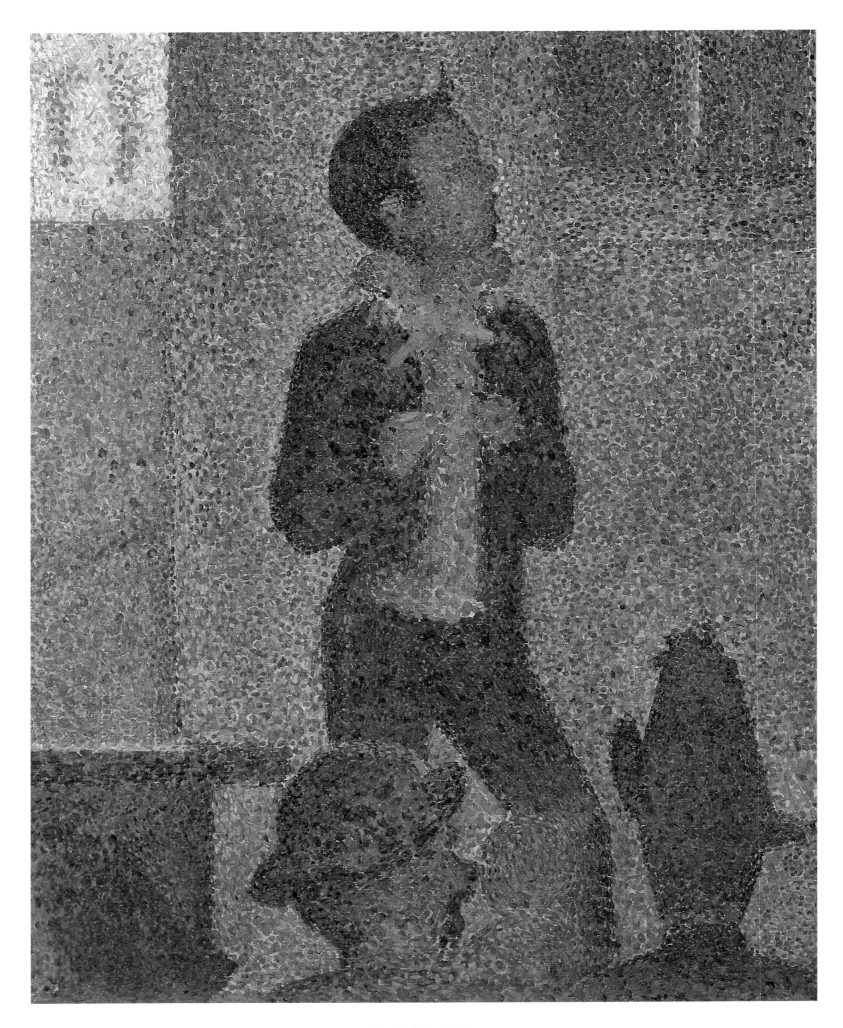

Detail of *The Sideshow*

colors that he can manipulate according to his needs and will, and not by his subject, that the painter is affective."[4]

While Gauguin declared with disdain, "In art we have come to a period of aberration brought about by physics, chemistry, mechanics, and the study of nature,"[5] and Cézanne complained that "the ignorance of harmony is revealed more and more in the discordance of the coloring and, what is even worse, by the deadness of tone,"[6] Seurat continued to work for a rebirth of order through science. He studied O. N. Rood's *Modern Chromatics, with Applications to Art and Industry;*[7] he plunged into the researches of Charles Henry[8] (with whom Signac collaborated for a time); he collected David Sutter's six articles on the phenomena of vision, which appeared in the review *L'Art* in 1880.[9]

Sutter's work interested Seurat as much for the laws revealed by his research, set down in a series of 167 rules, as for the general conclusion elucidated by their author. Indeed, Sutter's point of departure was a principle dear to Seurat:

One must look at nature with the eyes of the mind and not merely with the eyes of the body, like beings without reason. . . . There are colorists' eyes just as there are tenor voices, but these gifts of nature have to be stimulated by science to develop to the full. . . . Despite their absolute character, rules do not hamper the spontaneity of invention or execution. Science delivers us from every form of uncertainty and enables us to move freely within a wide circle; it would be an injury both to art and science to believe that one necessarily excludes the other. Since all rules are derived from the laws of nature, nothing is easier to learn or more necessary to know. In art everything should be willed.[10]

Seurat also found in Sutter's writings the answer to a problem that had long been preoccupying him: the relation between the laws of optics and of music. Many times he had asked his friends whether they thought that the innovations in painting had any technical similarity to, or at least any intuitive kinship with, the art of Wagner, for example.[11] Sutter's categorical assertion that "the laws of aesthetic harmony of colors are taught as the rules of musical harmony are taught",[12] could not but confirm his own convictions.

The 167 rules formulated by Sutter contained many propositions, or rather precepts, that confirmed the results of Seurat's own investigations. Among Sutter's declarations one finds:

V. Perspective is the primary element in the composition of a painting; for the gradation of light and color is in direct proportion to the perspective gradation of lines.

XIV. The unity of a picture is composed of the unity of aesthetic

Detail of *The Sideshow*

Detail of *The Sideshow*

lines, masses, disjunctions, chiaroscuro, colors, and the moral character of the subject.

XXVIII. There are two characteristic dispositions for a subject: vertical and horizontal.

XXXIX. The mass of light must be either more or less than the mass of shadow.

XL. Mass appears to be greater to the degree that it includes fewer small details.

XLIX. A plane is most luminous when light falls on it in a sharp perpendicular.

L. The more intense the light, the greater the reflection of the shadows.

LXXIII. The dominant color of the picture should be supported by analogous tones that constitute the unity of colors.

LXXIV. The complementary colors—red and green, orange and blue, yellow and violet—have the property of producing white light.

LXXVIII. There are three warm colors: red, orange, yellow.

LXXIX. There are three cold colors: green, blue, violet.

LXXX. When the light is warm, the shadows are cold.

LXXXI. When the light is cold, the shadows are warm.

LXXXIX. The intensity of reflections is in direct proportion to the quantity of light.

XC. A color is always modified by the proximity of another color.

CXXIV. The best ordered form is that which most completely captivates the intelligence.

CLXVII. Science can be learned, sentiment can be improved, genius comes from God.[13]

And he concluded that "instinct does not change, but reason progresses without pause, and man takes advantage of his own experience of others. Reason is one of the most beautiful faculties of the human mind, and he who does not passionately seek to extend his knowledge by that fact alone renounces his greatest privilege."[14]

Far from renouncing this privilege, Seurat resolved, after examining his own experience and that of others, to sum up in clear formulas the principles that inspired his work. He expressed himself not as a painter but as a scholar. That Seurat had perused the scientific works of Chevreul and Sutter is betrayed by the impeccable logic and precision with which he set down his artistic theories. Having revealed his jealousy of his work and ideas, he now seemed to feel a certain satisfaction in an unambiguous formulation of the laws of his aesthetic and technique. He was only too willing to explain these rules to his friends Maurice Beaubourg and Jules Christophe. It was in a letter to the former dated August 28 1890, that Seurat gave a complete exposition of his theories:[15]

Aesthetic

Art is Harmony

Harmony is the analogy of opposites, the analogy of similar elements of *tone*, *color*, and *line*, considered according to their dominants and under the influence of light, in gay, calm, or sad combinations.

The opposites are:

For tone, a more $\begin{cases} \text{luminous} \\ \text{lighter} \end{cases}$ shade against a darker.

For color, the complementaries, i.e., a certain red opposed to its complementary, etc. red—green

orange—blue

yellow—violet

For line, those forming a right angle.

Gaiety of tone is given by the luminous dominant; of *color*, by the warm dominant; of *line*, by lines above the horizontal

Calm of tone is the equality of dark and light; of color, [equality] of warm and cool; and the horizontal for the line.

Sadness of tone is given by the dominance of dark; of color, by the dominance of cold; of line, by downward directions

Technique

Taking as given the phenomena of the duration of the impression of light on the retina

Synthesis follows as a result. The means of expression is the optical mixture of tones, and of colors (local color and the illuminating color—sun, oil lamp, gas lamp, etc.), that is to say, of light and their reactions (shadows) according to the laws of *contrast*, gradation of irradiation.

The frame is in harmonious contrast to the tones, colors, and lines of the picture.

In his studies for *La Grande Jatte* Seurat had begun to give more unity to his pictures by painting the edges of his canvases with a border of small touches of color. Clearly separated from the subject and varying according to the tints near them, these color spots softened the otherwise abrupt transition between the picture and the standard white frame. Toward the end of 1888, in order to suppress anything that might negate the carefully calculated harmonies in his paintings, he decided to paint the frame itself with the colors in the painting, which would thus be both prolonged and limited. Emile Verhaeren claims that Seurat, having "thought that at Bayreuth the hall was darkened in order to present the stage suffused with light as the single point of attention, this contrast of great light and shadow caused him to adopt dark frames, although now, as in the past, he observed the laws of complementaries."[16]

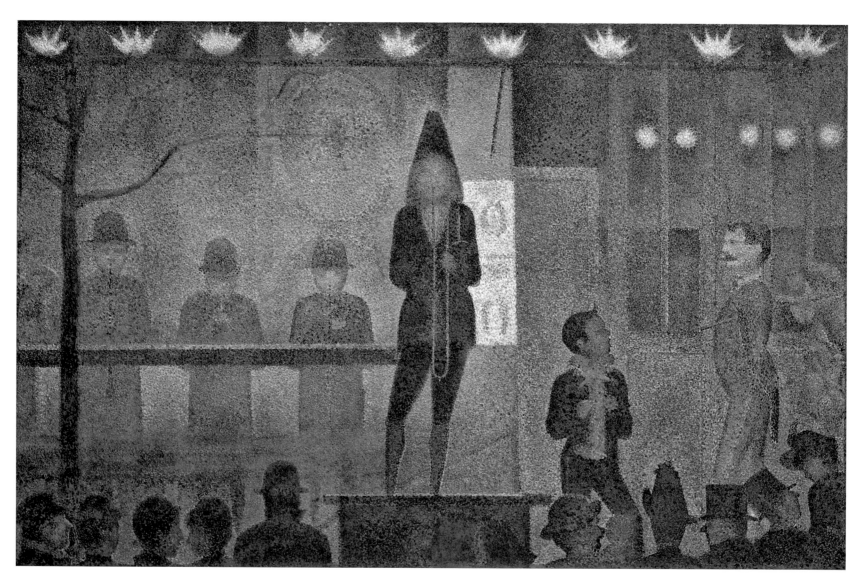

The Sideshow. 1887–88

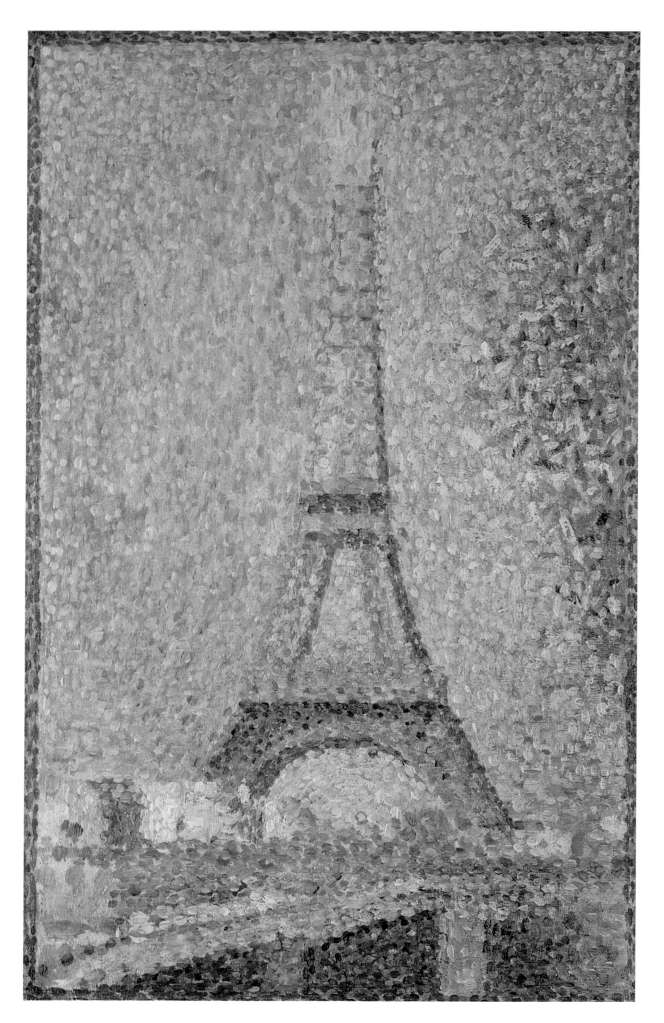

The Eiffel Tower. c. 1889

Commendation and Condemnation

Seurat's theories, which formed the basis of his work, were not allowed to pass unnoticed. His ideas were contested even by artists and writers who could not be characterized as reactionary, some of whom actually admired his talent. While they admitted being moved by his paintings, especially his landscapes, they continued to object to "the pernicious confusion of art and science," as Julien Leclercq, a friend of Gauguin, put it. They were disturbed by what they saw as a will to *prove* in Seurat's compositions, which was less apparent in his landscapes. It was not so much the absence of imagination in his work that baffled them as the presence of a cold will to exclude it. As early as 1886, a few months after the final exhibition of the Impressionist group, Emile Hennequin, in a long article devoted to Seurat in *La Vie Moderne*, noted:

His method is a device, as are all methods of painting, and on this score he should be judged solely on his ability to represent nature better than others have. But, oddly enough, for anyone not forewarned, the pictures of M. Seurat, like those of the artists who follow him, are almost entirely devoid of luminosity.

In total contrast to his detailed theories, the seascapes of M. Seurat excel precisely because they are gray; as for his *Grande Jatte*, however, in which figures are set in shadows cast by a full

sun, one can hardly imagine anything dustier or more lusterless. . . . [1] M. Seurat's failure at just the point where he should have surpassed himself shows clearly that aesthetics can expect little from abstract theorizing, that it has its own laws, which must be established by observation and not predicated on the basis of physical experiments.

The talent of M. Seurat and of his followers is not in question; but it cannot be said too often that one technique more or less contributes little to art, to the beauty of the works, that is, to their capacity to move. [2]

While Seurat could have answered this criticism by pointing out that the small size of the room in which *La Grande Jatte* had been exhibited prevented a full apprehension of its luminosity, an even more vehement attack by Joris-Karl Huysmans left less room for reply. In the spring of 1887 this famous critic reviewed the third exhibition of the Indépendants, in which Seurat showed eight paintings and a dozen drawings: [3]

Last year, in addition to *La Grande Jatte*, M. Seurat exhibited a number of truly beautiful seascapes, quiet seas under calm skies; these light, blond canvases suffused with a powdery film of light reveal a very personal yet very accurate approach to nature. . . .

The views of the sea he exhibits this year, views of Honfleur, especially his *Lighthouse*, affirm the very real talent of which he has already provided indisputable proof. These images still rely on the sensation they express, of a nature more apathetic than melancholy, a nature calmly at ease under peaceful skies, sheltered from the wind. . . . Strange indeed! This landscape painter, whose seascapes can induce an unending flow of reveries, becomes superficial and unimaginative when he introduces human figures; and it is at this point that the technique he employs—the trill of little dots, the mesh of tiny stitches, the mosaics of colored inlays—ensnares him. . . .

Strip his figures of the colored fleas that cover them, underneath there is nothing, no thought, no soul, nothing. Nothingness in a body that consists only of contours. Thus, in his painting *La Grande Jatte*, the human armature becomes rigid and hard; everything is immobilized and congealed. I very much fear that there have been too many methods, too many systems, and not enough sparks of fire, there is not enough of the fire that crackles! [4]

While the poet Huysmans condemned Seurat's technique because in his opinion it did not make up for the absence of spirituality, intellect, and ardor, the painters opposed to divisionism contented themselves with condemning the method out of hand, along with all methods. Gauguin, although himself partial to theories of color and symbols, spoke with scorn of the "little green chemists who pile up tiny dots"[5] and advised his friend Sérusier to avoid complementary colors—

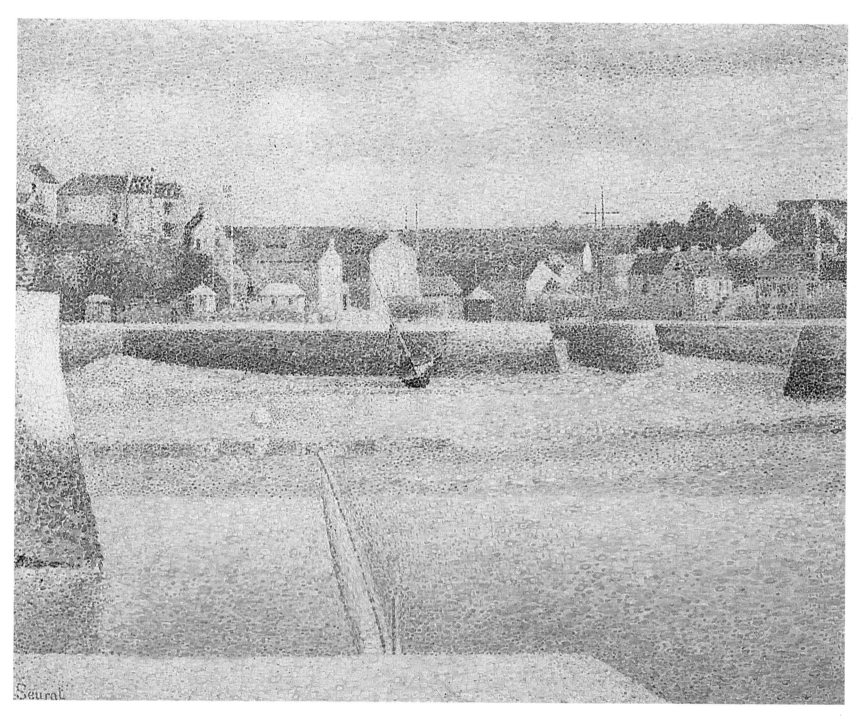

Port-en-Bessin: The Outer Harbor at Low Tide. 1888

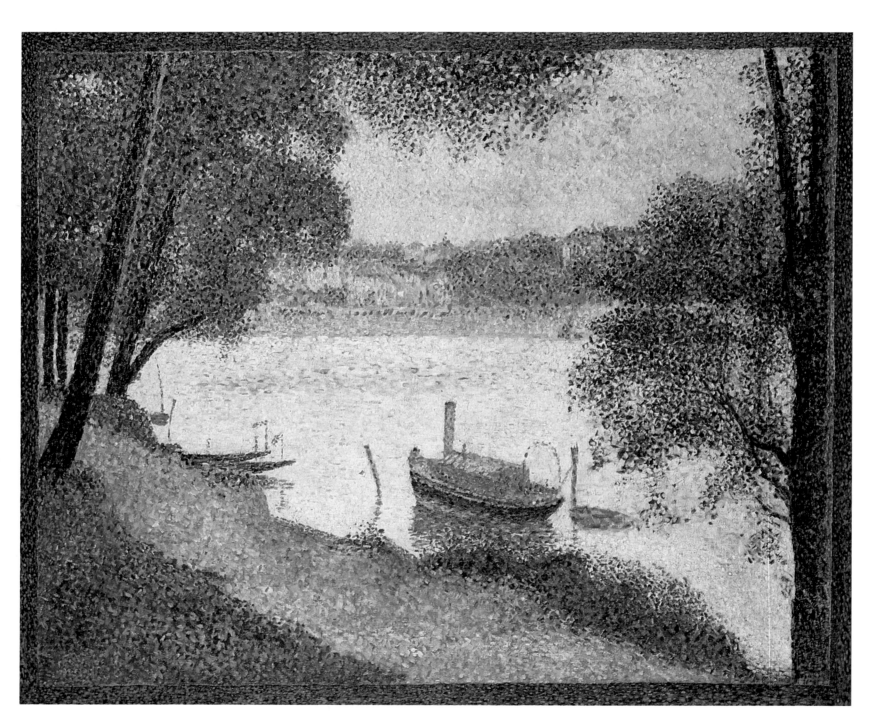

A Gray Day at the Grande Jatte. 1888

"they clash, they do not harmonize"—and even went so far as to say that Neo-Impressionism, since it was based on science, would "lead straight to color photography."[6]

Renoir, Monet, and Sisley, all of whom had refused to exhibit with Seurat in the 1886 exhibition of the Impressionists, took an equally firm stand against him. Their opposition was purely instinctive, for none of them had given any serious consideration to divisionist theories. In a conversation with Renoir, Pissarro was surprised to find that the latter based his aversion to these ideas on complete ignorance of them. Renoir made no bones about his disinclination to encumber himself with scientific explanations, since, in his view, "there is something extra in painting that cannot be explained, which is the essential. You approach nature with theories, nature knocks them to the ground. . . . The truth is that in painting, as in the other arts, there is no single method, no matter how unimportant, that can be fit into a formula."[7]

Monet, whom Fénéon accused of "brilliant vulgarity," also preferred to investigate nature without the intrusion of a theory he found obsessive. He maintained, "One cannot make pictures with doctrines. Methods change, but art remains the same."[8]

Sisley, for his part, replied with some heat to a critic who had used the word "pointillist" in connection with his use of small, comma-like strokes: "To say that a painter is a pointillist is not an evaluation but a statement of fact: pointillism is a method, one might almost say a mechanical method, so well known that it should be impossible to mistake it. As far as my work is concerned, the description is false."[9]

If Seurat seldom answered attacks of this kind, it was because Fénéon from the beginning had taken up the task of refuting them. As early as 1886 he had written of Seurat and his friends:

These painters are accused of subordinating art to science. They use scientific data only to direct and perfect the education of their eyes and to control the accuracy of their vision. . . . But Monsieur X could spend an eternity studying treatises on optics and he would never paint *La Grande Jatte*. . . . The truth is that the neo-impressionist method demands an exceptionally delicate eye: its dangerous strictness will frighten all the clever fellows who mask their visual incapacity beneath manual dexterity. This type of painting is accessible only to *painters*.[10]

But even so loyal a friend as Fénéon could not hide his disapproval when in 1888 at the Salon des Indépendants Seurat and Dubois-Pillet introduced colored frames. Fénéon

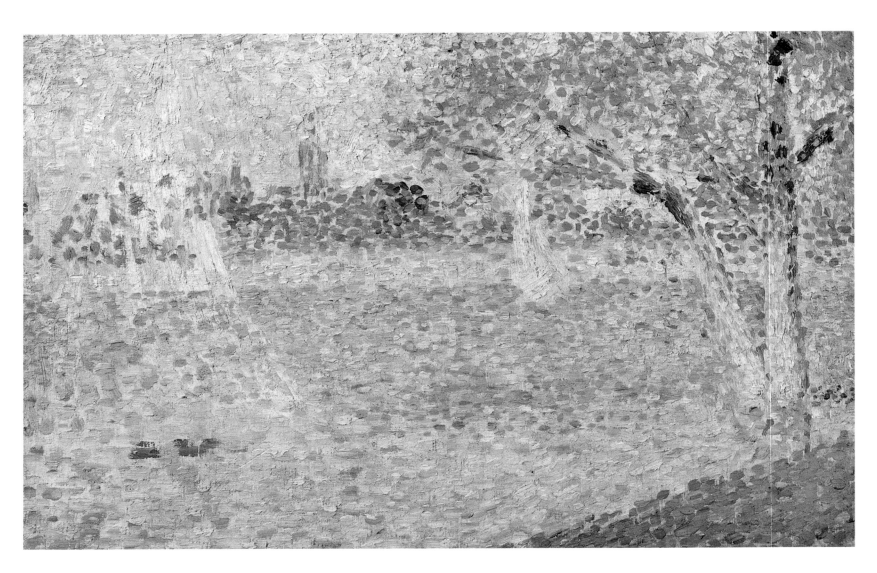

The Seine Seen from the Grande Jatte. 1888

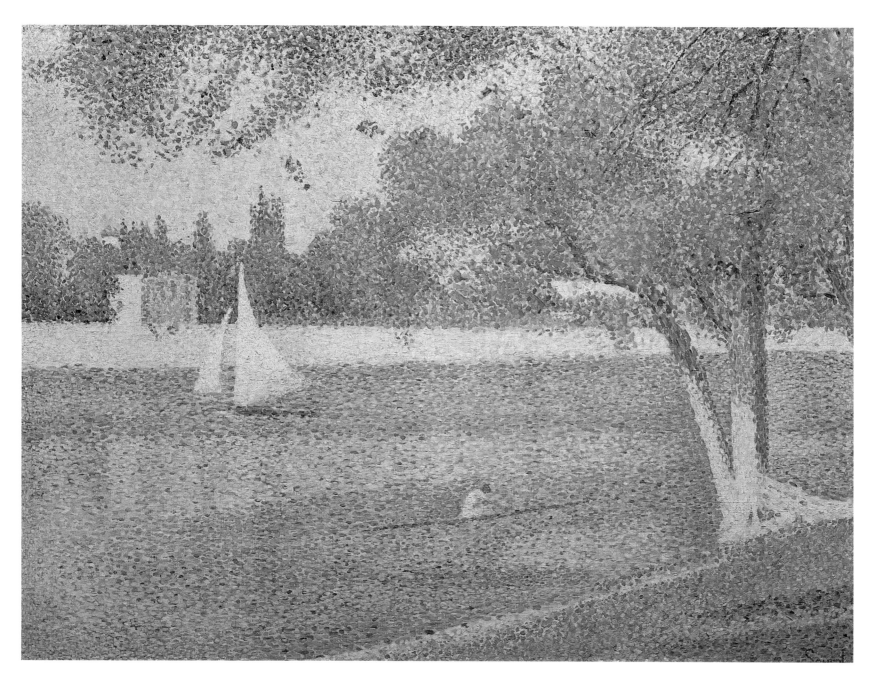

The Seine at the Grande Jatte. 1888

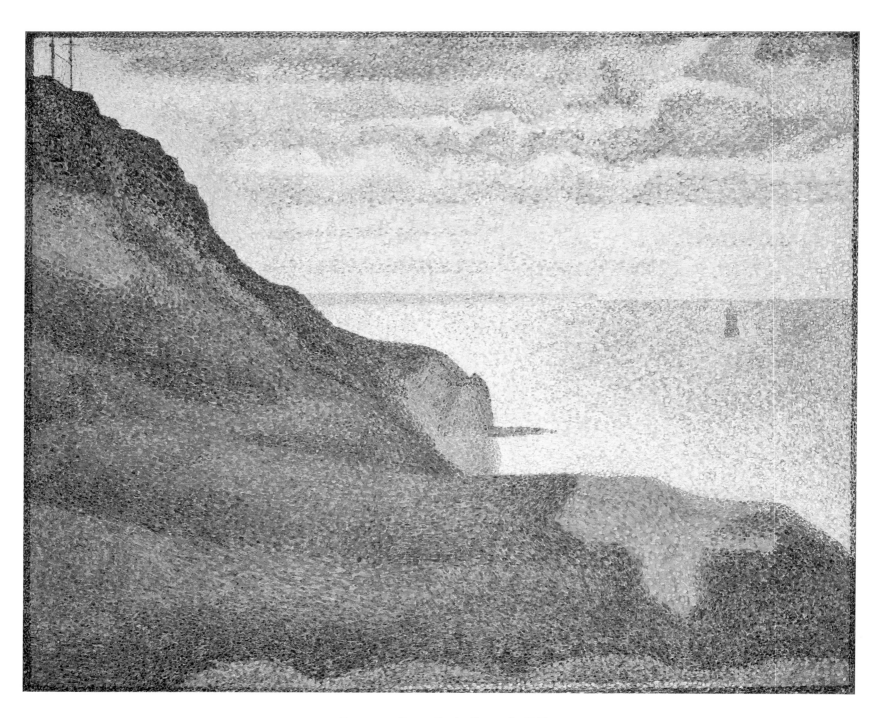

Seascape at Port-en-Bessin, Normandy. 1888

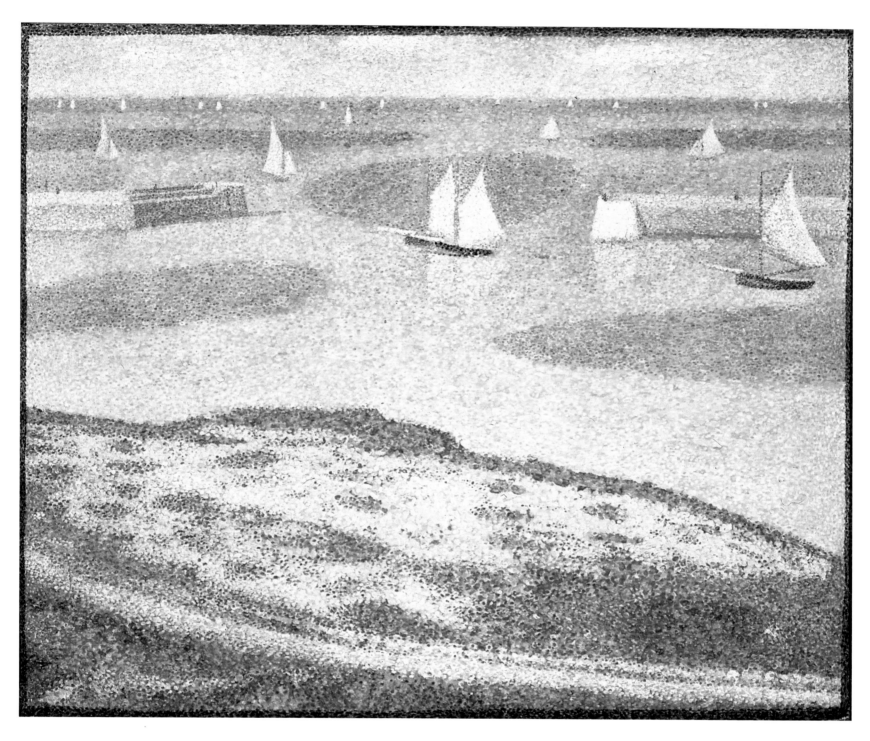

Port-en-Bessin: Entrance to the Harbor. 1888

was opposed to this innovation, which he made clear in his review of the exhibition:

The canvas [of Dubois-Pillet] is set in an oval frame decorated with bold variations in violet. The frame is no longer anonymous, it has its own identity. Is it painted to emphasize the picture, or vice versa? An uncomfortable question lurks in this rejuvenated polychromy of the less systematic, already outdated endeavors of Gauguin and Mary Cassatt. M. Seurat's essay is more legitimate, with reservations.

The advantages of the white frame are obvious. Also, M. Seurat, far from adopting the *painted* frame, simply indicates on his white frame the reflections of the adjacent colors. So far, so good. But at times the frame, just at the point where it is still philosophically *white* and *abstract*, is influenced by the painting. Seurat imagines the frame as surrounding the *actual* landscape and, complying with the logic of this pointless hypothesis, he punctuates it with orange or blue, according to whether the sun is behind or in front of the observer, that is, whether the frame is in light or shadow. And while the frame remains essentially white, it acquires—as in the system of M. Dubois-Pillet—an absurd reality. [11]

However, neither praise nor criticism had any effect on Seurat's incessant labor. "To look at life, to have sensations and arrange them, I believe that is enough for our joys as well as our torments," expressed an attitude he shared with his friend Henri-Edmond Cross. [12] Despite his elders' objections to his introduction of science into art, for him, as Verhaeren pointed out, his works were truly significant only insofar as they proved a law or concept, only insofar as they were a conquest of the unknown. [13]

While Seurat's landscapes were respected even by his adversaries, outright laughter, abuse, and stupidity were unleashed when he exhibited a large composition. To the objections of the critics who held that the stumbling block to his pointillist method would be the human figure, Seurat responded with his large canvases *The Models* and *The Sideshow.* He sent these paintings, the fruit of more than a year's work, to the Indépendants of 1888, at which for the first time he did not exhibit any landscapes. [14] *The Models* provoked the most malicious taunts. One could read this description in *L'Echo du Nord:* "A studio where three nude women, painted in the pointillist manner, expose pathetic, rachitic skeletons smeared with all the colors of the rainbow." [15]

And an American critic sent his newspaper this comment: "M. Seurat, a hardened offender, contributes ten startling compositions, the least incoherent of which is perhaps a trio of "Poseuses" innocent of raiment—unless a pair of stockings counts as raiment." [16]

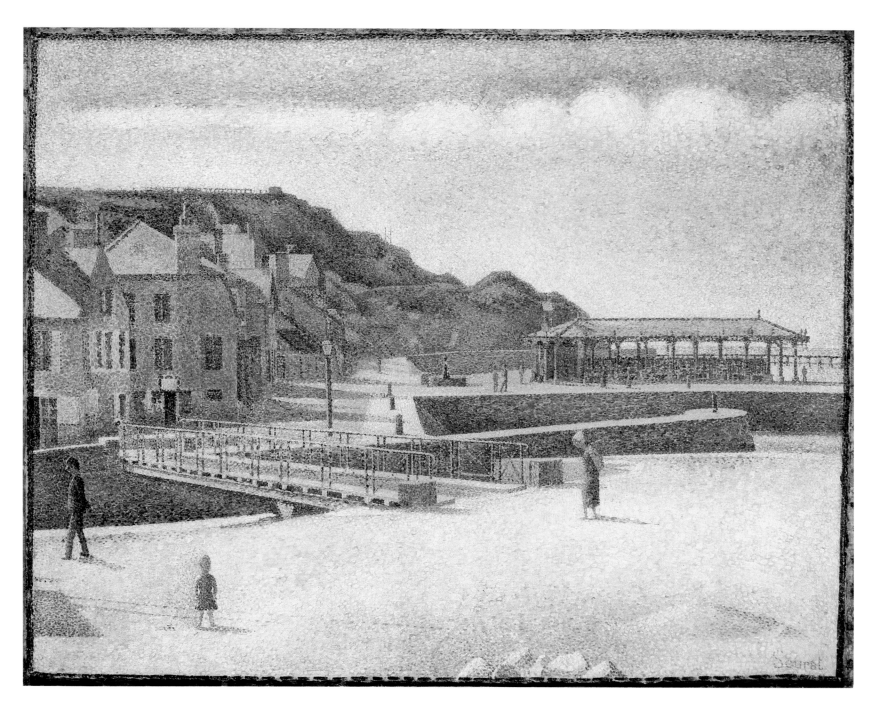

Port-en-Bessin. 1888

Detail of *Port-en-Bessin*

Detail of *Port-en-Bessin*

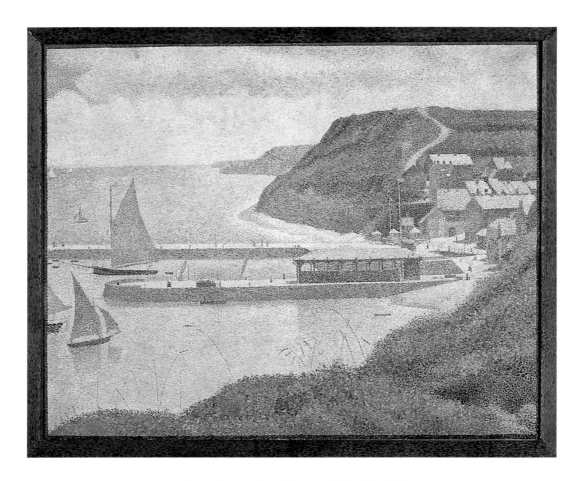

Port-en-Bessin, Outer Harbor at High Tide. 1888

Sunday at Port-en-Bessin. 1888

It was Paul Adam who undertook to defend Seurat's method. He wrote:

The Models achieves perfection. Three nude women, one standing, the other two seated at each side, before the gray wall of the studio, which is suddenly cut at an angle by *La Grande Jatte*, that much-discussed work. The figures in stiff Sunday attitudes are the same size as the models. One can be discovered there fully dressed on the arm of a superb gentleman; she passes through the deep perspective of the leafy island that extends the gray perspective of the studio. Here, beings in their natural simplicity, the enigmatic feminine smile on their lips, with elegant contours and the tiny breasts of adolescent girls, and the opalescent, soft skins. There, beings in holiday attire, stiff and tight-laced, solemn under the warm summer foliage, with gestures and poses that align them with Egyptians filing in pious procession on steles and sarcophagi.

The synthesis of these two worlds activated by the painter's art is expressed with sumptuous harmony of tones from which the three splendid female bodies shine. Their flesh retains its fullness, its tints flushed or pale, the shadows caught in the hollows of their form. Even more commanding than the science of flesh tones is the unity of structure, the unity of a precisely proportioned figure sheathed in its flesh. Although in repose, these lithe, agile, sleek women seem ready to live, to leap, to laugh, to desire.[17]

In 1889, when Seurat sent this canvas, along with eight landscapes and three drawings, to the exhibition of Les XX in Brussels,[18] his paintings were no longer the main targets of the ignorant public. Now it was the work of Gauguin—invited along with Pissarro, Luce, Cross, and Monet—that drew howls of laughter. Next to "the scientific Impressionism of Seurat, Gauguin represented barbarism, revolution, fever," Maurice Denis would later observe as he went on to explain that Gauguin's new formula no longer consisted of "*reproducing* nature and life by approximations or trompe l'oeil improvisations but, on the contrary, reproduced his emotions and his dreams by *representing* them by forms and harmonious colors."[19]

Despite the attention focused on Gauguin's work, Seurat's *Models* and one of his drawings found a prospective buyer. Octave Maus, president of Les XX, wrote the artist to determine the price of his canvas, to which Seurat replied in a letter dated February 17, 1889:

I should like to know the collector's name. I would be satisfied if you could get 60 francs for my drawing.

As for my *Models*, I am hard put to set a price. I calculate that it cost me 7 francs a day for one year; you see where that leads. To sum up, let me add that the personality of the collector might make up the difference between his price and mine.[20]

Despite these terms, the collector could not decide. Seurat returned to Brussels to appear at a banquet tendered by Les XX and brought back his large painting, for which, according to habit, he had executed a replica as well as some studies, among them three panels depicting each of the three models. All in all there were hardly more than a dozen such studies. After *La Grande Jatte* Seurat no longer made as many drawings and preparatory paintings for any of his works. Back in Paris, *The Models* dozed beside *La Grande Jatte* in Seurat's new studio on the passage de l'Elysée des Beaux-Arts, which would be his last.

Never again would new works by Seurat hang alongside new works by Pissarro. After this exhibition the old master deserted the small group of young friends, not, however, without explaining his reasons. And among all the artists who had voiced their disagreement with Seurat, it was perhaps Camille Pissarro, his earliest adherent, who expressed himself with the most severity. In 1887 Pissarro had already begun to soften the rigid execution of pointillist divisionism, without abandoning divisionism itself. However, he soon recognized and admitted with his usual frankness, that he had been deluding himself in following these young innovators, for his paintings no longer fully satisfied him.[21] For Pissarro, a theory was not good in *itself*, it was good if it enabled him to get results; the moment the results did not meet his needs, no scientific proof could keep him from abandoning the theory and seeking salvation elsewhere. "I believe," Pissarro later wrote Henri Van de Velde,

it is my duty to write you frankly and tell you how I [now] regard the experiment I made with systematic divisionism by following our friend Seurat. Having tried this theory for four years and having then abandoned it, not without painful and relentless efforts to regain what I had lost and not to lose what I had learned, I can no longer consider myself one of the neo-impressionists who abandon movement and life for a diametrically opposed aesthetic which is perhaps the right thing for the man who has the temperament for it, but which is not for me, anxious as I am to avoid all narrow and so-called scientific theories. Having found after many attempts (I speak for myself) that it was impossible to be true to my sensations and consequently to render life and movement, impossible to be faithful to the effects, so random and so admirable, of nature, impossible to give an individual character to my drawing, I had to let go. And none too soon! Fortunately it appears that I was not made for this art which gives me the impression of the monotony of death![22]

After a time, Pissarro would completely rework a good many of the paintings he had executed in Seurat's manner.

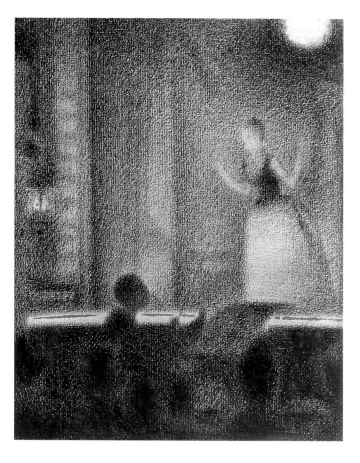

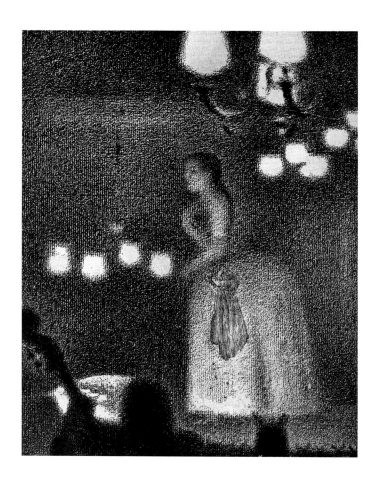

A Music Hall Artist. 1887–88

Eden Concert. 1887–88

Study for "Le Chahut." 1889–90

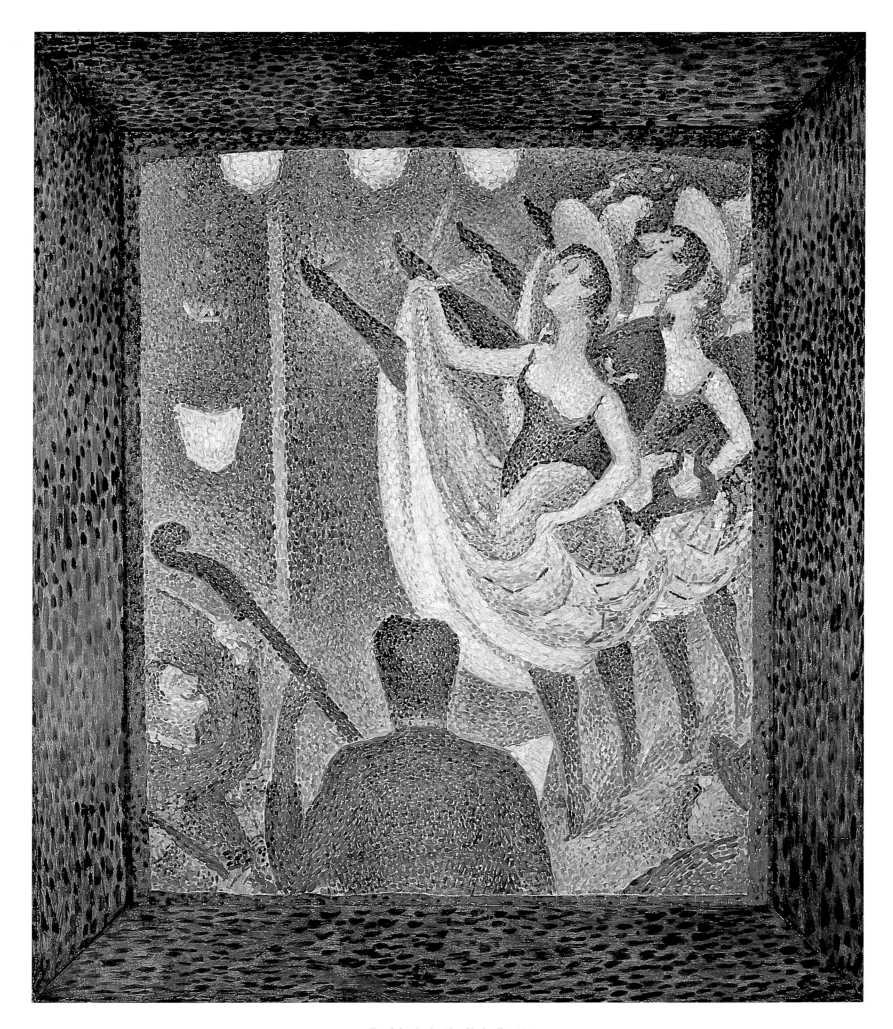

Final Study for "Le Chahut". 1889

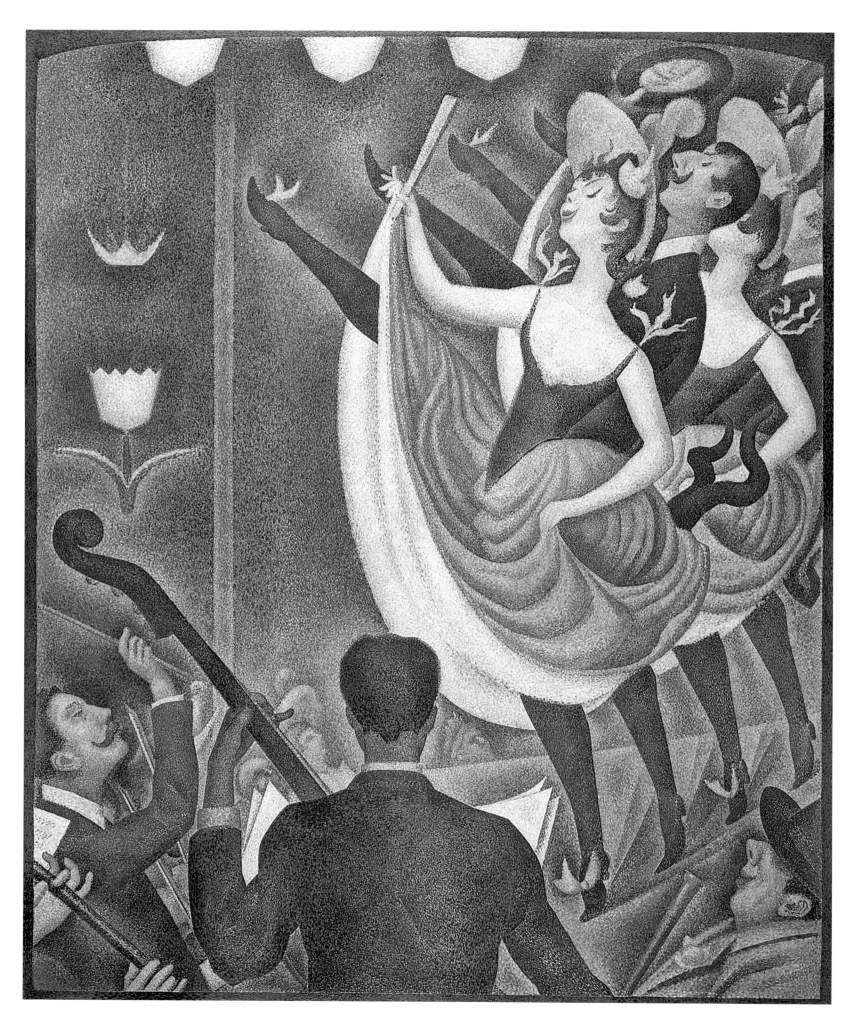

Le Chahut. 1889–90

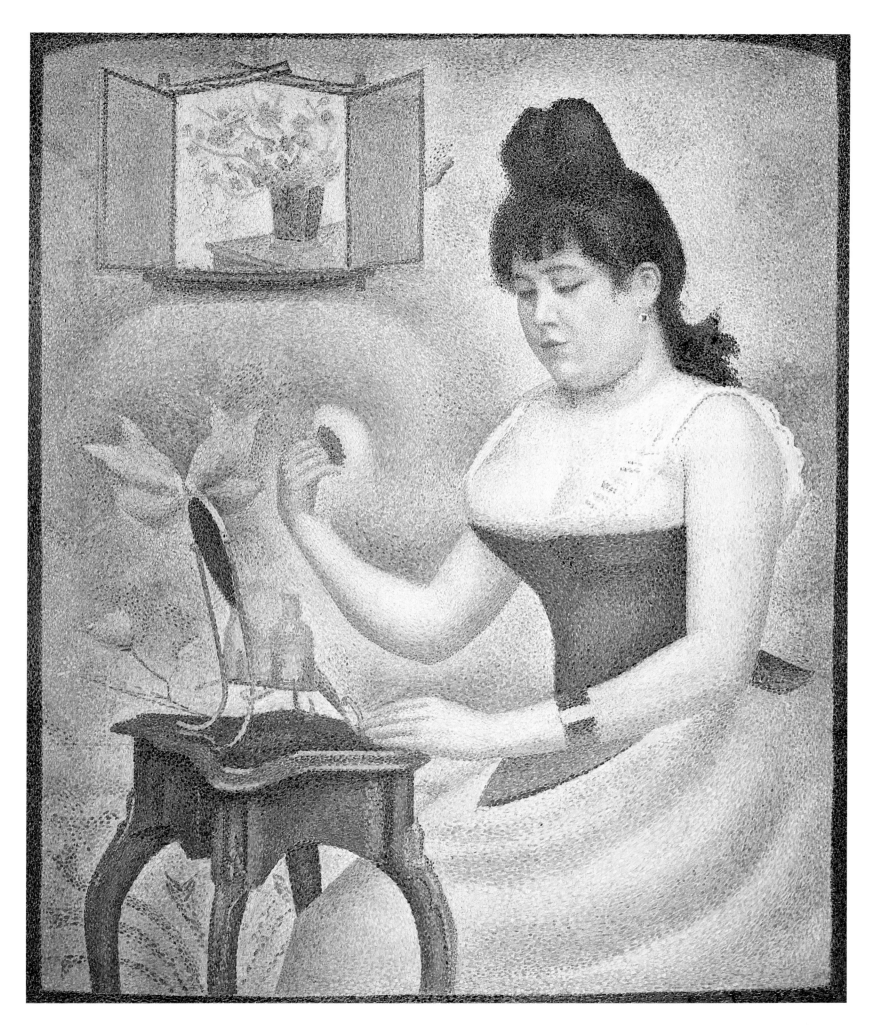

Young Woman Powdering Herself. 1890

The Last Works

I n the spring of 1889 Seurat left Paris for Le Crotoy to paint those seascapes that prompted his friend Charles Angrand to remark in a letter to Henri-Edmond Cross that Seurat was the first artist to render the feeling the sea inspires on a calm day. In the previous year Seurat had brought back from his stay at Port-en-Bessin several of those views of the sea that poets found poetical, painters admired for their unequaled mastery, and in which even hostile critics discovered a serene and moving beauty.

Seurat explained to Emile Verhaeren that scenic views were his summer's occupation, undertaken regularly each year at the seashore or just outside Paris, while each winter he completed a large canvas, a composition of much research and, if possible, of conquest. Verhaeren wanted to call these winter paintings "canvases with a thesis," but Seurat did not approve and insisted that during the summer his objective was simply "to wash the studio light from his eyes and transcribe most exactly the vivid outdoor clarity in all its nuances."[1]

Seurat's entries in the fall exhibition of the Indépendants were seascapes done at Port-en-Bessin and Le Crotoy during the summer.[2] Again Fénéon assumed the role of faithful spokesman for the painter, described the works, analyzed them, and formulated the artist's intentions, no doubt much as Seurat himself had expressed them. But this did not prevent the critic from expressing certain reservations:

M. Seurat knows very well that apart from its topographical role, a line has an abstract and measurable value. In each of his landscapes the forms are governed by one or two directions which are related to the dominant tints and with which the accessory lines are forced to contrast. In *Le Crotoy (Afternoon)* one notices a sandbar with corners that bend toward the shore and a cloud shaped like the head of a Medusa or a mushroom from which vertical strands descend against the horizontal in the background: these are essentially right-angle oppositions. It is just such contrasts that Jules Chéret favors and perhaps it is this that accounts for the effectiveness of his posters. Instinctively honest, the art of M. Seurat barely thinks of disguising this research, and the plausibility of the spectacles suffers from it. The cloud forms of *Le Crotoy (Morning)* are not very convincing. One should have preferred that the figures circulating on the quay of Port-en-Bessin were less stiff.

Then, turning to the subject of frames, Fénéon added:

These two Crotoy views are rimmed by a border painted on the canvas itself; such an arrangement prevents the strip of shadow that a relief would produce and allows the actual frame to be colored as the execution of the painting progresses. Theoretically, this frame is white, since only the complementaries projected by the neighboring colors are inscribed on it. Last year M. Seurat added still another element to these customary responses: blue or orange, according to whether the light fell on the landscape from the back toward the front or from the front toward the back. One can only praise him for having given up this practice which called attention to the frame.[3]

If Seurat's figures appeared stiff even to Fénéon, it is not surprising to find Camille Pissarro writing to his son Lucien in reference to this exhibition of the Indépendants: "At first view the neo-impressionists appeared to me to be sparse, mean, pale, particularly Seurat and Signac, but once the eye became acclimatized, this appeared to be less so, although there is a kind of stiffness that I find disagreeable."[4]

The accusation of "stiffness" was often directed at Seurat's large compositions, particularly *Young Woman Powdering Herself*, which he began in 1889. The woman in the painting is Madeleine Knobloch, Seurat's mistress, whose existence remained unknown even to his intimate friends until the artist's death. She is depicted as a young woman of generous proportions putting the finishing touches to her southern beauty at an old-fashioned dressing table. Her bearing and gesture confer on her that strange solemnity so often found in Seurat's work. Her plain undergarments underline the contrast between the dark bodice and the pale, soft skin, while the background lights up like a halo about her dark hair. Originally the painting showed Seurat's own head reflected in a mirror hanging on the wall—the only self-portrait the artist

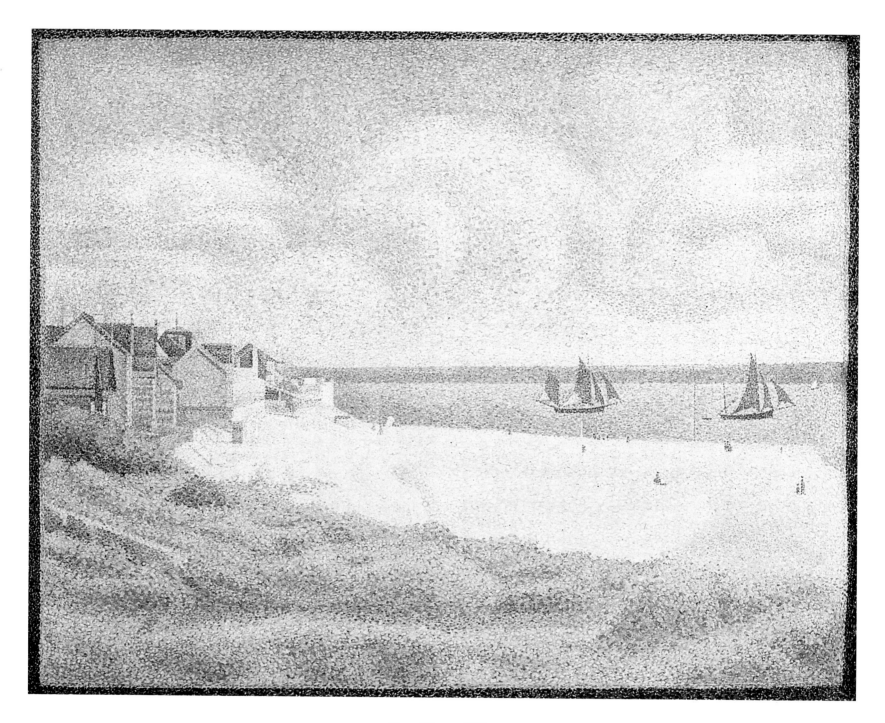

View of Crotoy. 1889

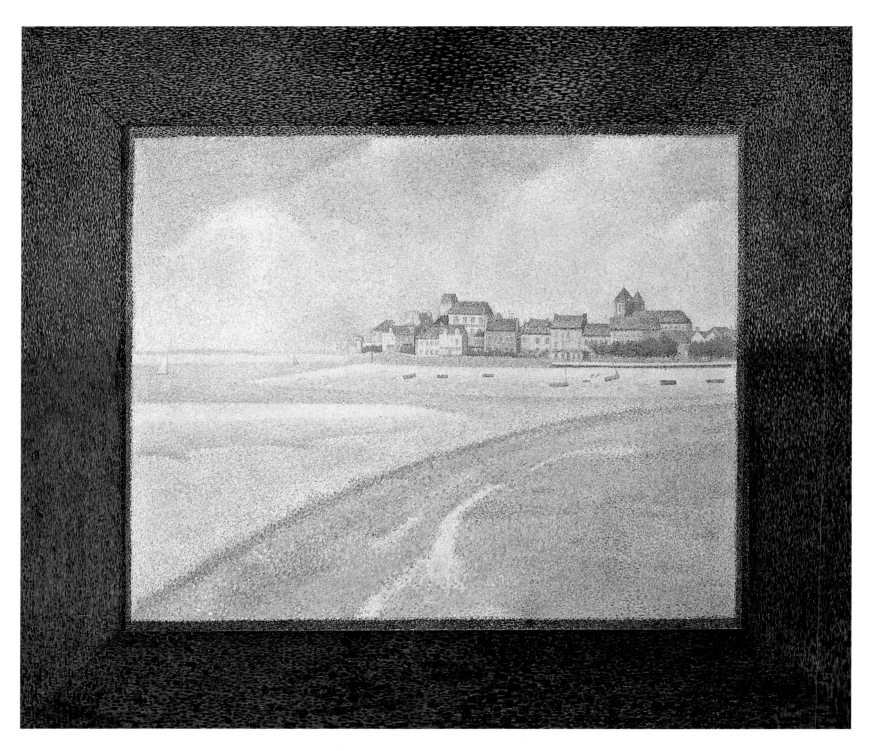

View of Crotoy from Upstream. 1889

ever made. But one of his friends, ignorant of the bond between the artist and his model, remarked that his image rising behind this woman powdering herself might invite unkind remarks. Whereupon Seurat replaced his image with a pot of flowers.[5] The painting was shown at the exhibition of the Indépendants in 1890, along with *Le Chahut*,[6] and it was actually this last composition rather than *Young Woman Powdering Herself* that drew the ridicule of the press. The report in *Le Salut Public* found that *Le Chahut* was "the pictorial representation of the choreographic frolics indulged in by the clients of [the music hall] l'Elysée-Montmartre. It is as though one were in front of those colored patterns that serve as models for concierges' house slippers. One could die laughing."[7]

Whereas *The Sideshow*, exhibited in 1888 at the fourth Indépendants, presented a somber row of cornet and trombone players under the artificial evening light of a fair, and in its horizontals expressed a uniformity reinforced by a muted color scheme, *Le Chahut* (purchased by Gustave Kahn) conceals a highly complicated linear system beneath its network of verticals and diagonals. By discovering the geometric key whose presence one senses in this painting, Robert Rey has demonstrated the mathematical rigor and consistency that governs the arrangement of these straight and curved lines.[8] It would appear from his analysis that the golden section played an important role in this composition and that here, too, the artist observed one of the principles of Delacroix: "If, in a composition already interesting by choice of subject, you add an arrangement of lines that increases the impression, a chiaroscuro that appeals to the imagination, and color suited to the characters, this is harmony, and its components merge into a unique song."[9]

In a letter Theo van Gogh wrote his brother after attending the vernissage of the 1890 Indépendants, he remarked: "Seurat is showing a very curious picture there in which he has made an effort to express things by means of the direction of lines. He certainly gives the impression of motion, but it has a very queer appearance, and it is not very generous from the standpoint of ideas."[10]

Nevertheless, despite the more or less apparent emphasis on linear composition in *The Sideshow* and *Le Chahut*, Seurat, in a conversation with Angrand and Cross, insisted that his vision prompted him to conceive values before lines, and that he never began a canvas with lines. Moreover, he explained, the colors of the objects changed their design.[11]

The Circus, the canvas undertaken after *Le Chahut*, is a freer and more direct conception. In accord with Seurat's

The Channel at Gravelines, Grand Fort-Philippe. 1890

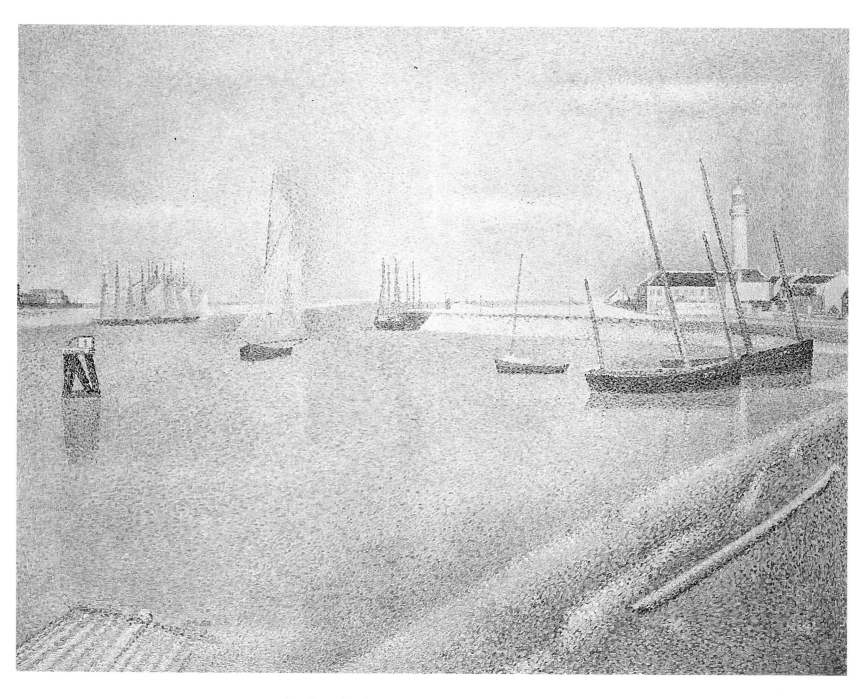

The Channel at Gravelines, in the Direction of the Sea. 1890

Channel at Gravelines, Petit Fort-Philippe. 1890

The Channel at Gravelines, Evening. 1890

Moored Boats ãnd Trees. 1890

statement that his first view of an ensemble was always in terms of masses and the interplay of values, *The Circus* is conceived with less insistence on the geometric scaffolding that supports the composition of *Le Chahut*. Without abandoning either his ideas or his sensibilities, Seurat achieved in *The Circus* an exceptionally happy effect because neither the figures nor their setting have been subordinated to a schematic design. While continuing to favor the profile, frontal, or back view for his figures and arranging the planes of his scenes one behind the other in parallel rows that are almost always horizontal, Seurat now introduced diagonals into his compositions which created a new sensation of space and rhythm. And while maintaining his characteristic repetitions of certain lines and colors across the canvas, he wove these echoed forms into more complex and freer designs. The purely horizontal composition of *The Sideshow* was succeeded by the pyramidal organization of *Le Chahut* and *The Circus*. It is in this last painting—which Seurat did not consider to be a completed work but felt was "finished" enough to be exhibited—that a new element appeared in his art: dynamism.

In 1890 the sea again attracted Seurat during the summer months. Once more the sun-kissed piers, solitary lighthouses, and boats with light sails summoned this magnificent translator of their majestic solitude. After Grandcamp in 1885, Honfleur in 1886, Port-en-Bessin in 1888, and Le Crotoy the following year, it was to Gravelines that Seurat went in 1890 to capture that singular atmosphere that hovers between land and sea: fog, wind, twilight, and salt air. The canvases he brought back had to wait in the studio for work on *The Circus* to progress in order for all to appear together at the Indépendants. This year Seurat was again invited to show in the forthcoming annual exhibition of Les XX in Brussels.[12] Among others invited were Pissarro, Gauguin, Guillaumin, Sisley, and Chéret. A retrospective showing was to be devoted to Van Gogh, who had committed suicide earlier that summer.

Once again the jeering and indignation of the Belgian critics focused on the French entries:

This year, as in previous exhibitions, it is the guests who arouse the greatest interest. Pride of place must go to Seurat, one of the mad masters who has most influenced the Vingtist tendencies.

Le Chahut, even more than *La Grande Jatte* of hilarious memory, gives an exact idea of the degree of aberration that can be obtained by the practice of this doctrine of abracadabra which consists in negating everything that exists and creating a new formula all the same. Seurat, this pope of the art of painting with blobs of sealing

wax, this rediscoverer marked with the stamp of genius, draws and smears with the most supreme ignorance. . . .

The Impressionists of the group Les XX . . . have invited to their pointillist saturnalia a cobbler who is their equal: M. Gauguin. This joker—I cannot imagine that he takes himself seriously . . . has undertaken to carve, à la Seurat, enigmatic erotic scenes! His bas-reliefs . . . go beyond all limits of insanity.[13]

The press seems to have agreed on a veritable orgy of invective. Gauguin was referred to as a "pornographic inventor," a "dissolute genius," a "dilettante of infamy"; Pissarro was accused of uselessly trying to add spice to "the indecent crudeness of his unpleasant technique." It spoke of "the late Vincent van Gogh, who, from afar, must be enjoying a good laugh at the sight of all the fools asking themselves what he means as they stand in front of his grotesque canvases."[14] But it was *Le Chahut* above all that fueled the prolixity of the experts, witness the verbal debauch of a certain Edgar Baes:

This work is nothing but a frenetic spasm of a breathless gnome and a ghoul in heat. Supreme hymn to palpitating flesh, but flatulent and slimy, like the mucus of a disemboweled snail, his dancers have the dull, dead colors of pustulated sores. Nevertheless, it is spicy, for I myself am breathless, and more than one onlooker, I swear, sticks out his tongue and twists his insatiable arms, hypnotized by the hectic paroxysms of a monstrous and degrading prurience.[15]

Shortly before this new shower of abuse rained down on him, on February 3, 1891, to be exact, Seurat spent an evening with a group of men who would become the symbols of his epoch for future generations. At a banquet given in honor of Jean Moréas, whose manifesto had set down the principles of literary symbolism, an occasion presided over by Mallarmé that constituted a veritable apotheosis of Symbolism, Seurat rubbed elbows with Anatole France, André Gide, Jules Renard, Octave Mirbeau, Maurice Barrès, Henri de Régnier, Félix Fénéon, Paul Gauguin, Odilon Redon, Paul Signac, and many others. Some of the guests had already achieved fame; others awaited it; for a few, fame hovered in the wings. Among these last was Georges Seurat. In the previous year, Jules Christophe had devoted an issue of the popular *Hommes d'Aujourd'hui* series to Seurat, in which he reviewed the painter's life, described his work, and reported his theories, outlined to him by the artist himself. Painters and writers in Seurat's circle unanimously recognized his genius and admired his art. They knew the role this young man, barely thirty-one years old, had played; they knew that his name was beginning to stand for a new vision, and they divined the place he was destined to occupy in the history of art. But they did not

Woman Rider (study for "The Circus"). 1890

Head of a Clown (study for "The Circus"). 1890

Monsieur Loyal (study for "The Circus"). 1890

Complete Study for "The Circus." 1890

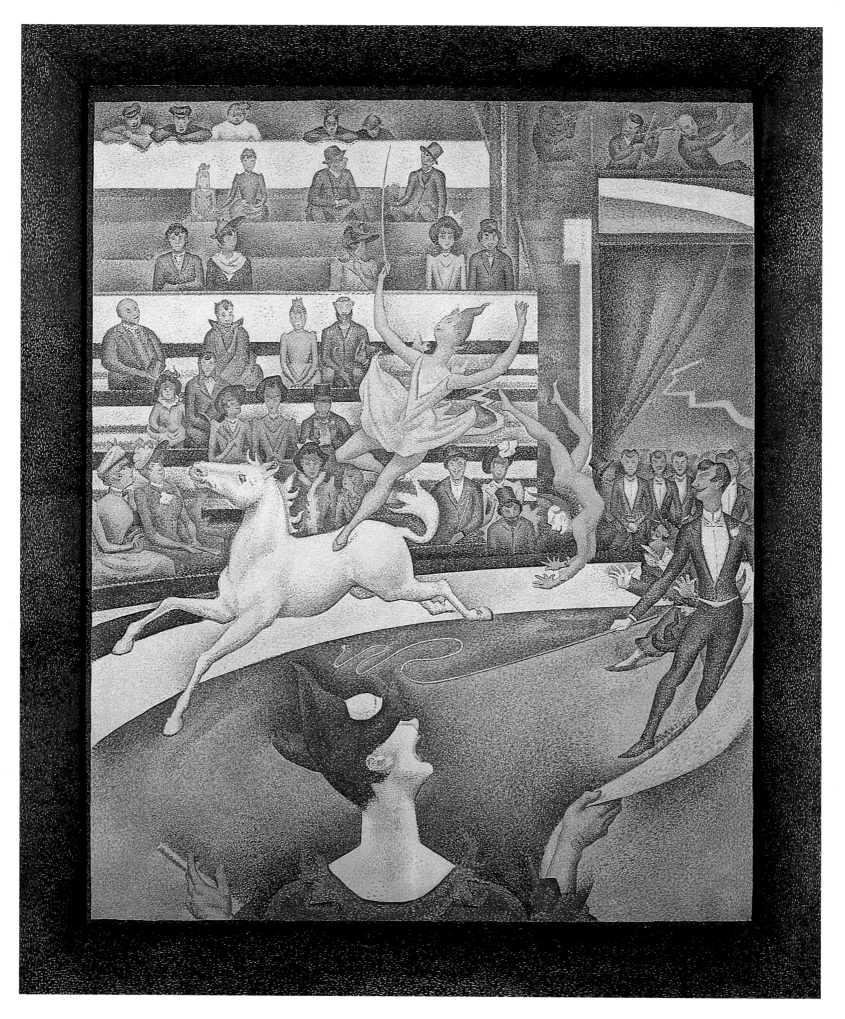

The Circus. 1890–91

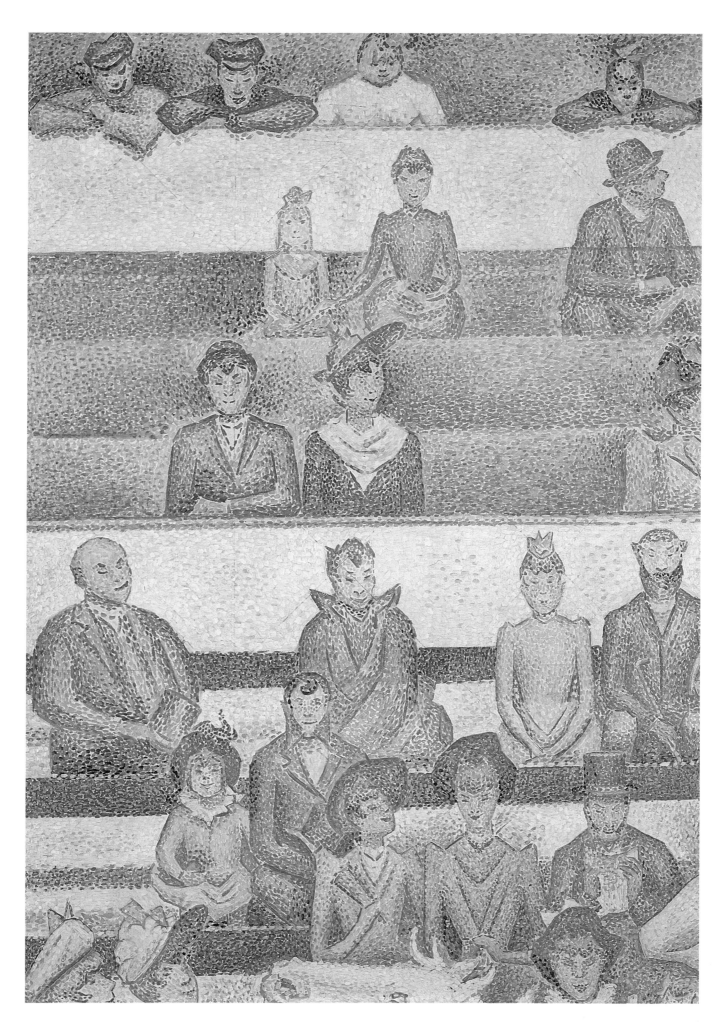

Detail of *The Circus*

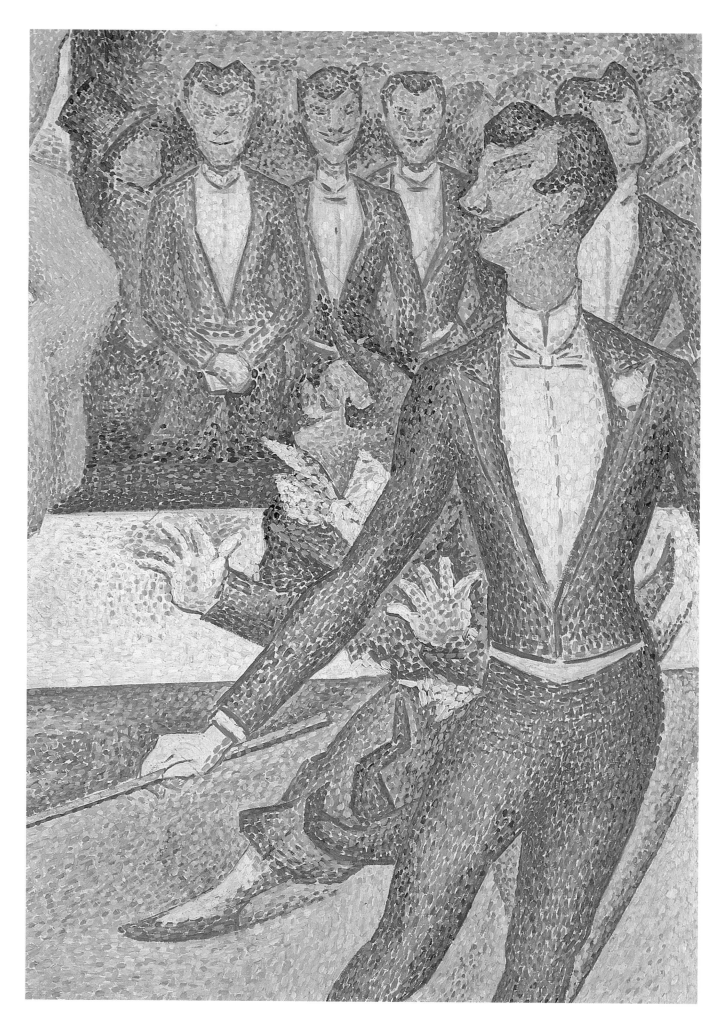

Detail of *The Circus*

Detail of *The Circus*

Detail of *The Circus*.

foresee that among all the celebrants at this banquet, the one whose future seemed to hold enormous promise would be the first to go.

In the early part of March 1891 Seurat worked every day as a member of the hanging committee of the exhibition of the Indépendants, which was again being held at the Pavillon de la Ville de Paris, on the Champs-Elysées, and which would include retrospectives of Van Gogh and Dubois-Pillet, who had died a short time before. As usual, Seurat examined the entries, supervised the placement, and directed the installation of the paintings. His own entries included *The Circus* and four views of the channel at Gravelines.[16] He hardly noticed an ordinary sore throat that followed a cold. The vernissage of the exhibition was set for March 19. A week later, a sudden fever sent Seurat to bed at his mother's place on the boulevard Magenta. In a few days he was dead. His infant son, who had contracted his illness, soon followed him to the grave.

In his brief period of agony Seurat may have recalled the words of Delacroix, which he had once carefully copied:

Sterility is not only a misfortune for art, it is a blemish on the talent of the artist. All the work of a man whose resources are meager must necessarily bear the mark of fatigue. A school can be created only by presenting great and numerous works as models.[17]

During the ten years of his artistic activity, Seurat had been prolific; he had created great works and promulgated ideas that have withstood time and fate. But when he died on March 29, 1891, only his intimate friends understood humanity's irreparable loss.[18] Jules Christophe lamented: "A sudden and stupid illness carried him off in a few hours when he was in the midst of his triumph! I curse Providence and death!"[19]

On March 30, 1891, Camille Pissarro wrote his eldest son:

Terrible news to report: Seurat died after a very brief illness. I heard the cruel news only this morning. He had been in bed for three days with a disturbance of the throat. Improperly treated, the illness developed with ruinous speed. . . . The funeral takes place tomorrow. You can conceive the grief of all those who followed him or were interested in his artistic researches. It is a great loss for art.[20]

A few days later he reported:

Yesterday I went to Seurat's funeral. I saw Signac who was deeply moved by this great misfortune. I believe you are right, pointillism is finished, but I think it will have consequences which later on will be of the utmost importance for art. Seurat really added something.[21]

Detail of *The Circus*.

Notes

*Full bibliographical citations are given only for those works
not listed in the bibliography.*

Beginnings

1 See letter of Aman-Jean; cited in Coquiot, *Seurat*, pp. 28–29; On Lequien
and nineteenth-century French art instruction in general, see Albert Boime, "The
Teaching of Fine Arts and the Avant-Garde in France during the Second Half of the
Nineteenth Century," *Arts Magazine* (December 1985), pp. 46–57; on Seurat
especially, see pp. 51–53.

2 Ibid., p. 29.

3 An observation by Albert Boime suggests that even an imperfect teacher may
have a liberating effect. Boime has noted that although Lehmann was an "arch
conservative," his oeuvre reveals an astonishing difference between finished works
and sketches, with the latter showing "vigorous brush strokes and slashes of color"
reminiscent of Delacroix. He suggests that since both Seurat and Alexandre Boiron,
a fellow student in Lehmann's studio, begin to use a similar vigorous brushwork in
the early 1880s (which will culminate in Seurat's first masterwork, the *Bathers* of
1884), it may have been Lehmann's sketch technique that provided the initial
release from academic rigidity for both young painters; see Albert Boime, *The
Academy and French Painting in the Nineteenth Century* (New Haven: Yale
University Press, 1971), pp. 113–15 and 206, especially notes 34 and 35.

4 The archives of the Ecole des Beaux-Arts indicate that Seurat entered in
February 1878. Of the eighty students admitted to the class in painting on March
19, 1878, Seurat was rated sixty-seventh. At the end of the summer semester he
dropped to seventy-third on the list. However, on the report for March 18, 1879,
he ranks forty-seventh; see Rey, *La Renaissance du sentiment classique*, p. 101.

5 Charles Blanc, *Grammaire des arts du dessin: architecture, sculpture, peinture* (Paris: Renouard, 1867); *The Grammar of Painting and Engraving*, translated by K. Newell Doggett (New York: Hurd and Houghton, 1875), pp. 164–65.

6 According to Félix Fénéon (in conversation with the author), the lyrical descriptions of boats found in one of Seurat's notebooks and published in Coquiot (op. cit., pp. 122–25) are not the painter's own impressions but were copied from some publication.

7 Marx, "Le Salon," *Le Progrès Artistique* (June 15, 1883).

8 Charles Baudelaire, "L'Oeuvre et la vie d'Eugène Delacroix," in *Variétés critiques* (Paris: G. Crès, 1924), vol. 2, pp. 3–36; Charles Baudelaire, "The Life and Work of Eugène Delacroix [1863]," in *The Painter of Modern Life and Other Essays*, translated and edited by Jonathan Mayne (London: Phaidon, 1964), p. 47.

9 Ibid., p. 47.

10 Blanc, op. cit., pp. 146 and 156.

11 Ibid., p. 162.

12 Fénéon, "Notes inédites de Seurat sur Delacroix [1881]," *Le Bulletin de la Vie Artistique* (April 1, 1922); translation in Broude, *Seurat*, pp. 13–15. For *Fanatics of Tangier* (1832, Minneapolis Institute of Arts), see Lee Johnson, *The Paintings of Eugène Delacroix. A Critical Catalogue*, vol. 3, *1832–1863* (Oxford: Clarendon Press, 1986), no. 360.

13 Kahn, "Seurat," *L'Art Moderne* (April 5, 1891), p. 108; translation in Broude, op. cit., p. 22.

14 Michel Eugène Chevreul, *De la loi du contraste simultané des couleurs et de l'assortiment des objets colorés consideré d'après cette loi dans ses rapports avec le peinture* (Paris: Pitoir-Levrault, 1839); *The Principles of Harmony and Contrast of Colours, and Their Applications to the Arts*, translated by Charles Martel (London: Longman, Brown, 1854), statement 78.

15 Signac, "Les Besoins individuels," p. 16'84-7.

16 Marx, "L'Exposition des artistes indépendants," *Le Voltaire*, May 16, 1884.

17 Jacques-Emile Blanche, three years younger than Seurat, who studied painting under Gervex and at the Académie Julian, relates that at the time "they used to go to sketch near the fortifications outside Paris, near the factories of Suresnes, and on the island of La Grande Jatte"; see Jacques-Emile Blanche, *De Gauguin à La Revue nègre* (Paris: Emile-Paul, 1928), p. 37.

18 Cited in Signac, *De Eugène Delacroix au néo-impressionnisme*, ch. 1, p. 21.

Salon des Indépendants

1 Exhibition of Independent Artists, 1884, Authorized by the Director of Fine Arts of the City of Paris, Barrack B, Courtyard of the Tuileries, May 15 to July 1.

2 Signac, "Le Néo-impressionnisme," *Gazette des Beaux-Arts* (January 1934), p. 50.

3 Katow, "Le Salon des artistes indépendants," *Gil Blas* (May 17, 1884).

4 Clarétie, in *Le Temps*, May 1884.

5 Trublot [Paul Alexis], "Exposition des Indépendants," *Le Cri du Peuple*, May 15 and 17, 1884.

6 Jacques, "Salon des Indépendants," *L'Intransigeant* (May 24, 1884).

7 Marx, "L'Exposition des artistes indépendants," *Le Voltaire*, May 16, 1884.

8 Signac, *De Eugène Delacroix*, ch. 4, p. 64.

9 Signac to Claude Monet; quoted in Gustave Geffroy, *Claude Monet: Sa vie, son oeuvre* (Paris: G. Crès, 1924), vol. 1, p. 175.

10 Ibid., vol. 2, p. 166; see also vol. 1, p. 215.

11 Signac, *De Eugène Delacroix*, ch. 2, p. 42.

12 Ibid., p. 41.

13 Fénéon, "L'Impressionnisme aux Tuileries," *L'Art Moderne* (September 19, 1886), p. 300.

14 Marx, in *Lè Voltaire*, December 10, 1884.

A Sunday Afternoon on the Island of La Grande Jatte

1 Pissarro to Paul Durand-Ruel, November 6, 1886; cited in Venturi, *Les Archives de l'impressionnisme*, vol. 2, p. 24.

2 Signac, *De Eugène Delacroix*, ch. 4, p. 59.

3 See Rich, *Seurat and the Evolution of "La Grande Jatte,"* especially pp. 15–24.

4 Signac, *De Eugène Delacroix*, ch. 5, p. 73.

5 Signac, "Les Besoins individuels," p. 16'84-9.

6 See the letter of Charles Angrand; cited in Coquiot, *Seurat*, p. 40.

7 Signac, *De Eugène Delacroix*, ch. 1, p. 11. See the color scales in Arthur Pope, *An Introduction to the Language of Drawing and Painting*, vol. 1, *The Painter's Terms* (Cambridge: Harvard University Press, 1929), pls. II–IV.

8 Letter of Charles Angrand; cited in Coquiot, *Seurat*, pp. 39–40; translation in Rich, *Seurat and the Evolution of "La Grande Jatte,"* p. 10.

9 Letter of Maurice Beaubourg; cited in Coquiot, ibid., pp. 45–46; translation in Rich, ibid., p. 11. The complete quotation reads, "He would begin the picture over again and they would continue to shatter it." As Seurat hardly ever painted on canvas on the island of La Grande Jatte, Fénéon is rightly skeptical of this anecdote.

10 Letter of Charles Angrand; cited in Coquiot, ibid., p. 41.

11 Signac, "Les Besoins individuels," p. 16'84-9. This remark should perhaps be understood less as an expression of Seurat's real attitude than as a sally intended to put a stop to literary interpretations of his paintings. All his subsequent work shows that he could, as he himself said, "paint only what he saw before him"; see Kahn, *Les Dessins de Seurat*, Introduction.

The Eighth Exhibition of the Impressionists

1 Pissarro to his son Lucien, March 1886; cited in *Camille Pissarro: Letters to His Son Lucien*, pp. 73–74.

2 Seurat's listing in the catalogue of the exhibition (May 15–June 15, 1886) reads: *Un Dimanche à la Grande-Jatte (1884); Le Bec du Hoc (Grand-Camp); Le Fort Samson (Grand-Camp); La Rade de Grand-Camp; La Seine, à Courbevoie; Les Pecheurs* (Collection M. Appert); *Une Parade (Dessin); Condoléances, idem* (Collection M. J.-K. Huysmans); *La Banquiste, idem* (Collection Mme Robert-Caze).

3 Moore, *Confessions of a Young Man*, pp. 43–44.

4 Ibid., p. 44.

5 Signac, "Le Néo-impressionnisme," *Gazette des Beaux-Arts* (January 1934), p. 55.

6 *Le Figaro*, May 16, 1886.

7 Verhaeren, *Sensations*, p. 196.

8 Moore, *Modern Painting*, p. 89.

9 Fouquier, in *Le XIXe Siècle* (May 16, 1886).

10 Mirbeau, "Exposition de peinture impressionniste," *La France* (May 21, 1886).

11 Hennequin, "Les Impressionnistes," *La Vie Moderne* (June 19, 1886), p. 390.

12 Wyzewa, "L'Art contemporain," *La Revue Indépendante* (November–December 1886).

13 "Les Vingtistes parisiens," *L'Art Moderne* (June 27, 1886), p. 204.

14 "I had been in Paris for three years, I had been to all the museums, to Durand-Ruel's gallery and to all the last exhibitions of the old guard impressionists, when Seurat's art was revealed to me by the *Bathers (Asnières)*, which I saw in the canteen of the Salon des Artistes Indépendants. Although I did not commit myself in writing, I then completely realized the importance of this painting; the masterpieces that followed were the logical consequences of it without repeating the spice of surprise. I think it was at the famous Eighth Exhibition of Paintings in the rue Laffitte that I first saw and became acquainted with Seurat and the painters he influenced." Fénéon to the author, Marseilles, May 8, 1940.

15 Fénéon, "Les Impressionnistes en 1886," *La Vogue* (June 13–20, 1886).

16 Fénéon refers here to the work of the Columbia University physicist O. N. Rood; see Ogden Nicholas Rood, *Modern Chromatics, with Applications to Art and Industry* (New York, 1879), published in a French translation, *La Théorie scientifique des couleur* (Paris, 1881).

17 Fénéon, "Les Impressionnistes en 1886," op. cit.

18 Kahn, "Gauguin," *L'Art et les Artistes* (November 1925), p. 42.

Félix Fénéon and the Neo-Impressionists

1 Kahn, in *Les Dessins de Georges Seurat*, Introduction.

2 Ibid.

3 Rémy de Gourmant, in *Cinquantenaire du Symbolisme*, exhibition catalogue (Paris: Bibliothèque Nationale, 1936), p. 115.

4 Wilenski states, "The critic Félix Fénéon, then twenty-two, saw what Seurat was after and founded the *Revue Indépendante* to help the new Classical Renaissance" (*Modern French Painters*, p. 85). The founding of *La Revue Indépendante*—the first issue of which appeared in May 1884, edited by Georges Chévrier and Félix Fénéon—had no connection with Seurat, about whom Fénéon did not write until 1886 and then not in *La Revue Indépendante* but in *La Vogue* (June 13–20, 1886). The contributors to the *Revue* were recruited, according to Fénéon, from "the declining Naturalists and rising Symbolists." The first articles mentioning Seurat published in the *Revue* appeared in 1886 and 1887, written respectively by Teodor de Wyzewa and J.-K. Huysmans, and were clearly antagonistic to divisionism. The facts about *La Revue Indépendante* and *La Vogue* can be found in *Cinquantenaire du Symbolisme*, op. cit., pp. 53–54.

5 At twenty-five, Charles Henry, who was the same age as Seurat, had published a remarkable theoretical work on rhythm and measure.

6 Trublot [Paul Alexis], "Visite à la *Revue Indépendante*," *Le Cri du Peuple*, April 14, 1888.

7 Fénéon, "Le Musée du Luxembourg," *Le Symboliste* (October 15–22, 1886).

8 Miomandre, "Vingt ans après," *Le Bulletin de la Vie Artistique* (February 15, 1926), pp. 51–52.

9 This very year, in collaboration with Paul Adam, Jean Moréas, and Oscar Méténier, Fénéon also published *Petit Bottin des lettres et des arts* (Who's Who in Literature and Art), issued anonymously. This book contains comments on Huysmans, Monet, Pissarro, Redon, Renoir, Verlaine, Zola, and others. The passage on Seurat reads, "He brushes flowing waters, plastic grass, and the air that synthesizes all this."

10 According to Rey (*La Renaissance du sentiment classique*, p. 122), the term "néo-impressionnisme" was first used by Arsène Alexandre in his review of Fénéon's brochure that appeared in December 1886. But the term had already been employed by Fénéon in an article published in the September 19, 1886, issue of *L'Art Moderne* (p. 302). There is little doubt that the word was first used by Fénéon, who may have gotten it from the painters themselves.

11 Signac, *De Eugène Delacroix*, ch. 4, pp. 57–58. In 1896 the American painter Theodore Robinson wrote, "Of course there have appeared the men of small talent, with their little invention, who have tacked themselves on to the [Impressionist] movement (notably the genius who imagined the fly-speck or dot *facture*)"; Robinson, "Claude Monet," in *Modern French Masters: A Series of Biographical and Critical Reviews by American Artists*, edited by John C. Van Dyke (New York: Century, 1896), p. 169.

12 Fénéon, "Le Néo-impressionnisme," May 1, 1887, pp. 138–39. In his articles, Fénéon, meticulous in the extreme, always mentioned the frames selected by his friends, making it possible to trace precisely the evolution of these enclosures, which were so important to Seurat. Thus we learn from this article: "Carpentry.—One notes a growing tendency to abandon the flat, white frame. This summer, Neo-Impressionist paintings carry wide frames of oak with an inner white panel of several centimeters. Those of M. Albert Dubois-Pillet are gallantly embellished with astragals. Those of M. Charles Angrand are matte gilt. All are still rectangular—yet they seem most suitable for enclosing oval or circular landscapes." Later, Maximilien Luce would paint a number of oval landscapes.

New Exhibitions: New York, Paris, Brussels

1 Unsigned article, in the *New York Daily Tribune*, April 10, 1886.

2 Durand-Ruel showed works by Manet, Monet, Renoir, Sisley, Pissarro, Degas, Morisot, Boudin, Guillaumin, and Forain, among others. Seurat's contribution consisted of two paintings and twelve "studies" (doubtless "croquetons").

3 "Mémoires de Paul Durand-Ruel," in Venturi, *Les Archives de l'impressionisme*, vol.2, pp. 216–17.

4 "The French Impressionists" in *The Critic*, April 17, 1886, pp. 195–96. The author of this article went so far as to say, "New York has never seen a more interesting exhibition than this." Another unsigned article, in *Art Age* (April 1886), observed, "The impressionists are highly trained and fully developed technicists who have experienced reactionary desires in favor of truth and simplicity, as they understand those attributes."

On the other hand, *The Sun*, April 11, 1886, was as hostile as the French papers had been: "The great master, from his own point of view, must surely be Seurat whose monstrous picture of *The Bathers* consumes so large a part of Gallery D. This is a picture conceived in a coarse, vulgar, and commonplace mind, the work of a man seeking distinction by the vulgar qualification and expedient of size. It is bad from every point of view, including his own."

The anonymous author of the article in the *Mail and Express* of April 26, 1886, was no kinder: "We enter Gallery D fully prepared for anything. There are no surprises left. The eye has been focussed to every gradation of sweet, and crude, and gaudy pigment. It naturally falls first upon the enormous Bathing by Seurat, which occupies the middle of the west wall. Here we have a composition, full of affected naivete, which pretends to be a study from nature. It is luminous, but everything is hard. The sky is made of marble, and in a metallic river a number of wooden youths are bathing. Others are seated on the bank, consciously posing for the artist. All details of drawing, anatomical or otherwise, are left out, and the local color of flesh is scarcely distinguishable from that of the draperies, so that it is difficult to say whether the naked are covered with peach-blow undershirts, or if the figure lounging supine in front is really clothed in a blouse of the same hue, or is simply of worse drawn nudity than the others. There is no realism, not even in a pair of shoes, or in the orange-tinted dog. A glance around the gallery is like a *coup d'oeil* into a *Salon Refusée* [sic] of which this picture is the worst. The rest are not, by any means, all that bad."

It is interesting to note that following this exhibition, a certain Celen Sabbrin published a brochure entitled *Science and Philosophy in Art* (Philadelphia, 1886). This study is, however, principally devoted to the works of Monet and does not even mention Seurat.

5 As early as April 26 the *New York Daily Tribune* reported that "seven or eight" pictures had been sold. For further discussion of this exhibition, see Hans Huth, "Impressionism Comes to America," *Gazette des Beaux-Arts* (April 1946), pp. 237–44.

6 At this second exhibition of the Indépendants (August 21–September 21, 1886), Seurat's entries are listed in the catalogue as: *Un Dimanche après-midi à l'île de La Grande Jatte; Le Bec du Hoc (Grandcamp); Le Rade de Grandcamp; La Seine à Courbevoie; Coin d'un bassin à Honfleur; Grandcamp (soir); La Luzerne (St. Denis); Bateaux (Courbevoie)*, croqueton; *Bords de Seine*, croqueton.

7 Notice, in *Le Figaro*, May 16, 1886.

8 Pissarro to his son Lucien, September 1886; cited in *Camille Pissarro: Letters to His Son Lucien*, p. 81.

9 Fénéon, "L'Impressionnisme aux Tuileries," *L'Art Moderne* (September 19, 1886) pp. 300–302.

10 Seurat exhibited *Le Phare et l'Hospice à Honfleur* and *La Grève du Bas Butin*.

11 The catalogue of the fourth annual exhibition of Les XX (1887) lists Seurat's entries as: *Un dimanche à la Grande Jatte. 1884; Le Bec du Hoc. Grandcamp; La Rade de Grandcamp; Coin d'un bassin. Honfleur* (Collection M. Emile Verhaeren); *L'Hospice et le phare d'Honfleur; La Grève du Bas-Butin. Honfleur; Embouchure de la Seine. Soir.*

12 Signac to Camille Pissarro [Brussels, February 1887]; letter courtesy Rodo Pissarro.

13 Tyrtée, in *Le Moniteur des Arts*, February 18, 1887.

14 Notice, in *Le Matin*, February 7, 1887.

15 In *La Vie Moderne* (June 19, 1886), pp. 389–90.

16 Verhaeren, "Le Salon des *Vingt* à Bruxelles," *La Vie Moderne* (February 26, 1887), p. 138. *Le Bec du Hoc*, purchased in Brussels for three hundred francs, was the first painting Seurat sold. It seems that exactly one year later, in March 1888, Theo van Gogh either bought a painting by Seurat or exchanged some painting for one of his canvases; see Vincent to Theo van Gogh, March 10 [1888], letter no. 468.

Seurat and His Friends

1 In 1886 Gauguin painted a landscape of Pont-Aven in the pointillist manner (Rewald, *Post-Impressionism* [1956], ill. p. 144). In the following year he executed a still life (ibid. [1982], ill. p. 274), which he entitled—ironically, no doubt— *Ripipoint*, after a Neo-Impressionist he and Emile Bernard had invented the previous year to amuse themselves. Both paintings hung in the dining room of the inn at Le Pouldu, the still life inscribed to his landlady, Mme Marie Henry; see Charles Chassé, *Gauguin et le groupe de Pont-Aven* (Paris: H. Floury, 1921), p. 39. The landscape was much admired and even inspired some light verse by Emile Bernard (published in E. Bernard, "Souvenirs," *La Rénovation Esthétique* [April 1909]):

<div align="center">

Les Ripipointillades
Mélopée des Petits Points

</div>

En peinture il faut être sage:
Si vous peignez un paysage
Restez deux jours plantés devant
En vous disant, en vous disant:
Un petit point, avec grand soin,
Deux petits points, trois petits points } bis

Après, vous prenez la palette
Et vous mettez une serviette
Afin de peindre proprement
Tout doucement, tout doucement:
Puis vous posez avec grand soin
Un petit point, deux petits points } bis

A la quarantième séance
Votre toile à valser commence!
Mieux que la peinture au balai
Ca danse, ça vibre et c'est . . . laid
Continuez avec grand soin,
Un petit point, deux petits points } bis

Aux mécontents qui vont vous dire:
"Ils sont trop rounds." Sans un sourire,
Avec emphase répondez:
"Ils font très bien aussi carrés."
Car ils font toujours bien de loin,
Les petits points, les petits points. } bis

2 Vincent to Theo van Gogh, letter no. 500. In a letter to Maurice Beaubourg, August 28 [1890], Seurat said of Van Gogh: "In 1887 I spoke to him for the first time in a cheap restaurant near La Fourche, avenue de Clichy, now closed. An immense skylighted hall was decorated with his canvases. He exhibited with the Indépendants in 1888, 1889, 1890" (Rey, *La Renaissance du sentiment classique*, opp. p. 132). According to Van Gogh himself, he paid a visit to Seurat's studio to "see his beautiful great canvases" (Vincent to Theo, letter no. 553). Writing to Gauguin in the fall of 1888, Vincent mentions that he visited Seurat's studio just a few hours before he left Paris for Arles (Claude Roger-Marx, "Lettres inédites de Vincent van Gogh et de Paul Gauguin," *Europe*, vol. 17, no. 194 [February 15, 1939], p. 166). Vincent observed to his brother: "Painting as it is now promises to become more subtle—more like music and less like sculpture—and above all it promises *color*. If only it keeps this promise. . . . As for stippling and making halos or other things, I think they are real discoveries, yet we must already see to it that this technique does not become a universal dogma any more than any other. That is another reason why Seurat's "Grande Jatte" . . . will become even more personal and even more original" (Vincent to Theo, letter no. 528).

3 Verhaeren, *Sensations*, p. 201.

4 Reported to the author by Paul Signac.

5 Pissarro to Paul Durand-Ruel, November 6, 1886; cited in Venturi, *Les Archives de l'impressionnisme*, vol. 2, p. 24.

6 Georges Lecomte, "Camille Pissarro," *Les Hommes d'Aujourd'hui*, no. 366 (Paris: Vanier, 1890).

7 See letter of Angrand; cited in Coquiot, *Seurat*, p. 44.

8 Ibid., pp. 42–43.

9 Lugné-Poë, *La Parade*, vol. 1, *Le Sot du tremplin* (Paris, 1930), p. 104.

10 Letter from Félix Fénéon to the author; The Pierpont Morgan Library, New York.

11 Verhaeren, *Sensations*, p. 200.

12 Kahn, "Seurat," *L'Art Moderne* (April 5, 1891), p. 109; translation in Broude, *Seurat*, p. 24.

13 Reported to the author by Paul Signac. George Heard Hamilton has pointed out that "if it was difficult during Cézanne's lifetime to appreciate his work, it was equally difficult to see it." Until the exhibitions mounted by Vollard in 1895, 1898, and 1899 (all occurring after Seurat's death in 1891), few Cézanne paintings had been shown. "Only those few who knew the artist himself, or were aware of the stack of paintings in Père Tanguy's obscure little color shop, could have had any real familiarity with his work"; George Heard Hamilton, "Cezanne and His Critics," in *Cézanne: The Late Work*, edited by William Rubin (New York: Museum of Modern Art, 1977), p. 140.

14 Kahn, "Au temps du pointillisme," *Mercure de France* (May 1924).

15 Verhaeren, *Sensations*, p. 200. See also Herbert, "Seurat and Jules Chéret," *Art Bulletin* (June 1958), pp. 156–58.

16 Aman-Jean, cited in Coquiot, op. cit., p. 26; for Cousturier, see Kahn, "Au temps du pointillisme," op. cit.; Carabin, cited in Coquiot, op. cit., p. 48; Kahn, *Les Dessins de Seurat*, Introduction; Wyzewa, "Georges Seurat," *L'Art dans les deux Mondes* (April 18, 1891), translation in Broude, op. cit., p. 31; for Degas, see Kahn, *Les Dessins*, op. cit.; Signac, cited in Coquiot, op. cit., p. 30; Van de Velde, to the author; Pissarro to his son Lucien, May 15, 1887, cited in *Camille Pissarro: Letters to His Son Lucien*, p. 110.

When asked about these varying descriptions of Seurat, Fénéon wrote the author: "Henri de Régnier, in his book of poems *Vestigia Flammae*, has in my opinion given the best portrait of Seurat. I don't see what could be added to it." Régnier's poem reads:

> Seurat, une âme ardente et haute était en vous . . .
> Je me souviens. Vous étiez grave, calme et doux,
> Taciturne, sachant tout ce que la parole
> Gaspille de nous-mêmes en sa rumeur frivole.
> Vous écoutiez sans répondre, silencieux
> D'un silence voulu que démentaient vos yeux
> Mais si votre art était sujet de la querelle
> Un éclair animait votre regard rebelle,
> Car vous aviez en vous, conçue avec lenteur,
> Seurat, votre obstination de novateur
> Auprès de quoi rien ne prévaut et rien n'existe,
> Cette obstination qui fait le grand artiste.

17 Cousturier, *Seurat*, pp. 8–9

18 Kahn, *Les Dessins de Seurat*, Introduction.

19 Ibid. When George Moore's *Confessions of a Young Man* appeared in *La Revue Indépendante* in 1888, Seurat found not only the persiflage of his *Grande Jatte*, but also this quotation of Whistler, which cannot have failed to interest him, "Painting is absolutely scientific; it is an exact science"; see Moore, *Confessions of a Young Man*, p. 126.

20 Signac to Fénéon, October 23, 1934.

21 Kahn, "Seurat," *L'Art Moderne* (April 5, 1891), p. 108; translation in Broude, op. cit., p. 22.

Artists' Quarrels

1 This chapter first appeared in the French edition of this study published in 1948. A substantial portion in English translation may be found in Broude, *Seurat*, pp. 103–7. All quotations unaccompanied by indications of source are from unpublished documents that were provided by Mme Ginette Signac and M. Rodo Pissarro, both now deceased.

2 The dimensions of a size 25 canvas are $32 \times 25\frac{1}{2}$ inches (81×65 cm); those

of a size 15 are 25½ × 21¼ inches (65 × 54 cm); a size 10 canvas measures 21¾ × 18 inches (55 × 46 cm).

3 In the summer of 1887, Lucien Pissarro was earning his living at a printing firm, making little dots by hand on the plates that were used for chromolithography.

4 Pissarro to his son Lucien, February 25, 1887; cited in *Camille Pissarro: Letters to His Son Lucien*, p. 100.

5 Pissarro refers here to Fénéon's important article "Le Néo-impressionnisme" that would appear in the avant-garde Belgian publication *L'Art Moderne* (May 1, 1887), pp. 138–40, as a review of the third exhibition of the Indépendants held in Paris, March 26–May 3, 1887.

6 Alexandre, "Le Mouvement artistique: Exposition des Indépendants," *Paris* (August 13, 1888).

7 Seurat refers here to Fénéon's review of the eighth Impressionist exhibition which first appeared as an article in *La Vogue* (June 13–20, 1886), and was reprinted, with additions, as a forty-three-page pamphlet in October of the same year; see Fénéon, *Oeuvres plus que complètes*, vol. 1, p. 46 note.

8 See Pissarro to Paul Durand-Ruel, November 6, 1886; cited in Venturi, *Les Archives de l'impressionnisme*, vol. 2, p. 24. For the particular passage Pissarro is referring to here, see page 134.

Seurat's Theories

1 Kahn, *Les Dessins de Seurat*, Introduction.

2 Fénéon, "Paul Signac," *Les Hommes d'Aujourd'hui*, vol. 8, no. 373 (Paris: Vanier, 1890).

3 Adam, "Les Impressionnistes à l'exposition des Indépendants," *La Vie Moderne* (April 15, 1888), pp. 228–29.

4 Signac, "Les Besoins individuels," p. 16'84-8.

5 Gauguin to Charles Morice, April 1903; in Charles Morice, *Paul Gauguin* (Paris: H. Floury, 1919), p. 121.

6 Cézanne to Emile Zola, November 27, 1884; in *Paul Cézanne: Letters*, edited by John Rewald (London: Bruno Cassirer, 1941), p. 173.

7 Published in New York in 1879; translated into French as *La Théorie scientifique des couleurs et ses applications à l'art et à l'industrie* (Paris, 1881).

8 *Cercle chromatique de M. Charles Henry, présentant tous les compléments et toutes les harmonies de couleurs, avec une introduction sur la théorie générale du contraste, du rhythme et de la mesure* (The Chromatic Circle . . . Giving All the Complementaries and Harmonies of Colors, with an Introduction on the General Theory of Contrast, Rhythm, and Measure [Paris: Verdin, 1888]) and *Rapporteur esthétique de M. Charles Henry. Notice sur les applications à l'art industriel, à l'histoire de l'art, à l'interprétaion de la méthode graphique, en général à l'étude et à la rectification esthétique de toutes formes* (The Aesthetic Table . . . Notice on Its Application to Industrial Art, to the History of Art, to the Interpretation of the Graphic Method and in General to the Study and Rectification of All Forms [Paris: G. Séguin, 1888]).

9 D. Sutter, "Les Phénomènes de la vision," *L'Art*, vol. 20, pt. 1 (1880), pp. 74–76, 124–28, 147–49, 195–97, 216–20, 268–69.

10 Ibid., passim.

11 Kahn, op. cit., Introduction.

12 Sutter, op. cit., p. 219, XCIX.

13 Ibid., pp. 75, 76, 197, 216, 218, 219, 220, 268.

14 Ibid., p. 269.

15 Seurat to Maurice Beaubourg, August 28 [1890]; published in Rey, *La Renaissance du sentiment classique*, preceding p. 133.

16 Verhaeren, *Sensations*, p. 199.

Commendation and Condemnation

1 It may be interesting to note here what Blanche, writing in 1928, had to say on the subject of Seurat's colors: "Many of Seurat's canvases are faded, are out of

tune, already a dirty gray. The *Bathers* has lost much of its light and resonance"; Jacques-Emile Blanche, *De Gauguin à La Revue nègre* (Paris: Emile-Paul), p. 37. However, in 1900 Signac noted in his journal on the occasion of a Seurat exhibition, "The *Bathers*, painted in broad strokes with well-observed contrasts, outshines the much-changed *Grande Jatte*; *The Circus* is in pristine condition, the most fresh"; Signac, "Fragments du Journal," *Arts de France* (1947), p. 98.

2 Hennequin, "Notes d'Art: L'Exposition des artistes Indépendants," *La Vie Moderne* (September 11, 1886), pp. 581–82. The author closed his discussion of Seurat with the following observations:

"When M. Seurat uses his method to paint Norman seascapes, especially when he describes the approach of evening on a gray day, as in the marvelous canvas entitled *Grandcamp*, he is excellent. But when, as in *La Grande Jatte*, he undertakes the representation of bright sunlight and moving figures, his failure is evident, not only by the absence of light but also by the absence of life in these figures whose contours have been painstakingly stippled with colored dots as in a tapestry. These are painted Gobelins, as unpleasant as the originals."

And he concluded:

"These painters [Seurat, Signac, et al.] attempt to render reality by means of a style based not on form but on color; thus:

As a result of their desire to see objectively, they cease seeing things accurately as they are received by the eye. That is, they reject the entire education of this organ—that store of tactile experience acquired by heredity which allows our brains to perceive forms in images far truer than those yielded by the eye alone—and undertake to represent objects as colored touches, as having no contours, only demarcations projected on the retina. In limiting the sensibility of the eye to responses to color, by training themselves to perceive shadows as colors in order to break up the tones according to the play of complementary colors, they end up no longer experiencing pure tones; they break them up in their paintings and thereby eliminate luminosity. By their rejection of form and preference for color they render imperfectly the image of nature inherent in the human race."

3 The catalogue of the third exhibition of the Indépendants (March 26–May 3, 1887) lists the following works under "Seurat, Georges, born in Paris.—Boulevard de Clichy, 128 *bis*": *Le Phare de Honfleur* (Collection M. Emile Verhaeren); *La Grève du Bas Butin* (Honfleur) (Collection M. Van Cutsem); *Embouchure de la Seine* (Honfleur); *Le Pont de Courbevoie* (Collection M. Arsène Alexandre); *Entrée du port de Honfleur* (Collection M. Félix Fénéon); *La Maria (Honfleur)*; *Bout de la jetée de Honfleur*; *Poseuse*; twelve sketches; and *Eden Concert* [drawing].

4 Huysmans, "Chronique d'Art," *La Revue Indépendante* (April 1887).

5 Gauguin to his wife, Tahiti [March 1892]; see *Lettres de Gauguin à sa femme et à ses amis*, ed. Maurice Malingue (Paris: Bernard Grasset, 1946), p. 221.

6 Paul Gauguin, *Racontars de rapin* [Atuona, Marquesas Islands, September 1902] (Paris: Falaise, 1951), p. 74. Daniel de Monfreid reports that Gauguin had also warned van Gogh against all systems of painting: division of tones, optical mixture of colors, and so on; see Charles Chassé, *Gauguin et le groupe de Pont-Aven* (Paris: H. Floury, 1921), p. 38.

7 Renoir to Ambroise Vollard; see Ambroise Vollard, *En écoutant Cézanne, Degas, Renoir* (Paris: B. Grasset, 1938), pp. 211–12.

8 Monet to Florent Fels, quoted in Blanche, op. cit., p. 25. However, Monet added a remark to these words that is truly surprising coming from an Impressionist and that one would have expected from a painter of Seurat's inclinations: "One is not an artist if one does not carry the picture in one's imagination before executing it, and if one is not entirely certain of one's craft, of one's composition . . ."; ibid., pp. 25–26.

9 Unpublished letter of Sisley (probably to Auguste-Emile Bergerat), April 21, 1898.

10 Fénéon, "L'Impressionnisme aux Tuileries," *L'Art Moderne* (September 19, 1886), p. 302.

11 Fénéon, "Le Néo-impressionnisme," *L'Art Moderne* (April 15, 1888), p.122. Not all the dotted frames in which Seurat's works appear today were made by the artist himself.

12 Henri-Edmond Cross to Félix Fénéon; unpublished letter.

13 Verhaeren, *Sensations*, p. 202.

14 The catalogue of the fourth exhibition of the Indépendants (March 22–May 3, 1888) lists two canvases, *Poseuses* and *Parade de Cirque;* and eight drawings: *Au Concert Européen, A la Gaîté Rochechouart, Au Divan Japonais, Forte Chanteuse, Dîneur, Lecture, Balayeur, Jeune fille.*

15 *L'Echo du Nord* (Lille), March 29, 1888.

16 "Too Independent. Art Runs Wild at the Pavilion de la Ville de Paris," *New York Herald* (Paris), March 23, 1888.

17 Adam, "Les Impressionnistes à l'exposition des Indépendants," *La Vie Moderne* (April 15, 1888), p. 229.

18 Seurat's entry in the catalogue of the sixth (1889) exhibition of Les XX lists the following works: Paintings. 1. *Les Poseuses;* 2. *Bords de la Seine (Ile de La Grande Jatte);* 3. *Temps gris (idem);* 4. *Port-en-Bessin—Un dimanche;* 5. *Idem—Le Pont et les quais;* 6. *Idem—L'Avant-port (marée haute);* 7. *Idem—L'Avant-port (marée basse);* 8. *Idem—Les Jetées;* 9. *Les Grues et la Percée.* Drawings. 10. *M. Paul Alexis;* 11. *Au Concert Européen;* 12. *A la Gaîté Rochechouart.*

19 Maurice Denis, "De Gauguin et de Van Gogh au classicisme," *L'Occident* (May 1909); reprinted in Maurice Denis, *Théories 1890–1910,* 4th ed. (Paris: L. Rouart and J. Watelin, 1920), pp. 265 and 271. For a comparison of Seurat's and Gauguin's tendencies, see Goldwater, "Some Aspects of the Development of Seurat's Style," *Art Bulletin* (June 1941), pp. 117–30.

20 Seurat to Octave Maus, February 17, 1889; published in Madeleine Octave Maus, *Trente années de lutte pour l'art, 1884–1914* (Paris: Librairie de l'Oiseau Bleu, 1926), p.87. Seurat's price, amounting to 2,555 francs, appears to be very low even for the period if one judges by what Vincent van Gogh wrote his brother in 1888: "In my opinion we must put his big pictures of the "Models" and the "Grande Jatte" down at well—let me see—say 5000 [francs] apiece at the lowest" (Vincent to Theo van Gogh, letter no. 551).

21 Pissarro to Félix Fénéon, February 21, 1889: "At the moment I am trying to master this technique, which ties me down and prevents me from producing with spontaneity of sensation." Signac later tried to explain Pissarro's desertion: "Pissarro seeks balance by adjustments; he very carefully juxtaposes two contrasting tints in order to obtain vibrancy by their opposition, but the outcome, on the contrary, reduces the disparity between these two tints by his introduction of intermediary elements to each of them, which he calls *passages.* But the neo-impressionist technique is based precisely on this contrast, for which he feels no need, and on the radiant purity of tints, which hurts his eye. He has retained only the technique of *divisionism,* the *little dot,* whose raison d'être lies in the very fact that it permits the notation of this contrast and the preservation of this purity. Thus, it is easy to understand why he gave up this manner, given its inadequacy when used in isolation"; Signac, *De Eugène Delacroix,* ch. 4, p. 61.

22 Pissarro to Henri van de Velde, from the original draft found among Pissarro's papers. The letter actually sent to Van de Velde, dated March 27, 1896—a protest against the inclusion of Pissarro's name in a list of Neo-Impressionists—is somewhat shorter.

The Last Works

1 Verhaeren, *Sensations,* p. 199.

2 Seurat showed only three paintings at the fifth exhibition of the Indépendants (September 3–October 4, 1889): *Le Crotoy (aval), Le Crotoy (amont), Port-en-Bessin.*

3 Fénéon, "Exposition des Artistes Indépendants à Paris," *L'Art Moderne* (October 27, 1889), p. 339. He concluded these remarks with the following words of advice: "It is on the colored band that M. Seurat inscribes his name in pale letters. To complete the toilette of these paintings, one should put them under glass and substitute a monogram for the signature, which is always too literary." Signac would occasionally use a monogram, especially when, for a brief period, he assigned numbers to his paintings instead of giving them titles.

4 Pissarro to his son Lucien, September 9, 1889; cited in *Camille Pissarro: Letters to His Son Lucien,* p. 136.

5 Rey, *La Renaissance du sentiment classique,* p. 129.

6 The catalogue of the sixth exhibition of the Indépendants (March 20–April 17, 1890) lists nine paintings and two drawings for "Seurat, 39, passage de l'Elysée des Beaux-Arts": *Le Chahut; Jeune femme se poudrant; Port-en-Bessin, un dimanche; Port-en-Bessin, l'avant-port (marée basse)* (Collection M. de la Hault); *Port-en-Bessin, l'avant-port (marée haute); Port-en-Bessin, entrée de l'avant-port; Les Grues et la Percée; Temps gris, Grande Jatte; Printemps, Grande Jatte; Paul Alexis* [drawing]; *Paul Signac* [drawing].

7 M. de la Montagne, in *Le Salut Public* (Lyons), March 27, 1890.

8 Rey, op. cit., pp. 126–27.

9 Delacroix, quoted in Signac, *De Eugène Delacroix*, ch. 1, p. 20.

10 Theo van Gogh to Vincent, Paris, March 19, 1890; letter no. T29.

11 "Inédits d'Henri-Edmond Cross. V, Feuilles volantes (de toutes dates)," *Le Bulletin de la Vie Artistique* (September 15, 1922), p. 425.

12 The catalogue of the eighth exhibition of Les XX (1891) lists as Seurat's entries: 1. *Chahut; Le Crotoy:* 2. *Amont,* 3. *Aval; Le Chenal de Gravelines:* 4. *Grand Fort Philippe,* 5. *Direction de la Mer,* 6. *Petit Fort Philippe,* 7. *Un Soir.*

13 Champal [Achille Chainaye], reprinted in "Documents à Conserver. Le Carnaval d'un ci-devant: A propos du Salon des XX," *L'Art Moderne* (February 18, 1891), pp. 55–56. The *L'Art Moderne* presentation of this attack, which had appeared in a Belgian magazine, concludes with the observation, "When, sooner or later, a historian will render an account of the vicissitudes of modern art, this piece will be cited." That prophecy is fulfilled here.

14 These extracts were collected in *L'Art Moderne* (March 29, 1891), pp. 102–3, under the heading "A propos des XX." Among others is this morsel: "The city has just closed the exhibition of Les XX. Three visitors succumbed to smallpox, contracted before a painting covered with pockmarks; others are ill. A young woman of society went mad. Finally, there is an unconfirmed report that the wife of a provincial burgomaster, who had imprudently visited the Les XX exhibition while in the family way, has brought forth a tattooed infant." Identical inanities in the Paris press accompanied the early Impressionist exhibitions.

15 Edgar Baes, from an article published in *La Revue Belge*, article reprinted in *L'Art Moderne* (March 29, 1891).

16 The catalogue of the seventh exhibition of the Indépendants (March 20–April 27, 1891) lists five entries for Seurat: *Cirque; Le Chenal de Gravelines: Grand Fort Philippe; Le Chenal de Gravelines: Direction de la mer; Le Chenal de Gravelines: Petit Fort Philippe; Le Chenal de Gravelines: Un soir.*

Angrand, in a letter quoted by Coquiot (Seurat, pp. 166–67), related: "We were at the Pavillon de Paris sitting on a bench in the last hall when Puvis de Chavannes entered with a woman. He looked at the drawings by [Maurice] Denis for *Sagesse* near the door, and slowly made the rounds. 'He will see,' Seurat said to me, 'the mistake I made in the drawing of my horse'—in *The Circus*—but Puvis passed without stopping. This was a cruel blow for Seurat."

17 Fénéon, "Notes inédites de Seurat sur Delacroix [1881]," *Le Bulletin de la Vie Artistique* (April 1, 1922), p. 156.

18 In an unsigned notice (in *Entretiens Politiques et Littéraire*, vol. 2, no. 13 [1891]), which is without doubt from Fénéon's pen, the faithful friend offered a concise review of the painter's life and announced the preparation of the oeuvre catalogue on which he would work until his death in 1944. This notice reads: "On March 29, at thirty-one years of age, Seurat died. He exhibited at: the Salon in 1883; with the Groupe des Artistes Indépendants in 1884; with the Société des Artistes Indépendants in 1884–85, 1886, 1887, 1888, 1889, 1890, and 1891; with the Impressionnistes, rue Laffitte, in 1886; in New York in 1885–86; in Nantes in 1886; with Les XX, Brussels, in 1887, 1889, and 1891; with Blanc et Noir, Amsterdam, in 1888. The catalogue of his works comprises some 170 panels of cigar-box size, 420 drawings, 6 sketchbooks, and some 60 canvases (figures, seascapes, landscapes), among them: five measuring several meters (*Bathers, A Sunday at la Grande Jatte, The Models, Le Chahut, The Circus*) and, probably, numerous masterpieces."

19 Christophe, in *La Plume* (September 1, 1891), p. 292.

20 Pissarro to his son Lucien, March 30, 1891; cited in *Camille Pissarro: Letters to His Son Lucien*, pp. 155–56.

21 Idem, April 1, 1891; ibid., p. 158.

List of Illustrations

PAGE 50

Young Peasant in Blue (The Jockey). 1882. Oil on canvas, 18⅛ × 15″. Musée d'Orsay, Paris

PAGE 52

Man Painting a Boat. 1883. Oil on panel, 6¼ × 9¾″. Courtauld Institute Galleries, London, Courtauld Collection

PAGE 54 (top)

Leg (study for *Bathers, Asnières*). 1883–84. Conté crayon, 9¹/₁₆ × 11¹³/₁₆″. Private Collection

PAGE 54 (bottom)

Reclining Man Listening (study for *Bathers, Asnières*). 1883–84. Conté crayon, 9½ × 11¹³/₁₆″. The Beyeler Collection, Basel

PAGE 55 (left)

The Echo (The Call). 1883. Conté crayon, 12¼ × 9¼″. Yale University Art Gallery, New Haven, Connecticut. Bequest of Edith Malvina K. Wetmore

PAGE 55 (right)

Seated Nude. 1883–84. Conté crayon, 12⅜ × 9½″. Private Collection

PAGE 57

Five Men (study for *Bathers, Asnières*). 1883. Oil on panel. 6 × 9⅞″. Private Collection, Paris

PAGE 59

The River Banks (study for *Bathers, Asnières*). 1883–84. Oil on panel, 6¼ × 9¾″. Glasgow Art Gallery and Museum

PAGE 60

The Rainbow (study for *Bathers, Asnières*). c. 1883. Oil on panel, 6⅛ × 9⅝″. Berggruen Collection, Switzerland

PAGE 61

The Seine with Clothing on the Bank (study for *Bathers, Asnières*). 1883–84. Oil on panel, 6¾ × 10⅜″. Collection Mr. and Mrs. Paul Mellon, Upperville, Virginia

PAGE 62

The Bathers (study for *Bathers, Asnières*). c. 1883–84. Oil on panel, 6 × 9⅝″. Collection Mr. and Mrs. Paul Mellon, Upperville, Virginia

PAGE 63

Horse and Boats (study for *Bathers, Asnières*). 1883–84. Oil on panel, 6¼ × 9⅞″. Collection Mr. and Mrs. Paul Mellon, Upperville, Virginia

PAGE 64

Boys Bathing (study for *Bathers, Asnières*). 1883–84. Oil on panel, 6⅛ × 9⅞″. Musée d'Orsay, Paris

PAGE 65

Banks of the Seine at Suresnes (study for *Bathers, Asnières*). 1883–84. Oil on canvas, 6⅛ × 9½″. The Cleveland Museum of Art. Bequest of Leonard C. Hanna, Jr.

PAGE 66

Study for "Bathers, Asnières." 1884. Oil on panel, 6¼ × 9¾″. National Gallery of Scotland, Edinburgh

PAGE 67

Seated Bather (study for *Bathers, Asnières*). 1883–84. Oil on panel, 6⅞ × 10⅜″. The Nelson-Atkins Museum of Art, Kansas City, Missouri. Nelson Fund

PAGE 68

Final Study for "Bathers, Asnières." 1883. Oil on panel, 6¼ × 9⅞″. The Art Institute of Chicago. Gift of Adele R. Levy Fund, Inc., 1962

PAGE 71

Bathers, Asnières. 1883–84. Oil on canvas, 6′7⅛ × 9′10″. The National Gallery, London

PAGE 72
Final Study for "A Sunday Afternoon on the Island of La Grande Jatte." 1884–85.
Oil on canvas, 27¾ × 41″. The Metropolitan Museum of Art, New York. Bequest of
Sam A. Lewisohn, 1951

PAGE 75 (top left)
Lady with a Parasol (study for "La Grande Jatte"). 1884–85. Conté crayon,
12¼ × 9½″. Collection, The Museum of Modern Art, New York. Bequest of Abby
Aldrich Rockefeller.

PAGE 75 (top right)
Woman with Raised Arms. 1884–85. Conté crayon, 11⁵⁄₁₆ × 7⅞″. Private Collection

PAGE 75 (bottom)
Young Girl Seated, Sewing. 1884–85. Conté crayon, 12 × 9½″. Philadelphia
Museum of Art: The Louis E. Stern Collection

PAGE 76 (top left)
Monkeys (sheet of studies for "La Grande Jatte"). 1884–85. Conté crayon,
11¾ × 8¾″. Private Collection

PAGE 76 (top right)
The Monkey (study for "La Grande Jatte"). 1885. Conté crayon, 6¼ × 9⅛″. The
Metropolitan Museum of Art, New York, Bequest of Miss Adelaide Milton de Groot

PAGE 76 (bottom)
Study for center section of "La Grande Jatte." 1884. Conté crayon, 26 × 18¾″. The
Art Institute of Chicago, The Helen Regenstein Collection

PAGE 78 (top)
Landscape with Dog (study for "La Grande Jatte"). 1884–85. Conté crayon,
16⅛ × 24⅜″. British Museum, London. Bequest of César M. de Hauke

PAGE 78 (bottom)
The Dog (study for "La Grande Jatte"). 1884–85. Conté crayon, 9⁷⁄₁₆ × 12³⁄₁₆″.
Whereabouts unknown

PAGE 79 (top)
Man and Tree (study for "La Grande Jatte"). c. 1884. Conté crayon, 24 × 18″. Von
der Heydt-Museum, Wuppertal, Germany

PAGE 79 (bottom left)
Lady Fishing (study for "La Grande Jatte"). c. 1885. Conté crayon, 12⅛ × 9⅜″.
The Metropolitan Museum of Art, New York, Purchase. Joseph Pulitzer Bequest,
1955, from the Museum of Modern Art, Lizzie P. Bliss Collection

PAGE 79 (bottom right)
Couple Walking (study for "La Grande Jatte"). 1884–85. Conté crayon, 11½ × 9″.
British Museum, London. Bequest of César M. de Hauke

PAGE 80
The Island of La Grande Jatte. 1884. Oil on canvas, 27½ × 33¾″. Collection Mrs.
John Hay Whitney, New York

PAGE 82
Woman Strolling with Parasol (study for "La Grande Jatte"). 1884. Oil on panel,
9⅞ × 6⅛″. Private Collection, Switzerland

PAGE 83 (top)
Study for "La Grande Jatte." 1884–85. Oil on panel, 6⅛ × 9½″. The Metropolitan
Museum of Art, New York. Robert Lehman Collection, 1975

PAGE 83 (bottom)
Study for "La Grande Jatte." 1884. Oil on panel, 6⅛ × 9⅞″. E. G. Bührle
Collection, Zurich

PAGE 84
Study for "La Grande Jatte." 1884. Oil on panel, 6⅛ × 9⅞″. The Art Institute of
Chicago, Gift of Mary and Leigh Block, 1981

PAGE 85–86
A Sunday Afternoon on the Island of La Grande Jatte. 1884–86. Oil on canvas,

6′9¾″ × 10′1¼″. The Art Institute of Chicago, Helen Birch Bartlett Memorial Collection, 1926

PAGE 87 (top)

Study for "La Grande Jatte." 1884. Oil on panel, 6⅛ × 9¾″. Albright-Knox Art Gallery, Buffalo, New York. Gift of A. Conger Goodyear, 1948

PAGE 87 (bottom)

Study for "La Grande Jatte." 1884–85. Oil on panel, 6⅛ × 9½″. Private Collection

PAGE 89

Detail of *A Sunday Afternoon on the Island of La Grande Jatte*

PAGE 90

Detail of *A Sunday Afternoon on the Island of La Grande Jatte*

PAGE 91

Detail of *A Sunday Afternoon on the Island of La Grande Jatte*

PAGE 93

Detail of *A Sunday Afternoon on the Island of La Grande Jatte*

PAGE 94

Detail of *A Sunday Afternoon on the Island of La Grande Jatte*

PAGE 96

Paris, Rue Saint-Vincent in Spring. c. 1884. Oil on panel, 9⅞ × 6⅜″. Fitzwilliam Museum, Cambridge, England

PAGE 99

In the Street. c. 1885. Oil on panel, 6½ × 9¾″. Private Collection, Switzerland

PAGE 101 (top)

Fishing Boats and Barges, High Tide, Grandcamp. 1885. Oil on panel, 6⅛ × 9⅞″. Collection Santara, Geneva

PAGE 101 (bottom)

Beached Boats, Grandcamp. 1885. Oil on panel, 6⅛ × 9⅞″. Collection Santara, Geneva

PAGE 102

Boats, Low Tide, Grandcamp. 1885. Oil on canvas, 25¾ × 32⅛″. Lefevre Gallery, London

PAGE 105

Le Bec du Hoc, Grandcamp. 1885. Oil on canvas, 25½ × 32⅛″. Tate Gallery, London

PAGE 106

Boats Riding at Anchor, Grandcamp. 1885. Oil on canvas, 25⅝ × 31⅞″. Private Collection

PAGE 109

The English Channel at Grandcamp. 1885. Oil on canvas, 26 × 32½″. The Museum of Modern Art, New York. Estate of John Hay Whitney

PAGE 110

Paul Signac. *Against the Enamel of a Background Rhythmic with Beats and Angles, Tones and Colors, Portrait of M. Félix Fénéon in 1890.* Oil on canvas, 29⅛ × 36⅝″. Private Collection

PAGE 117

Alfalfa Fields, Saint-Denis. 1885–86. Oil on canvas, 25¼ × 31⅞″. National Gallery of Scotland, Edinburgh

PAGE 118

The Seine at Courbevoie. c. 1885. Oil on canvas, 32¹⁄₁₆″ × 25⁹⁄₁₆″. Private Collection

PAGE 121

The Shore at Bas-Butin, Honfleur. 1886. Oil on canvas, 25⅜ × 32¼″. Musée des Beaux-Arts, Tournai. Gift of Henri Van Cutsem, 1904

PAGE 122

La Maria, Honfleur. 1886. Oil on canvas, 20¾ × 25″. National Gallery, Prague

PAGE 123

A Corner of the Harbor of Honfleur. 1886. Oil on canvas, 31¼ × 24¾″. Rijksmuseum Kröller-Müller, Otterlo, The Netherlands

PAGE 124

Evening, Honfleur. 1886. Oil on canvas, 25¾ × 32″. The Museum of Modern Art, New York. Gift of Mrs. David M. Levy

PAGE 126

End of the Jetty, Honfleur. 1886. Oil on canvas, 18 × 21¾″. Rijksmuseum Kröller-Müller, Otterlo, The Netherlands

PAGE 127

The Lighthouse at Honfleur. 1886. Oil on canvas, 26¼ × 32¼″. National Gallery of Art, Washington, D. C. Collection Mr. and Mrs. Paul Mellon

PAGE 128

Study for "Le Pont de Courbevoie." c. 1886–87. Conté crayon, 9½ × 12″. Private Collection

PAGE 129

Le Pont de Courbevoie. 1886–87. Oil on canvas, 18 × 21½″. Courtauld Institute Galleries, London, Courtauld Collection

PAGE 132

Théo Van Rysselberghe. *The Reading.* 1903. Oil on canvas, 71¼ × 94⅞″. Museum of Fine Arts, Ghent, Belgium

PAGE 135 (top)

Paul Gauguin. *Still Life: Ripipoint.* 1889. Oil on canvas, 12¾ × 15½″. Private Collection

PAGE 135 (bottom)

Vincent van Gogh. *Interior of a Restaurant, Paris.* 1887. Oil on canvas, 18 × 22¼″. Rijksmuseum Kröller-Müller, Otterlo, The Netherlands

PAGE 136 (top)

Paul Signac. *The Gas Meters at Clichy.* 1886. Oil on canvas, 25⅝ × 31⅞″. National Gallery of Victoria, Melbourne, Australia. Felton Bequest, 1948

PAGE 136 (bottom)

Camille Pissarro. *Charing Cross Bridge, London.* 1890. Oil on canvas, 23⅝ × 36⅜″. National Gallery of Art, Washington, D. C. Collection Mr. and Mrs. Paul Mellon

PAGE 139 (top left)

Portrait of Edmond-Francois Aman-Jean. c. 1883. Conté crayon, 24¾ × 18¾″. The Metropolitan Museum of Art, New York, Bequest of Stephen C. Clark, 1960

PAGE 139 (top right)

Ernest Joseph Laurent. *Portrait of Seurat.* 1883. Charcoal, 15¼ × 11⅜″. Musée du Louvre

PAGE 139 (bottom left)

The Artist's Mother ("Woman Sewing"). c. 1883. Conté crayon, 12⅞ × 9⁷⁄₁₆″. The Metropolitan Museum of Art, New York. Bequest of Joseph Pulitzer, 1955

PAGE 139 (bottom right)

Portrait of Paul Alexis. 1888. Conté crayon, 11¹³⁄₁₆ × 9¹⁄₁₆″. Whereabouts unknown

PAGE 140 (top left)

Madame Seurat Reading (The Artist's Mother). c. 1883. Conté crayon, dimensions unavailable. Private Collection

PAGE 140 (top right)

Man Dining (The Artist's Father). c. 1884. Conté crayon, 12³⁄₁₆ × 8⅝″. Private Collection

Bibliography

Works Devoted Exclusively to Seurat

Monographs and Exhibition Catalogues

Alexandrian, Sarane. *Seurat*. Translated by Alice Sachs. New York: Crown, 1980.

Barr, Alfred H., Jr. *Georges Pierre Seurat: Fishing Fleet at Port-en-Bessin*. New York: Twin Editions, 1945.

————. SEE ALSO *First Loan Exhibition*.

Bean, Jacob. *Seurat: Drawings and Oil Sketches from New York Collections*. Exhibition catalogue. New York: The Metropolitan Museum of Art, 1977.

Bertram, Hilge. *Seurat—Tegninger*. Copenhagen: Wivels Forlag, 1946.

Broude, Norma, ed. *Seurat in Perspective*. The Artists in Perspective Series. Englewood Cliffs, N.J.: Prentice-Hall, 1978.

Christophe, Jules. "Georges Seurat." *Les Hommes d'Aujourd'hui*, no. 368. Paris: Vanier, 1890, pp. 2–4.

Cogniat, Raymond. *Seurat*. Paris: Hypérion, 1951.

Cooper, Douglas. *Georges Seurat. Une Baignade, Asnières*. Gallery Books, No. 9. London: Percy Lund Humphries, 1946.

Coquiot, Gustave. *Seurat*. Paris: Albin Michel, 1924.

Courthion, Pierre. *Georges Seurat*. Translated by Norbert Guterman. New York: Harry N. Abrams, 1968.

Cousturier, Lucie. *Seurat*. Paris: G. Crés & Cie, 1921; 2d rev. ed., 1926.

Dorra, Henri, and John Rewald. *Seurat. L'Oeuvre peint; biographie et catalogue critique*. Paris: Les Beaux Arts, 1959.

George, Waldemar. *Seurat*. Les Albums d'Art Druet, No. 10. Paris: Librairie de France, 1928.

The "Grande Jatte" at 100. The Art Institute of Chicago Museum Studies, vol. 14, no. 2 (1989). Special issue. SEE individual listings under S. Hollis Clayson, Stephen E. Eisenman, Inge Fiedler, Mary Mathews Gedo, John House, Linda Nochlin, Richard Thomson, Michael E. Zimmermann.

Hauke, C. M. de. *Seurat et son oeuvre*. 2 vols. Paris: Gründ, 1961.

Hautecoeur, Louis. *Georges Seurat*. Milan: Fratelli Fabbri, 1972.

Herbert, Robert L. *Seurat's Drawings*. New York: Shorewood Publishers, 1962.

Homer, William Innes. *Seurat and the Science of Painting*. Cambridge: MIT Press, 1964; 1970. SEE reviews by J. Raymond Hodkinson and R. A. Weale.

Kahn, Gustave. *Les Dessins de Georges Seurat (1859–1891)*. 2 vols. Paris: Bernheim-Jeune, 1928. Eng. ed., *The Drawings of Georges Seurat*. Translated by Stanley Appelbaum. 2 vols. New York: Dover, 1971.

Laprade, Jacques de. *Georges Seurat*. Paris: J. Taupin, 1945.

———. *Seurat*. Paris: Somogy, 1952.

Lhote, André. *Georges Seurat*. Rome: Editions de "Valori Plastici," 1922.

———. *Seurat*. Paris: Editions Braun, 1948.

Minervino, Fiorella. *L'Opera completa di Seurat*. Introduction by André Chastel. Milan: Editore Rizzoli, 1972. Fr. ed., *Tout l'oeuvre peint de Seurat*. Paris: Flammarion, 1973.

Muller, Joseph-Emile. *Seurat*. Paris: Fernand Hazan, 1960.

Ogawa, Masataka. *Seurat* (in Japanese). Tokyo: Senshukai, 1978.

Pach, Walter. *Georges Seurat*. New York: Duffield, 1923.

Perruchot, Henri. *La Vie de Seurat*. Paris: Librairie Hachette, 1966.

Rewald, John. *Georges Seurat*. New York: Wittenborn, 1943; rev. ed., 1946. Fr. ed., rev. and enl., Paris: Editions Albin Michel, 1948.

Rich, Daniel Catton. *Seurat and the Evolution of "La Grande Jatte"*. Chicago: University of Chicago Press, 1935. Reprint, New York: Greenwood Press, 1969.

———. SEE ALSO *Seurat. Paintings and Drawings*.

Richardson, John. SEE *Seurat. Paintings and Drawings*.

Roger-Marx, Claude. *Seurat*. Les Artistes nouveaux. Paris: G. Crès & Cie, 1931.

Russell, John. *Seurat*. New York: Frederick A. Praeger, 1965.

Salmon, André. *La Révelation de Seurat*. Brussels: Editions Sélections, 1921.

Seligman, Germain. *The Drawings of Georges Seurat*. New York: Curt Valentin, 1946; 1947.

Seurat. Paintings and Drawings. Edited by Daniel Catton Rich. With an essay on Seurat's drawings by Robert L. Herbert. Exhibition catalogue. Chicago: Art Institute/New York: The Museum of Modern Art, 1958.

Seurat. Paintings and Drawings. Introduction by John Richardson. Exhibition catalogue. London: Artemis, David Carritt Ltd., 1978.

Georges Seurat. Zeichnungen. Essays by Erich Franz and Bernd Growe. Catalogue of exhibition held at Kunsthalle, Bielefeld, and Staatliche Kunsthalle, Baden-Baden. Munich: Prestel-Verlag, 1983.

Stuckey, Charles F. *Seurat*. A Medaenas Monograph on the Arts. Mount Vernon, N.Y.: The Artist's Limited Edition, 1984.

Sutter, Jean. "Recherches sur la vie de Georges Seurat (1859–1891)." 25 mimeographed copies, distributed to the Amis de Georges Seurat. Paris, 1964.

Terrasse, Antoine. *L'Univers de Seurat*. Les Carnets de Dessins. Paris: Scépel, 1976.

Thomson, Richard. *Seurat*. Oxford: Phaidon/Salem, N.H.: Salem House, 1985.

Wilenski, Reginald Howard. *Seurat (1859–1891)*. New York: Pitman, 1951.

Articles

A[bbott], J[ere]. "Woman with a Monkey." *Smith College Museum of Art Bulletin*, no. 15 (June 1934), pp. 12–13.

———. "Two Drawings by Seurat." *Smith College Museum of Art Bulletin*, no. 20 (1939), pp. 19–22.

[Anonymous.] "Ouverture du Salon des XX. L'Instaurateur du Néo-impressionnisme: Georges-Pierre Seurat." *L'Art Moderne*, vol. 12, no. 6 (February 7, 1892), pp. 41–42.

———. "X-Rays Reveal 'Indiscreet' Self-Portrait of Seurat." *New York Times*, February 6, 1958.

Apollonio, Umbro. "Disegni di Georges Seurat." In *Venice. XXV Biennale, 1950. Catalogo*, pp. 175–79.

Bissière. "Notes sur l'art de Seurat." *L'Esprit Nouveau*, vol. 1, no. 1 (October 15, 1920), pp. 13–28.

Blunt, Anthony. SEE Fry, Roger.

Boime, Albert. "Seurat and Piero della Francesca." *Art Bulletin*, vol. 47, no. 2 (June 1965), pp. 265–71.

Bouchot-Saupique, Jacqueline. "Trois dessins de Seurat." *Bulletin des Musées de France*, vol. 12, no. 7 (August 1947), pp. 15–19.

Broude, Norma. "New Light on Seurat's 'Dot': Its Relation to Photo-Mechanical
Color Printing in France in the 1880's." *Art Bulletin*, vol. 56, no. 4 (December
1974), pp. 581–89.

——. "The Influence of Rembrandt Reproductions on Seurat's Drawing Style: A
Methodological Note." *Gazette des Beaux-Arts*, vol. 88, no. 1293 (October 1976),
pp. 155–60.

Carré, J. "Le Grand Art. Georges Seurat." *La Vie* (September 1, 1922).

Chastel, André. "Une source oubliée de Seurat." *Etudes et Documents sur l'Art
français*, vol. 22 (1950–57; published 1959), pp. 400–407.

Chervachidze, A. "Georges Seurat" (in Russian). *Apollon* (Moscow) (July 1911).

Christophe, Jules. "Chromo-Luminaristes. Georges Seurat." *La Plume*, no. 57
(September 1, 1891), p. 292.

Clayson, S. Hollis. "The Family and the Father: The *Grande Jatte* and Its
Absences." *The Art Institute of Chicago Museum Studies*, vol. 14, no. 2 (1989),
pp. 155–64.

Deene, J. F. van. "Georges Seurat." *Maandblad voor Beeldende Kunsten*, vol. 8,
no. 6 (1931), pp. 163–76.

Dorra, Henri. "Re-Naming a Seascape by Seurat." *Gazette des Beaux-Arts*, vol. 51,
no. 1,068 (January 1958), pp. 41–48.

——. "The Evolution of Seurat's Style." In *Seurat. L'Oeuvre peint* . . . , by Henri
Dorra and John Rewald, pp. lxx–cvii. Paris: Les Beaux Arts, 1959.

——. "Seurat's Dot and the Japanese Stippling Technique." *Art Quarterly*, vol.
33, no. 2 (1970), pp. 108–13.

——. "Japanese Sources for Two Paintings by Seurat." *Gazette des Beaux-Arts*,
vol. 114, no. 1448 (September 1989), pp. 95–99.

Dorra, Henri, and Sheila C. Askin. "Seurat's Japonisme." *Gazette des Beaux-Arts*,
vol. 73, no. 1201 (February 1969), pp. 81–94.

Duthuit, Georges. "Seurat's System." *The Listener*, vol. 17, no. 421 (February 3,
1937), pp. 210–11.

——. "Georges Seurat, Voyant et physicien." *Labyrinthe* [Geneva], (December
1946).

Eglinton, Guy. "The Theory of Seurat." *International Studio*, vol. 81 (1925), pp.
113–17. Reprinted in *Reaching for Art*. Boston: May and Co., 1931.

Eisenman, Stephen F. "Seeing Seurat Politically." *The Art Institute of Chicago
Museum Studies*, vol. 14, no. 2 (1989), pp. 211–21.

Fels, Florent. "Les Dessins de Seurat." *L'Amour de l'Art*, vol. 8 (February 1927),
pp. 43–46.

——. "La Peinture française aux XIXe and XXe siècles. Seurat." *A.B.C.
Magazine d'Art*, vol. 3, no. 35 (November 1927), pp. 282–87.

Fénéon, Félix. "Influences: A propos de la *Révélation de Seurat* par A. Salmon." *Le
Bulletin de la Vie Artistique*, vol. 3, no. 1 (January 1, 1922), pp. 11–12.

——. "Précisions concernant Seurat." *Le Bulletin de la Vie Artistique*, vol. 5,
no. 16 (August 15, 1924), pp. 358–60.

——. "Georges Seurat und die öffentliche Meinung." *Der Querschnitt* (October
1926).

——. "Sur Georges Seurat." *Le Bulletin de la Vie Artistique*, vol. 7, no. 20
(November 15, 1926), pp. 347–48.

[Fénéon, Félix.] "Note sur Seurat." *Entretiens Politiques et Littéraires*, vol. 2, no. 13
(1891).

——. "Ecrits sur Georges Seurat." In *Seurat. L'Oeuvre peint* . . . , by Henri
Dorra and John Rewald, pp. x–xxxi. Paris: Les Beaux Arts, 1959.

Fiedler, Inge. "A Technical Evaluation of the *Grande Jatte*." *The Art Institute of
Chicago Museum Studies*, vol. 14, no. 2 (1989), pp. 173–79.

Fry, Roger. "Seurat." *The Dial*, no. 81 (September 1926), pp. 224–32. Reprinted
in *Transformations*. London: Chatto & Windus, 1926; idem, *Seurat*, with
foreword and notes by Anthony Blunt. London: Phaidon, 1965.

——. "Seurat's *La Parade*." *Burlington Magazine*, vol. 55, no. 321 (December
1929), pp. 289–93.

Gage, John. "The Technique of Seurat: A Reappraisal." *Art Bulletin*, vol. 69, no. 3
(September 1987), pp. 448–54.

Gedo, Mary Mathews. "The *Grande Jatte* as the Icon of a New Religion: A Psycho-
Iconographic Interpretation." *The Art Institute of Chicago Museum Studies*, vol.
14, no. 2 (1989), pp. 223–37.

Goldwater, Robert. "Some Aspects of the Development of Seurat's Style." *Art Bulletin*, vol. 23, no. 2 (June 1941), pp. 117–30.

Grohmann, Will. "Seurat." In *Allgemeines Lexikon der bildenden Künstler*, established by Ulrich Thieme and Felix Becker, edited by Hans Vollmer, vol. 30, pp. 539–40. Leipzig: E. A. Seemann, 1936.

Hefting, P. H. "Figuurstudie, Georges Seurat, 1859–1891." *Vereniging Rembrandt. Verslag* (1975), pp. 50–51.

Helion, Jean. "Seurat as a Predecessor." *Burlington Magazine*, vol. 69, no. 400 (July 1936), pp. 4, 8–14.

Herbert, Robert L. "Seurat in Chicago and New York." *Burlington Magazine*, vol. 100, no. 662 (May 1958), pp. 146–55.

————. "Seurat and Jules Chéret." *Art Bulletin*, vol. 40, no. 2 (June 1958), pp. 156–58.

————. "Seurat and Puvis de Chavannes." *Yale University Art Gallery Bulletin*, vol. 25, no. 2 (October 1959), pp. 22–29.

————. "Seurat and Emile Verhaeren: Unpublished Letters." *Gazette des Beaux-Arts*, vol. 54, no. 1091 (December 1959), pp. 315–28.

————. "Seurat." In *Encyclopedia of World Art*, vol. 12, cols. 883–886. New York: McGraw-Hill Book Company, 1966.

————. "Seurat's Theories." In *The Neo-Impressionists*, edited by Jean Sutter, pp. 23–42. Greenwich, Conn.: New York Graphic Society, 1970.

————. " 'Parade de Cirque' de Seurat et l'esthétique scientifique de Charles Henry." *Revue de l'Art*, no. 50 (1980), pp. 9–23.

Herz-Fischler, Roger. "An Examination of Claims Concerning Seurat and 'The Golden Number.'" *Gazette des Beaux-Arts*, vol. 101, no. 1,370 (March 1983), pp. 109–12.

Hildebrandt, Hans. "Neo Impressionisten. XI, Georges Seurat." *Aussaat. Zeitschrift für Kunst und Wissenschaft*. vol. 2, nos. 3–4 (August–October 1947).

Hodkinson, J. Raymond. Review of *Seurat and the Science of Painting* by William Innes Homer. *Journal of the Optical Society of America*, vol. 56, no. 2 (February 1966), pp. 262–63.

Homer, William Innes. "Seurat's Port-en-Bessin." *Minneapolis Institute of Arts Bulletin*, no. 2 (Summer 1957), pp. 17–41.

————. "Seurat's Formative Period: 1880–1884." *The Connoisseur*, vol. 142, no. 571 (September 1958), pp. 58–62.

————. "Notes on Seurat's Pallette." *Burlington Magazine*, vol. 101, no. 674 (May 1959), pp. 192–93.

————. "Further Remarks on Seurat's Port-en-Bessin." *Minneapolis Institute of Arts Bulletin* (October–December 1959), pp. 12–15.

Honig, A.-J. "Seurat." In *Dictionnaire biographique des artistes contemporains*, edited by Edouard-Joseph, vol. 3, pp. 293–96. Paris: Librairie Grund, 1934.

House, John. "Meaning in Seurat's Figure Paintings." *Art History*, vol. 3, no. 3 (September 1980), pp. 345–56.

————. "Reading the *Grande Jatte*." *The Art Institute of Chicago Museum Studies*, vol. 14, no. 2 (1989), pp. 115–31.

Huyghe, René. "Trois Poseuses de Seurat." *Bulletin des Musées de France*, vol. 12, no. 7 (August 1947), pp. 7–14.

Jamot, Paul. "Une Etude pour le 'Dimanche à la Grande Jatte,' de Seurat." *Bulletin des Musées de France*, vol. 2, no. 3 (March 1930), pp. 49–52.

Jedlicka, Gotthard. "Die Zeichnungen Seurats." *Galerie und Sammler* [Zurich] (October–November 1937).

Kahn, Gustave. "Seurat." *L'Art Moderne*, vol. 11, no. 14 (April 5, 1891), pp. 107–10.

Kuchling, Heimo. "Die moderne Kunst auf der XXV. Biennale." *Kunst ins Volk*, vol. 2, nos. 7/8 (July–August 1950), p. 304. Review of exhibition of Seurat's drawings in the main pavilion.

Langaard, Johan H. "Georges Seurat." *Kunst og Kultur*, vol. 9 (1921), pp. 32–41.

Leclercq, Julien. "Exposition Georges Seurat." *La Chronique des Arts*, no. 13 (March 31, 1900), p. 118.

Lee, Alan. "Seurat and Science." *Art History*, vol. 10, no. 2 (June 1987), pp. 203–26.

Lévy-Gutmann, Anny. "Seurat et ses amis." *Art et Décoration*, vol. 63 (1934), pp. 36–37.

Longhi, Roberto. "Un disegno per La Grande-Jatte e la cultura formale di Seurat." *Paragone*, vol. 1, no. 1 (January 1950), pp. 40–43.

Mabille, Pierre. "Dessins inédits de Seurat." *Minotaure*, vol. 3, no. 11 (1938), pp. 2–9.

Manson, J. B. "La Baignade." *Apollo*, vol. 1, no. 5 (May 1925), pp. 299–300.

Marx, Roger. "Seurat." *Le Voltaire* (1891).

M[iomandre], F[rancis de]. "Le Mois Artistique: Exposition Georges Seurat, Galerie Bernheim jeune et Cie." *L'Art et les Artistes*, vol. 4, no. 47 (February 1909), pp. 227–28.

Natanson, Thadée. "Un primitif d'aujourd'hui, Georges Seurat." *La Revue Blanche* (April 15, 1900), p. 613.

Newmarch, Anthony. "Seurat." *Apollo*, vol. 32 (July 1940), pp. 11–12.

Nicolson, Benedict. "Seurat's *La Baignade*." *Burlington Magazine*, vol. 79 (November 1941), pp. 139–46.

————. "The Literature of Art: Reflections on Seurat." *Burlington Magazine*, vol. 104, no. 710 (May 1962), pp. 213–14.

Niehaus, Kasper. "Georges Seurat." *Elsevier's Geillustreerd Maandschrift*, vol. 79, no. 5 (May 1930), pp. 297–312.

Nochlin, Linda. "Seurat's Grande Jatte: An Anti-Utopian Allegory." *The Art Institute of Chicago Museum Studies*, vol. 14, no. 2 (1989), pp. 133–53.

Ozenfant [Amédée]. "Seurat." *Cahiers d'Art*, vol. 1 (September 1926), p. 172.

Pach, Walter. "Georges Seurat (1859–1891)." *The Arts*, vol. 3, no. 5 (March 1923), pp. 161–74. Reprinted in the Arts Monographs series, New York, Duffield, 1923.

Parker, Robert Allerton. "The Drawings of Georges Seurat." *International Studio* (September 1928), pp. 17–23.

Pearson, Eleanor. "Seurat's Le Cirque." *Marsyas*, vol. 19 (1977–78), pp. 45–51.

Prak, Niels Luning. "Seurat's Surface Pattern and Subject Matter." *Art Bulletin*, vol. 53, no. 3 (September 1971), pp. 367–78.

Rewald, John. "Seurat. The Meaning of the Dots." *Art News*, vol. 48, no. 2 (April 1949), pp. 24–27, 61–63. Reprinted in *Studies in Post-Impressionism*. New York: Harry N. Abrams, 1986.

————. "La Vie et l'oeuvre de Georges Seurat." In *Seurat. L'Oeuvre peint . . .*, pp. xxxiii–lxxviii. Paris: Les Beaux Arts, 1959.

Rey, Robert. "A propos du Cirque de Seurat au Musée du Louvre." *Beaux-Arts*, vol. 4, no. 6 (March 15, 1926), pp. 87–88.

R[itchie], A[ndrew] C[arnduff]. "Purchases. An Important Seurat." *Albright Art Gallery, Gallery Notes*, vol. 10, no. 1 (May 1943), pp. 4–5.

Roger-Marx, Claude. "Georges Seurat." *Gazette des Beaux-Arts*, vol. 69, no. 782 (December 1927), pp. 311–18.

————. "Les Arts graphiques. Les Dessins de Seurat." *L'Europe Nouvelle*, vol. 12, no. 570 (January 12, 1929), p. 46.

Salmon, André. "Georges Seurat." *Burlington Magazine*, vol. 37, no. 210 (September 1920), pp. 114–22.

————. "Seurat." *L'Art Vivant*, no. 37 (1926), pp. 525–27.

Schapiro, Meyer. "Seurat and 'La Grande Jatte'." *Columbia Review*, vol. 17, no. 1 (November 1935), pp. 9–16.

————. "New Light on Seurat." *Art News*, vol. 57, no. 2 (April 1958), pp. 22–24, 44–45, 52. Reprinted in *Modern Art. 19th and 20th Centuries. Selected Papers*. New York: George Braziller, 1978.

————. "Seurat: Reflection." *Art News Annual*, vol. 29 (1964), pp. 23, 38.

Semin, Didier. "Note sur Seurat et le cadre." *Avant-Guerre* [Etienne, France], vol. 2 (1981), pp. 53–59.

Sitwell, Osbert. "Les Poseuses." *Apollo*, vol. 3, no. 18 (June 1926), p. 345.

Stumpel, Jeroen. "*The Grande Jatte*, That Patient Tapestry." *Simiolus. Netherlands Quarterly for the History of Art*, vol. 14, nos. 3/4 (1984), pp. 209–24.

Thomson, Richard. "The *Grande Jatte*: Notes on Drawing and Meaning." *The Art Institute of Chicago Museum Studies*, vol. 14, no. 2 (1989), pp. 181–97.

Van de Velde, Henry. "Georges Seurat." *La Wallonie*, vol. 6, nos. 3/4, (April 1891), pp. 167–71.

Venturi, Lionello. "The Art of Seurat." *Gazette des Beaux-Arts*, vol. 26, nos. 929–
934 (July–December 1944; published September 1947), pp. 421–30.

Verhaeren, Emile. "Georges Seurat." *La Société Nouvelle*, vol. 7, no. 1 (April
1891), pp. 429–38. Reprinted in idem, *Sensations*. Paris: G. Crès & Cie, 1927.

———. "Georges Seurat." *L'Art Moderne*, vol. 15, no. 13 (April 1, 1900), p. 104.

———. "Notes: Georges Seurat." *La Nouvelle Revue Française*, no. 1 (February 1,
1909), p. 92.

Walter, François. "Du paysage classique au surréalisme. Seurat." *La Revue de
l'Art*, vol. 63 (1933), pp. 165–76.

Watt, Alexander. "Notes from Paris. The Art of Georges Seurat." *Apollo*, vol. 23,
no. 135 (March 1936), pp. 168–69.

Wauters, A. J. "Aux XX, Seurat, La Grande Jatte." *La Gazette* [Brussels] (February
28, 1887).

Weale, R. A. Review of *Seurat and the Science of Painting* by William Innes
Homer. *Palette*, no. 40 (1972), pp. 16–23.

Werner, Bruno E. "Georges Seurat." *Die Kunst*, vol. 65, no. 5 (February 1932),
pp. 147–51.

Wyzewa, Téodor de. "Georges Seurat." *L'Art dan les Deux Mondes*, no. 22 (April
18, 1891), pp. 263–64.

Zervos, Christian. *"Un Dimanche à la Grande Jatte* et la technique de Seurat."
Cahiers d'Art, vol. 3 (1928), pp. 361–75.

Zimmermann, Michael E. "Seurat, Charles Blanc, and Naturalist Art Criticism."
The Art Institute of Chicago Museum Studies, vol. 14, no. 2 (1989), pp. 199–
209.

General Works with References to Seurat

Books and Exhibition Catalogues

[Aman-Jean, Edmond.] *Souvenir d'Aman-Jean (1859–1936)*. Introduction by
François Aman-Jean. Exhibition catalogue. Paris: Musée des Arts Décoratifs,
1970.

Aman-Jean, François. *L'Enfant oublié. Chronique*. Paris: Buchet/Chastel, 1963.

[Angrand, Charles.] *Charles Angrand. Correspondances 1883–1926*. Edited by
François Lespinasse. Rouen: Privately printed, 1988.

Apollinaire, Guillaume. *Les Peintres cubistes*. Paris: E. Figuière, 1913. Eng. ed.,
The Cubist Painters. New York: Wittenborn, 1944; 2d rev. ed., 1949.

Aurier, G. Albert. *Oeuvres posthumes*. Paris: Mercure de France, 1893.

Basler, Adolphe, and Charles Kunstler. *Le Dessin et la gravure modernes en France*.
Paris: G. Crès & Cie, 1930.

Bell, Clive. *Landmarks in Nineteenth Century Painting*. New York: Harcourt,
Brace, 1927.

Berson, Ruth, ed. *The New Painting 1874–1886. Documentation*. 2 vols. San
Francisco: Fine Arts Museums of San Francisco, distributed by the University of
Washington Press, Seattle, 1990.

Bourgeois, Stephan. *The Adolf Lewisohn Collection of Modern French Paintings and
Sculptures*. New York: Weyhe, 1928.

Brettell, Richard, and Scott Schaefer, Sylvie Gache-Patin, and Françoise Heilbrun.
A Day in the Country: Impressionism and the French Landscape. New York: Harry
N. Abrams, 1984.

Brizio, Anna Maria. *Ottocento novocento*. Turin: Ed. Torinesi, 1939.

Bulliet, Clarence Joseph. *The Significant Moderns and Their Pictures*. New York:
Covici, Friede, 1936.

Callen, Anthea. *Techniques of the Impressionists*. London: Orbis, 1982.

Canning, Susan Marie. *A History and Critical Review of the Salon of "Les Vingts,"
1884–1893*. Ann Arbor, Mich.: University Microfilms International, 1982.

Cheney, Sheldon. *The Story of Modern Art*. New York: Viking Press, 1941.

Clark, T. J. *The Painting of Modern Life: Paris in the Art of Manet and His
Followers*. Princeton: Princeton University Press, 1984.

Cooper, Douglas. *The Courtauld Collection*. London: University of London, The
Athlone Press, 1954.

Coquiot, Gustave. *Les Indépendants, 1884–1920*. Paris: Librairie Ollendorff, 1921.

———. *Des Peintres maudits*. Paris: Delpuech, 1924.

[Cross, Henri-Edmond.] Compin, Isabelle. *H.-E. Cross.* Preface by Bernard
　　Dorival. Paris: Quatre Chemins, 1964.

Denis, Maurice. *Théories, 1890–1910.* Paris: Bibliothèque de l'Occident, 1912.

Deri, Max. *Die Malerei im XIX. Jahrhunderts.* Berlin: P. Cassirer, 1919.

――――. *Die neue Malerei.* 6th ed. Leipzig: Seeman, 1921.

Dorival, Bernard. *Les Etapes de la peinture française contemporain.* Vol. 1, *De
　　impressionnisme au fauvisme, 1883–1905.* Paris: Gallimard, 1943.

[Dubois-Pillet, Albert.] Bazalgette, Lily. *Albert Dubois-Pillet. Sa vie et son oeuvre
　　(1846–1890).* Paris: Gründ Diffusion, 1976.

Faure, Elie. *Histoire de l'art: L'Art moderne.* Paris: G. Crès & Cie, 1924.

[Fénéon, Félix.] *Félix Fénéon. Oeuvres.* Introduction by Jean Paulhan. Paris:
　　Gallimard, 1948.

――――. *Félix Fénéon. Au-delà de l'impressionnisme.* Edited by Françoise Cachin.
　　Miroirs de l'Art. Paris: Hermann, 1966.

――――. *Félix Fénéon. Oeuvres plus que complètes.* Edited by Joan U. Halperin. 2
　　vols. Geneva: Librairie Droz, 1970.

――――. SEE ALSO Halperin, Joan Ungersma.

Fénéon, Félix, ed. *L'Art moderne et quelques aspects de l'art d'autrefois.* 2 vols.
　　Paris: Bernheim-Jeune, 1919.

[Fénéon, Félix; Paul Adam; Jean Moréas; and Oscar Méténier.] *Petit Bottin des
　　lettres et des arts.* Paris: E. Giraud, 1886.

First Loan Exhibition. Cézanne, Gauguin, Seurat, van Gogh. Introduction by Alfred
　　H. Barr, Jr. Exhibition catalogue. New York: The Museum of Modern Art, 1929.

Focillon, Henri. *La Peinture aux XIXe et XXe siècles.* Paris: Laurens, 1928.

Fontainas, André. *Histoire de la peinture française au XIXe siècle.* Paris: Edition du
　　Mercure de France, 1906.

Fontainas, André, and Louis Vauxcelles. *Histoire générale de l'art français de la
　　révolution à nos jours.* Paris: Librairie de France, 1922.

Francastel, Pierre. *L'Impressionnisme. Les Origines de la peinture moderne de Monet
　　à Gauguin.* Paris: La Librairie Belles Lettres, 1937.

George, Waldemar. *Le Dessin français de David à Cézanne.* Paris: Editions du
　　Chroniques au jour, 1929.

――――. *Profits et pertes de l'art contemporain.* Paris: Editions du Chroniques du
　　jour, 1931–32.

[Gogh, Vincent van.] *The Letters of Vincent van Gogh to His Brother, 1872–1886.
　　With a Memoir by His Sister-in-Law, J. van Gogh-Bonger.* 2 vols. New York:
　　Houghton Mifflin, 1927.

――――. *Further Letters of Vincent van Gogh to His Brother, 1886–1889.* New York:
　　Houghton Mifflin, 1929.

――――. *The Complete Letters of Vincent van Gogh.* 3 vols. Greenwich, Conn.: New
　　York Graphic Society, 1958; 2d ed., 1959.

Gómez de la Serna, Ramón. *Ismos.* Buenos Aires: Editorial Poseidon, 1943.

Gordon, Jan. *Modern French Painters.* London: Bodley Head, 1923; new ed.,
　　London: John Lane, 1929.

Halperin, Joan Ungersma. *Félix Fénéon. Aesthete & Anarchist in Fin-de-Siècle Paris.*
　　Foreword by Germaine Brée. New Haven: Yale University Press, 1988.

Hamann, Richard. *Der Impressionismus in Leben und Kunst.* Marburg: Kunst-
　　historisches Seminar, 1908.

Hamilton, George Heard. *Painting and Sculpture in Europe 1880 to 1940.* The
　　Pelican History of Art. Baltimore: Penguin Books, 1967.

Henning, Edward B. *Creativity in Art & Science.* Exhibition catalogue. Cleveland:
　　Cleveland Museum of Art, 1987.

Herbert, Robert L. *Neo-Impressionism.* Exhibition catalogue. New York: Solomon R.
　　Guggenheim Museum, 1968.

Herrmann, Curt. *Der Kampf um den Stil. Probleme der modernen Malerei.* Berlin:
　　Erich Reiss Verlag, 1911.

[Herrmann, Curt.] *Curt Herrmann 1854–1929. Ein Maler der Moderne in Berlin.*
　　Edited by Rolf Bothe. Berlin: Berlin Museum and Verlag Willmuth Arenhövel,
　　1989.

Hildebrandt, Hans. *Die Kunst des 19. und 20. Jahrhunderts.* Handbuch der
　　Kunstwissenschaft. Potsdam: Akademische Verlagsgesellschaft Athenaion, 1931.

Holl, J. C. *Après l'impressionnisme.* Paris: Librairie de XXe Siècle, 1910.

House, John, and Mary Anne Stevens, eds. *Post-Impressionism: Cross-Currents in European Painting*. Exhibition catalogue. London: Royal Academy of Arts, published in association with Weidenfeld and Nicolson, London, 1979.

Hughes, Robert. *The Shock of the New*. New York: Alfred A. Knopf, 1981.

Huyghe, René. *Histoire de l'art contemporain: La Peinture*. Paris: Alcan, 1934.

Huyghe, René, ed. *Histoire de l'art contemporain*. Paris: L'Amour de l'Art, 1933.

Impressionist and Post-Impressionist Masterpieces. The Courtauld Collection. Essays by Dennis Farr; John House; Robert Bruce-Gardner, Gerry Hedley, and Caroline Villers. Exhibition catalogue. New Haven: Yale University Press, for the International Exhibitions Foundation, Washington, D.C. and the Courtauld Institute Galleries, London, 1987.

Klingsor, Tristan L. *La Peinture*. Paris: F. Rieder, 1921.

Kröller-Müller, H. *Die Entwicklung der modernen Malerei*. Leipzig: Klinkhardt & Biermann, 1927.

Kuroe, Mitsuhiko. *Pissarro/Sisley/Seurat* (in Japanese). Tokyo: Shueisha, 1973.

Laver, James. *French Painting and the Nineteenth Century*. London: Batsford/New York: C. Scribner's, 1937.

Lebensztejn, Jean-Claude. *Chahut*. Paris, 1989.

Lee, Ellen Wardwell. *The Aura of Neo-Impressionism: The W. J. Holliday Collection*. Exhibition catalogue. Indianapolis: Indianapolis Museum of Art/Indianapolis University Press, 1983.

Lehel, Franz. *Notre art dément*. Paris: H. Jonquières, 1926.

Lewisohn, Sam Adolph. *Painters and Personality. A Collector's View of Modern Art*. New York: Harper, 1937.

Lhote, André. *La Peinture*. Paris: Denoël et Steele, 1933.

———. *Peinture d'abord*. Paris: Denoël, 1942.

Lovgren, Sven. *The Genesis of Modernism*. Stockholm: Almqvist & Wiksell, 1959; rev. ed., *The Genesis of Modernism: Seurat, Gauguin, van Gogh and French Symbolism in the 1880's*. Bloomington: Indiana University Press, 1971.

Mabille, Pierre. *Conscience lumineuse, conscience picturale*. Paris, 1989.

Les Maîtres de l'impressionnisme et leur temps. Exposition d'art français. Preface by H. Fierens-Gevaert. Entries by Marguerite Devigne and Arthur Laes. Exhibition catalogue. Brussels: Musée Royal des Beaux-Arts, 1922.

Mather, Frank Jewett. *Modern Painting*. New York: H. Holt, 1927.

Mauclair, Camille. *The French Impressionists*. London: Duckworth, 1903.

———. *L'Art indépendant français sous la IIIe République*. Paris: La Renaissance du Livre, 1919.

Maus, Madeleine Octave. *Trente années de lutte pour l'art, 1884–1914*. Brussels: Librairie de l'Oiseau Bleu, 1926. Reprint, Brussels: Lebeer Hossmann, 1980.

Meier-Graefe, Julius. *Der moderne Impressionismus*. Berlin: J. Bard, 1903.

———. *Entwicklungsgeschichte der moderner Kunst*. 3 vols. Stuttgart: J. Hofmann, 1904; 2d ed., enl., Munich: Piper, 1927. Eng. ed., *Modern Art*. Translated by Florence Simmonds and George W. Chrystal. 2 vols. London: W. Heinemann/New York: G. P. Putnam's Sons, 1908.

Mellerio, André. *Le Mouvement idéaliste en peinture*. Paris: Floury, 1896.

Moffett, Charles S., ed. *The New Painting: Impressionism 1874–1886*. An exhibition organized by the Fine Arts Museums of San Francisco with the National Gallery of Art, Washington, D.C. Geneva, Switz.: Richard Burton, Publishers, distributed in the United States by the University of Washington Press, Seattle, 1986.

Moore, George. *Confessions of a Young Man* (1886). Edited and annotated by George Moore in 1904 and again in 1916. Introduction by Robert M. Coates. New York: G. P. Putnam's Sons, Capricorn Books, 1959.

———. *Modern Painting*. New, enl. ed. London: Walter Scott, 1898.

Muther, Richard. *The History of Modern Painting*. Rev. ed. London: J. M. Dent/New York: E. P. Dutton, 1907.

———. *Geschichte der Malerei*. Vol. 3, *18. und 19. Jahrhundert*. Leipzig: K. Grethlein, 1909.

Nochlin, Linda, ed. *Impressionism and Post-Impressionism 1874–1904*. Sources and Documents. Englewood Cliffs, N.J.: Prentice-Hall, 1966.

Novotny, Fritz. *Cézanne und das Ende der wissenschaftlichen Perspektive*. Vienna: A. Schroll, 1938.

Osborn, Max. *Geschichte der Kunst*. Berlin: Ullstein, 1910.

Ozenfant, Amédée, and Charles Edouard Jeanneret. *La Peinture moderne*. Paris: G. Crès & Cie, 1925.

Pach, Walter. *The Masters of Modern Art*. New York: Viking Press, 1929.

Pica, Vittorio. *Gl'impressionisti francesi*. Bergamo: Arti Grafiche, 1908.

[Pissarro, Camille.] *Camille Pissarro: Letters to His Son Lucien*. Edited with the assistance of Lucien Pissarro by John Rewald. Translated by Lionel Abel. New York: Pantheon, 1944; rev. and enl. ed., Mamaroneck, N.Y.: Paul P. Appel, 1972. Reprint, Santa Barbara and Salt Lake City: Peregrine Smith, 1981.

Raphael, Max. *Von Monet zu Picasso*. Munich-Leipzig: Delphin Verlag, 1913.

————. *Proudhon, Marx, Picasso. Trois études sur la sociologie de l'art*. Paris: Excelsior, 1933.

Ratliff, Floyd. *Paul Signac and Color in Neo-Impressionism*. With an English translation of *From Eugène Delacroix to Neo-Impressionism* by Paul Signac, translated by Willa Sherman, edited by Floyd Ratliff. Berkeley: University of California Press, 1990.

Régnier, Henri de. *Vestigia flammae*. Paris: Editions du Mercure de France, 1929.

Rewald, John. *The History of Impressionism*. New York: Museum of Modern Art, 1946; 1955; rev. and enl., 1961; 1973.

————. *Post-Impressionism: From Van Gogh to Gauguin*. New York: Museum of Modern Art, 1956; 1962; 3d ed., rev. 1978; 1982.

Rey, Robert. *La Renaissance du sentiment classique. Degas—Renoir—Gauguin—Cézanne—Seurat*. Paris: Les Beaux-Arts, 1931.

Richardson, Edgar Preston. *The Way of Western Art, 1776–1914*. Cambridge: Harvard University Press, 1939.

Richardson, John Adkins. *Modern Art and Scientific Thought*. Urbana: University of Illinois Press, 1971.

Robb, David M., and Jane J. Garrison. *Art in the Western World*. New York: Harper and Brothers, 1935; rev. ed., 1942; 3d ed., 1953; 4th ed., 1963.

Roskill, Mark. *Van Gogh, Gauguin and the Impressionist Circle*. Greenwich, Conn.: New York Graphic Society, 1970.

Salmon, André. *Peindre*. Paris: La Sirène, 1921.

————. *Propos d'atelier*. Paris: G. Crès & Cie, 1922.

Schilderijen uit de Divisionistische School van Georges Seurat to Jan Toorop. Exhibition catalogue. Rotterdam: Museum Boymans, 1937.

Signac, Paul. *D'Eugène Delacroix au Néo-impressionnisme*. Paris: Editions de La Revue Blanche, 1899. Reprint, edited by Françoise Cachin. Paris: Hermann, 1964. SEE ALSO Ratliff, Floyd.

Sutter, Jean, ed. *The Neo-Impressionists*. With contributions by Robert L. Herbert, Isabelle Compin, Pierre Angrand, Lily Bazalgette, Alan Fern, Pierre Eberhart, Francine-Claire Legrand, Henri Thévenin, Marie-Jeanne Chartram-Hebbelinck. Translations from the French by Chantal Deliss. Greenwich, Conn.: New York Graphic Society, 1970.

Sweeney, James Johnson. *Plastic Redirections in 20th Century Painting*. Chicago: University of Chicago Press, 1934.

Thomson, Belinda. *The Post-Impressionists*. Oxford: Phaidon, 1983.

Thorold, Anne, ed. *Artists, Writers, Politics: Camille Pissarro and His Friends*. Exhibition catalogue. Oxford: Ashmolean Museum, 1980.

Van de Velde, E. *Die Renaissance im modernen Kunstgewerbe*. Rev. ed. Berlin: Cassirer, 1903.

Van de Velde, Henry. *Geschichte meines Lebens*. Edited by Hans Curjel. Munich: R. Piper, 1962.

Venturi, Lionello. *Les Archives de l'impressionnisme. Lettres de Renoir, Monet, Pissarro, Sisley et autres. Mémoires de Paul Durand-Ruel. Documents*. 2 vols. Paris/New York: Durand-Ruel, 1939.

Verhaeren, Emile. *Sensations*. Paris: G. Crès & Cie, 1927.

Volavka, Vojtěch. *Malirsky rukopis*. Prague: Statni Graficla Scola, 1934.

Waldmann, Emil. *Die Kunst des Realismus und des Impressionismus im 19. Jahrhundert*. Berlin: Propyläen Verlag, 1927.

[Whistler, James Abbott McNeill.] *From Realism to Symbolism: Whistler and His World*. Essays by Allen Staley and Theodore Reff. Exhibition catalogue. New York: Wildenstein/Philadelphia Museum of Art, 1971.

Wilenski, Reginald Howard. *Modern French Painters*. New York: Reynal & Hitchcock, 1940.

Wright, Willard Huntington. *Modern Painting*. New York: J. Lane, 1915.

Articles

Adam, Paul. "Les Peintres impressionnistes." *La Revue Contemporaine, Littéraire, Politique et Philosophique*, vol. 4, no. 4 (April–May 1886), pp. 541–51.

——. "Les Impressionnistes à l'exposition des Indépendants." *La Vie Moderne*, vol. 10, no. 15 (April 15, 1888), pp. 228–29.

Ajalbert, J. "Le Salon des impressionnistes." *La Revue Moderne* [Marseille], no. 30 (June 20, 1886), pp. 385–93.

Alexandre, Arsène. "Critique decadente." *L'Evénement*, December 10, 1886.

——. "La Semaine artistique." *Paris* (March 26, 1888).

——. "Le Mouvement artistique: Exposition des Indépendants." *Paris* (August 13, 1888).

Alexis, Paul. SEE Trublot.

[Anonymous.] "An Exhibition at New York." *Art Age* [New York], (April 1886).

——. "The French Impressionists." *New York Daily Tribune*, April 10 and 16, 1886.

——. "The Impressionists." *The Sun* [New York], April 11, 1886.

——. "The French Impressionists." *The Critic* (April 17, 1886), pp. 195–96.

——. "The Impressionists—No. III." *New York Mail and Express*, April 24, 1886.

——. "Les Vingtistes parisiens." *L'Art Moderne*, vol. 6, no. 26 (June 27, 1886), pp. 201–4.

——. "Ouverture du Salon des XX." *L'Art Moderne*, vol. 7, no. 5 (January 30, 1887), pp. 37–38.

——. Notice in *Le Matin*, February 7, 1887.

——. "Too Independent. Art Runs Wild at the Pavillon de la Ville de Paris." *New York Herald* [Paris], March 23, 1888.

——. Notice in *L'Echo du Nord* [Lille], March 29, 1888.

——. "Néo-impressionnisme." *L'Art Moderne*, vol. 8, no. 46 (November 11, 1888), pp. 365–67.

——. "Aux XX." *L'Art Moderne*, vol. 9, no. 5 (February 3, 1889), pp. 33–34.

——. "Types d'artistes." *L'Art Moderne*, vol. 10, no. 9 (March 2, 1890), pp. 65–67.

——. Notice in *Moniteur de l'Armée* (April 4, 1890).

——. "Documents à Conserver. Le Carnaval d'un ci-devant: A propos du Salon des XX." *L'Art Moderne*, vol. 11, no. 7 (February 15, 1891), pp. 55–56.

——. "Documents à Conserver: A propos des XX." *L'Art Moderne*, vol. 11, no. 13 (March 29, 1891), pp. 102–3.

——. "Quelques esquisses et dessins de Georges Seurat." *Documents*, no. 4 (September 1929).

Basler, Adolphe. "Le Problème de la forme depuis Cézanne, 1." *L'Amour de l'Art*, vol. 11, no. 9 (September 1930), pp. 361–64.

Bernard, Emile. "Souvenirs." *La Rénovation Esthetique* (April 1909).

Block, Jane, "A Study in Belgrade Neo-Impressionist Portraiture." *The Art Institute of Chicago Museum Studies*, vol. 13, no. 1 (1987), pp. 37–51.

Boime, Albert. "The Teaching of Fine Arts and the Avant-garde in France during the Second Half of the Nineteenth Century." *Arts Magazine*, vol. 60, no. 4 (December 1985), pp. 46–57.

Bouillon, Jean-Paul. "L'Impressionnisme." *Revue de l'Art*, no. 51 (1981), pp. 75–85.

Brettell, Richard R. "The Bartletts and the *Grande Jatte:* Collecting Modern Painting in the 1920s." *The Art Institute of Chicago Museum Studies*, vol. 12, no. 2 (1986), pp. 103–13.

Cachin-Signac, Ginette. "Autour de la correspondance de Signac." *Arts* (September 7, 1951), p. 8. Contains letters from Seurat and Pissarro to Signac. Published also as "Documenti inediti sul neoimpressionismo." *La Biennale di Venezia*, no. 6 (October 1951), pp. 20–23.

Christophe, Jules. "Les Evolutionnistes du Pavillon de la Ville de Paris." *Le Journal des Artistes* (April 24, 1887).

——. "Les Néo-impressionnistes au Pavillon de la Ville de Paris." *Le Journal des Artistes* (May 6, 1888).

Clarétie, Jules. Notice in *Le Temps*, May 1884.

Cousturier, Edmond. "Société des artistes Indépendants." *L'Endehors* (March 27, 1892).

———. "L'Art aux murs." *L'Endehors*, vol. 2, no. 62 (July 10, 1892).

Darzens, Rodolphe. "Chronique artistique: Exposition des Impressionnistes." *La Pléiade*, vol. 1 (May 1886), pp. 88–91.

Dorra, Henri. "Charles Henry's 'Scientific' Aesthetic." *Gazette des Beaux-Arts*, vol. 74, no. 1211 (December 1969), pp. 345–56.

F., R. M. "Notes on Some Modern Drawings." *Art Institute of Chicago Bulletin* (1927).

Faramond, F. de. Article on the Exhibition of the Indépendants. *La Vie Franco-Russe* (March 25, 1888).

Fénéon, Félix. "Les Impressionnistes en 1886." *La Vogue*, vol. 1, no. 8 (June 13–20, 1886), pp. 261–75. Reprint, *Les Impressionnistes en 1886*. Paris: La Vogue, 1886. Expanded version of article issued as a 43-page pamphlet in an edition of 227 copies.

———. "Correspondance particulière de 'L'Art Moderne': L'Impressionnisme aux Tuileries." *L'Art Moderne*, vol. 6, no. 38 (September 19, 1886), pp. 300–302.

———. "L'Impressionnisme." *Emancipation Sociale* [Narbonne] (April 3, 1887). Reprinted in *Félix Fénéon: Oeuvres plus que complètes*, edited by Joan U. Halperin. Vol. 1. Geneva: Librairie Droz, 1970.

———. "Le Néo-impressionnisme: Correspondance particulière de 'L'Art Moderne'." *L'Art Moderne*, vol. 7, no. 18 (May 1, 1887), pp. 138–40.

———. "Le Néo-impressionnisme." *L'Art Moderne*, vol. 8, no. 16 (April 15, 1888), pp. 121–23.

———. "Exposition des Artistes-Indépendants à Paris." *L'Art Moderne*, vol. 9, no. 43 (October 27, 1889), pp. 339–41.

———. "Paul Signac." *Les Hommes d'Aujourd'hui*, vol. 8, no. 373. Paris: Vanier, 1890.

———. "Notes inédites de Seurat sur Delacroix [1881]." *Le Bulletin de la Vie Artistique*, vol. 3, no. 7 (April 1, 1922), pp. 154–58.

———. "Inédits d'Henri-Edmond Cross. V, Feuilles volantes (de toutes dates)." *Le Bulletin de la Vie Artistique*, vol. 3, no. 18 (September 15, 1922), pp. 425–27.

[Fénéon, Félix.] "The Art Criticism of Félix Fénéon." Selections translated by Francis Kloeppel. *Arts Magazine*, vol. 31, no. 175 (January 1957), pp. 15–19.

Fèvre, H. "L'Exposition des impressionnistes." *La Revue de Demain* (May–June 1886), pp. 148–56.

Fontainas, André. "Art moderne." *Mercure de France* (May 1900), pp. 541–42.

Fouquier, Marcel. "Les Impressionnistes." *Le XIXe Siècle* (May 16, 1886).

———. "L'Exposition des artistes indépendants." *Le XIXe Siècle* (March 28, 1887).

Geffroy, Gustave. "Pointillé-Cloisonnisme." *La Justice*, April 11, 1888.

George, Waldemar. "The Spirit of French Art." *The Studio [Atelier]* (January 1932).

Germain, Alphonse. "Theorie des Néo-Luminaristes (Néo-Impressionnistes)." *L'Art Moderne*, vol. 11, no. 28 (July 12, 1891), pp. 221–22; no. 30 (July 26, 1891), pp. 239–40.

———. "Théorie Chromo-Luminariste." *La Plume*, no. 57 (September 1, 1891), pp. 285–87.

Guenne, Jacques. "Entretien avec Paul Signac, Président du Salon des Indépendants." *L'Art Vivant*, vol. 1, no. 6 (March 20, 1925), pp. 1–4.

Habasque, Guy. "Le Contraste simultané des couleurs et son emploi en peinture depuis un siècle." In *Problémes de la couleur*, edited by Ignace Meyerson, pp. 239–53. Paris: S.E.V.P.E.N., 1957. Paper read at colloquium held at the Centre de Recherches de Psychologie comparative, Paris, May 18–20, 1954. Discussion (pp. 248–53) contains extensive remarks by Meyer Schapiro.

Hanotelle, Micheline. "Le Néo-Impressionnisme dans l'oeuvre de Léo Gausson." *Gazette des Beaux-Arts*, vol. 114, no. 1450 (November 1989), pp. 219–26.

Hennequin, Emile. "Les Impressionnistes." *La Vie Moderne*, vol. 8, no. 25 (June 19, 1886), pp. 389–90.

———. "Notes d'Art: L'Exposition des artistes indépendants." *La Vie Moderne*, vol. 8, no. 37 (September 11, 1886), pp. 581–82.

Herbert, Robert L., and Eugenia W. Herbert. "Artists and Anarchism: Unpublished Letters of Pissarro, Signac, and Others—I." *Burlington Magazine*,

vol. 102, no. 692 (November 1960), pp. 473–82.

Hermel, Maurice. "L'Exposition de peinture de la rue Laffitte." *La France Libre*, May 28, 1886.

Hildebrandt, H. "Neo Impressionisten, X. Paul Signac." *Aussaat*, vol. 2, nos. 1–2 (May–July 1947).

Huth, Hans. "Impressionism Comes to America." *Gazette des Beaux-Arts*, vol. 29, no. 950 (April 1946), pp. 225–52.

Huysmans, Joris-Karl. "Chronique d'Art. Les Indépendants." *La Revue Indépendante* (April 1887), pp. 51–58.

Jacques, Edmond. "Salon des Indépendants." *L'Intransigeant* (May 24, 1884).

Jamot, Paul. "French Painting—II." *Burlington Magazine*, special number (January 1932), pp. 3–72.

Javel, Firmin. "Les Impressionnistes." *L'Evénement* (Paris), May 16, 1886.

Kahn, Gustave. "La Vie artistique." *La Vie Moderne*, vol. 9, no. 15 (April 9, 1887), pp. 229–31.

———. "Chronique de la littérature et de l'art: Exposition Puvis de Chavannes." *La Revue Indépendante*, vol. 6 (January 1888), pp. 142–46.

———. "Exposition des Indépendants." *La Revue Indépendante* (April 1888).

———. "Au temps du pointillisme." *Mercure de France*, vol. 171, no. 619 (April 1924), pp. 5–22.

———. "Gauguin." *L'Art et les Artistes*, no. 61 (November 1925), pp. 37–64.

Katow, Paul de. "Le Salon des artistes indépendants." *Gil Blas* (May 17, 1884).

Le Blond-Zola, Denise. "Paul Alexis. Ami des peintres, bohème et critique d'art." *Mercure de France*, vol. 290, no. 977 (March 1, 1939), pp. 293–303.

Leclercq, Julien. "Aux Indépendants." *Mercure de France* (May 1891), pp. 298–300.

Lecomte, George. "L'Exposition des Néo-Impressionnistes, Pavillon de la Ville de Paris." *Art et Critique* (March 29, 1890).

———. "Société des artistes Indépendants: Sixième Exposition." *L'Art Moderne*, vol. 10, no. 13 (March 30, 1890), pp. 100–101.

Le Fustec, J. "Indépendants." *Journal des Artistes* (October 20, 1884).

———. "Exposition de la Société des Artistes Indépendants." *Journal des Artistes* (August 22, 1886).

———. "Exposition des Artistes Indépendants." *Journal des Artistes* (April 10, 1887).

Lepeseur, F. "L'Anarchie artistique, les Indépendants." *La Renovation Esthétique* (June 1905).

Lhote, André. "Composition du tableau." In *Encyclopédie française*, vol. 16, pp. 30–36. Paris, 1965.

Marlais, Michael. "Seurat et ses amis de l'Ecole des Beaux-Arts." *Gazette des Beaux-Arts*, vol. 114, no. 1449 (October 1989), pp. 153–68.

Marx, Roger. "Le Salon." *Le Progrès Artistique* (June 15, 1883).

———. "L'Exposition des artistes indépendants." *Le Voltaire*, May 16, 1884.

———. "Les Impressionnistes." *Le Voltaire*, May 17, 1886.

———. Notice in *Le Voltaire*, December 10, 1884.

Maus, Octave. "Le Salon des XX à Bruxelles." *La Cravache Parisienne* (February 16, 1889).

Michel, Albert. "Le Néo-impressionnisme." *La Flandre Liberale* (February–March 1888). Reprinted in *L'Art Moderne*, vol. 8, no. 1 (March 10, 1888), pp. 83–85.

Miomandre, Francis de. "Vingt ans après." *Le Bulletin de la Vie Artistique*, vol. 7, no. 4 (February 15, 1926), pp. 51–52.

Mirbeau, Octave. "Exposition de peinture impressionniste." *La France*, May 21, 1886.

———. "Néo-impressionnistes." *Echo de Paris*, January 23, 1894.

Montagne, M. de la. Notice in *Salut Public* [Lyon] (March 27, 1890).

Paulet, Alfred. "Les Impressionnistes." *Paris*, June 5, 1886.

Rewald, John. "Camille Pissarro and Some of His Friends." *Gazette des Beaux-Arts*, vol. 23, no. 916 (June 1943), pp. 363–76.

———. "Félix Fénéon, I." *Gazette des Beaux-Arts*, vol. 32, nos. 965–966 (July–August 1947), pp. 45–62; II, vol. 33, no. 972 (February 1948), pp. 107–126.

Rewald, John, ed. "Extraits du journal inedit de Paul Signac/Excerpts from the Unpublished Diary of Paul Signac. I, 1894–1895. II, 1897–1898. III, 1898–1899." *Gazette des Beaux-Arts*, vol. 36, nos. 989–991 (July–September 1949), pp. 97–128, Eng. trans., pp. 166–74; vol. 39, no. 1,001 (April 1952), pp.

265–84, Eng. trans. pp. 298–304; vol. 42, nos. 1014–1015 (July–August 1953), pp. 27–57, Eng. trans., pp. 72–80.

Schapiro, Meyer. "Nature of Abstract Art." *Marxist Quarterly*, vol. 1, no. 1 (January–March 1937), pp. 77–98.

———. SEE ALSO Habasque, Guy.

Seurat et ses amis. Introduction by Paul Signac. Catalogue by Raymond Cogniat. Exhibition catalogue. Paris: Galerie Wildenstein, 1933. Eng. ed., *Seurat and His Contemporaries*. London: Wildenstein, 1937. SEE ALSO Signac, Paul.

Signac, Paul. "Les XX (letter from Néo [Signac] to Trublot [Alexis])." *Le Cri du Peuple* (February 9, 1888).

———. "IVe Exposition des Artistes Indépendants (letter from Néo [Signac] to Trublot [Alexis])." *Le Cri du Peuple* (March 24, 1888).

———. "Catalogue de l'Exposition des XX, Bruxelles." *Art et Critique* (February 1, 1890).

———. "Le Néo-impressionnisme. Documents." *Gazette des Beaux-Arts* vol. 11, no. 852 (January 1934), pp. 49–59. Preface to catalogue of exhibition *Seurat et ses amis*. Paris: Galerie Wildenstein, 1933.

———. "Les Besoins individuels et la peinture." *Encyclopédie française*, vol. 16, ch. 2, pt. 3, pp. 16:84-7–10. Paris, 1935.

———. "Fragments du Journal." *Arts de France*, nos. 11–12 (1947), pp. 97–102.

———. SEE ALSO Rewald, John, ed.

Sitwell, Osbert. "The Courtauld Collection." *Apollo*, vol. 2, no. 7 (July 1925), pp. 63–69.

Smith, Paul. "Paul Adam, Soi et les 'Peintres impressionnistes': La Genèse d'un Discours moderniste." *Revue de l'Art*, no. 82 (1988), pp. 39–50.

Steiner, Wendy, "Divide and Narrate: The Icon Symbol in Seurat." *Word & Image* [United Kingdom], vol. 2, pt. 4 (October–December 1986), pp. 342–48.

Stillson, B. "Port of Gravelines (Petit Fort-Philippe) by Georges Seurat." *Bulletin of the Art Association of Indianapolis, Indiana* (October 1945).

Tériade, E. "Jeunesse," *Cahiers d'Art*, vol. 6, no. 1 (1931), pp. 11–35.

Thomson, Richard. " 'Les Quat' Pattes': The Image of the Dog in Late Nineteenth-Century French Art." *Art History*, vol. 5, no. 3 (September 1982), pp. 323–37.

Tiphereth. "Néo-impressionnistes." *Le Coeur* (July 1894).

Trublot [Paul Alexis]. "Exposition des Indépendants." *Le Cri du Peuple* (May 15 and 17, 1884).

———. "L'Exposition des artistes indépendants." *Le Cri du Peuple* (March 26, 1887).

———. "Visite à la *Revue Indépendante*." *Le Cri du Peuple* (April 14, 1888).

Tyrtée. Notice in *Le Moniteur des Arts* (February 18, 1887).

Van de Velde, Henry. "Die Belebung des Stoffes als Schönheitsprincip." *Kunst und Künstler*, vol. 1, no. 12 (December 1903), pp. 453–63.

Venturi, Lionello. "Piero della Francesca—Seurat—Gris." *Diogenes*, vol. 2 (Spring 1953), pp. 19–23.

Verhaeren, Emile. "Le Salon des *Vingt* à Bruxelles." *La Vie Moderne*, vol. 9, no. 9 (February 26, 1887), pp. 135–39.

———. "Chronique artistique: Les XX." *La Société Nouvelle*, vol. 7 (1891), pp. 248–54.

———. "Le Salon des Indépendants." *L'Art Moderne*, vol. 11, no. 14 (April 5, 1891), pp. 111–12.

———. "Exposition des XX." *Art et Critique* (February 13, 1892).

Ward, Martha. "The Rhetoric of Independence and Innovation." In *The New Painting: Impressionism 1874–1886*, edited by Charles S. Moffett, pp. 41–42. Geneva, Switz.: Richard Burton, Publishers, distributed in the United States by University of Washington Press, Seattle, 1986.

Webster, J. Carson. "The Technique of Impressionism: A Reappraisal." *College Art Journal*, vol. 4, no. 1 (November 1944), pp. 3–22.

Wyzewa, Téodor de. "L'Art contemporain." *La Revue Indépendante* (November–December 1886).

Zervos, Christian. "Idéalisme et naturalisme dans la peinture moderne." *Cahiers d'Art*, vol. 2 (1927), pp. 293–98.

Zimmermann, Michael F. "Die Utopie einer wissenschaftlichen, sozialen Kunst. Zur Theorie des Neo-Impressionismus und ihrer Aufnahme in Deutschland." In *Curt Herrmann 1854–1929*, edited by Rolf Bothe, pp. 264–83. Berlin: Berlin Museum and Verlag Willmuth Arenhövel, 1989.

Index

Page numbers in *italic* indicate illustrations;
references to notes are indicated by "n." or "nn."

Photograph Credits